BARRINGTON BARBER

THE COMPLETE INTRODUCTION TO

DRAWING

BARRINGTON BARBER

THE COMPLETE INTRODUCTION TO
DRAWING

METRO BOOKS

NEW YORK

© 2007 by Arcturus Publishing Limited

This 2008 edition published by Metro Books by arrangement with
Arcturus Publishing Limited

Metro Books
122 Fifth Avenue
New York, NY 10011

ISBN-13: 978-1-4351-0120-3

Printed and bound in Singapore

3 5 7 9 10 8 6 4 2

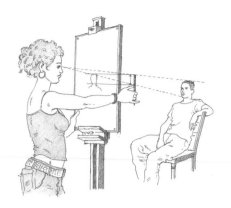

CONTENTS

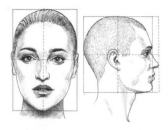

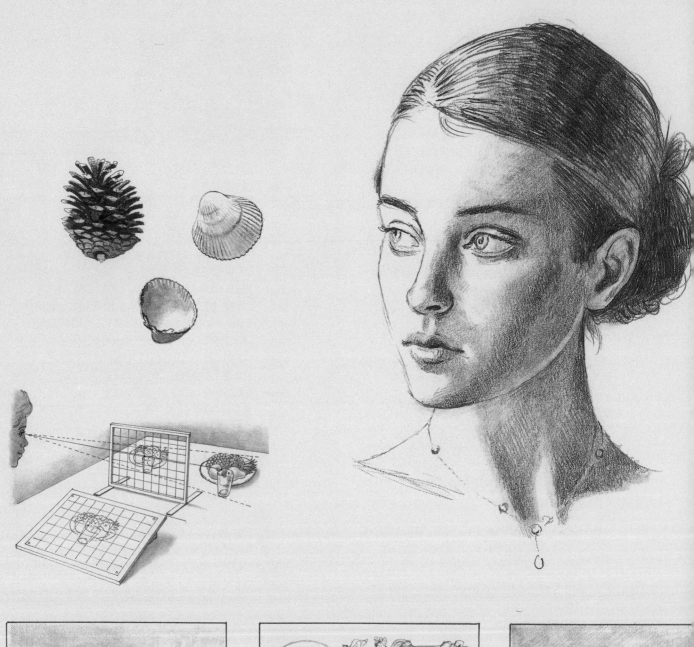

INTRODUCTION

Starting to draw is an interesting and sometimes a daunting business. I want to be able to help you find ways of gradually improving your skill and thereby increase your enthusiasm, because this is perfectly possible, no matter how little formal teaching you may have had. One of the great advantages of coming to drawing relatively unpractised is the freshness with which you can approach the subject. So even if you are a complete novice, this book should help you to get some drawing practice under your belt.

The principal skill in drawing that you need to achieve is the co-ordination of the eye and the hand. It is not as difficult as it sounds, because we all learn to do this naturally, by having to pick things up, catch a ball, write a list and the many other day-to-day tasks that human beings are expected to do. The eye can see very much more than we generally give it credit for and our mind analyzes the information quite readily and with remarkable accuracy. It is also amazing how precisely our hands can move in the right direction, with just the right amount of pressure and degree of judgement, when required.

When drawing, these skills will naturally come to your aid, as long as you don't get in the way of the action by thinking too much. In fact, thinking too much is often the chief obstacle to making improvements in drawing. Many of the exercises that I demonstrate in this book are time-honoured practices employed by artists for centuries.

We shall look at the materials that you require if you are going to draw seriously; and at ways of using them to their best advantage, so you don't waste time trying to find that out for yourself; although a certain degree of experimentation is recommended after introduction to any medium.

There will be a series of exercises to help you refine your eye and hand co-ordination, which takes practice if you really want to draw well. I will be emphasizing the importance of seeing clearly and of being able to check that in a practical way, as a major function of the practices that appear in this book.

I shall guide your attempts at drawing all kinds of things from the very smallest, such as drawing pins and matchsticks, to the biggest, like skyscrapers. You will be shown how to draw plants and flowers, and stones and mountains. We will tackle the elements, earth, air, fire, water, and even space. We will then progress to the human figure and face, and learn to put together all these things, so that eventually you will be able to build a complete picture of almost anything you care to imagine.

Skill isn't achieved overnight: there will be a certain lapse of time between your first efforts and the more adept results that will then proceed from practice and effort. However, I can guarantee that if you carry out all the exercises in this book, and practice regularly, there will be a remarkable improvement in your work. So, I wish you good luck and happy drawing.

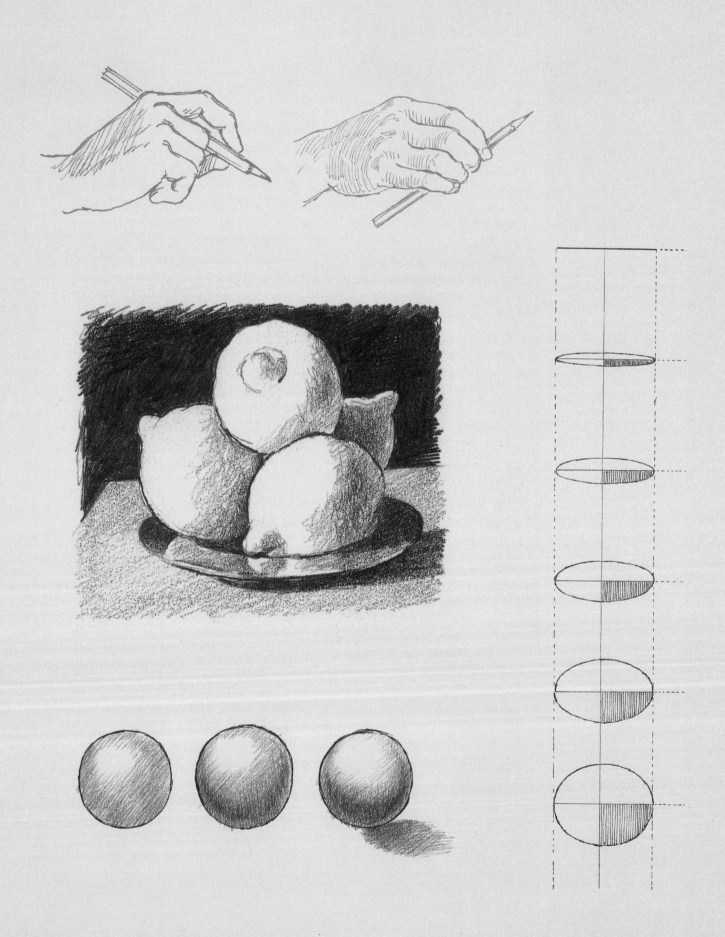

BASIC MARK MAKING

When you draw, you are not creating the objects you draw; you are merely making marks on paper that represent some kind of visual experience that we recognize as something familiar in our view of the world: the drawings are illusions of form and shapes that we see. So mark making is important and we need to practice improving and extending our ability to do it easily and effectively.

Probably the first thing to consider when you begin to draw is exactly how you are going to organize yourself. So, in this section we will examine whether you sit or stand to draw; the way you hold your drawing implements; how you assume your viewpoint; and even the size of the image that you draw. It is well worth spending time over these matters, although much of it is a matter of common sense.

We will look at various ways of practising drawing with simple exercises to encourage confidence in your methods. There will also be a consideration of mechanical devices and their usage, designed to help you produce naturalistic drawing.

POSITIONS AND GRIPS

Here we consider ways of standing or sitting to draw and ways of holding the drawing implement to get the best results.

When drawing things laid out upon a table, you can sit and work on a large enough drawing board to take the size of paper you are using, which will be attached with clips, drawing pins or masking tape. Of these, I prefer the latter as it is easier to change the paper and it doesn't matter if you lose the bits of masking tape.

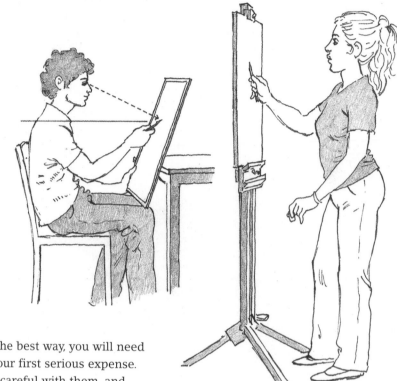

To draw standing up, which is much the best way, you will need some kind of easel, and this will be your first serious expense. However, they last for ever if you are careful with them, and make drawing so much easier. There are several types, such as portable easels, radial easels (my own favourite), and large studio easels, which you should buy only if you have sufficient space and are intent upon a career in art.

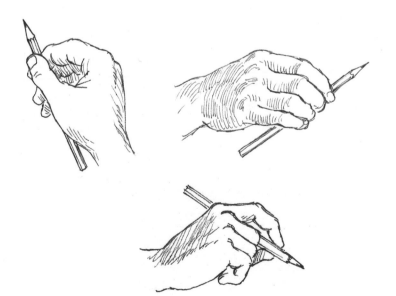

The way that you hold your drawing implement has a great bearing on your drawing skill. Don't hold the pencil too tightly: try to relax your hand and wrist and hold the implement loosely so that there is no unnecessary tension; the quality of your line should improve immediately.

Also, try out different ways of holding it, for instance more like a stick or sword than a pen. The pen-holding method is not wrong but often too constrained for really effective drawing.

SKETCHING

Going to a place that you know, and simply drawing what you see to the best of your ability, is one of the best exercises that you can perform. Rather than loose sheets of paper, consider keeping a bound sketch book to record your immediate impressions of a scene. You will need a small one (A5), and another one a bit larger (A4 or A3). There are many versions with various types of binding and you just have to choose those that suit your particular needs.

When you make sketches of things, people and places, you will need to draw them from several viewpoints to become really familiar with them. And don't forget to include as many details as you can, because this information is often useful later on.

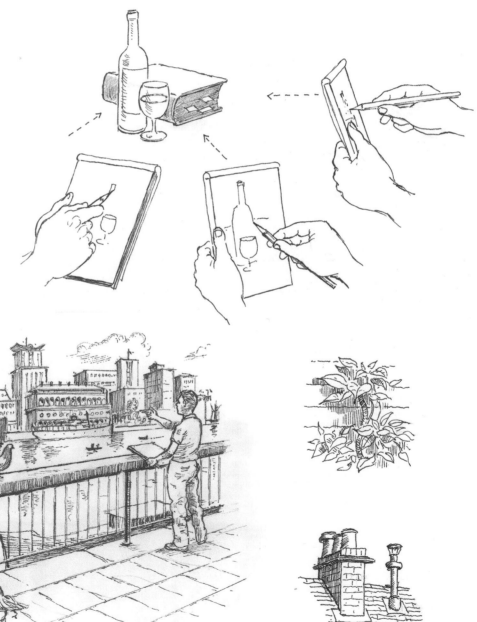

MEASURING AND FRAMING

There are ways of measuring the subjects of your drawings and this one is called 'sight size' drawing, where you reproduce everything the size that it appears to you from your point of view. This system is very useful where you have a large area to draw, however it is often difficult to correct when you go wrong because the difference between the correct and the incorrect marks on the paper can be very small.

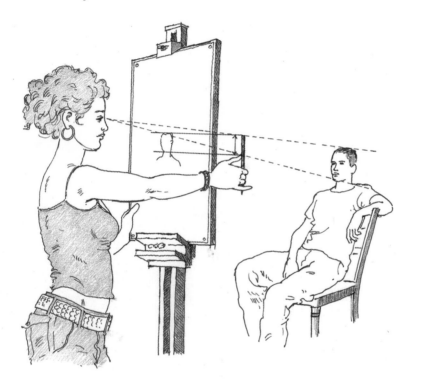

When portraying smaller subjects take measurements to get the proportions right, but draw the item up larger in order to make correction easier. It is most important to correct your drawings rigorously in order to learn to draw well. It doesn't matter if the final work looks a bit of a mess, the habit of continual correcting will lead you to draw much better as you go on. One day you will get it right.

If, for some reason, you cannot find the time to draw your subject, or even if you can, it is always a good idea to take photographs as well, to supplement your sketches. The information you require to work further on your drawings cannot be too detailed. And don't forget to take the subject from more than one angle, exactly as you would if you were sketching it.

Another thing that you should consider before deciding on your finished piece, is whether your composition is to be a vertical ('portrait') or horizontal ('landscape') picture. Make sure you try out both possibilities before you get too involved.

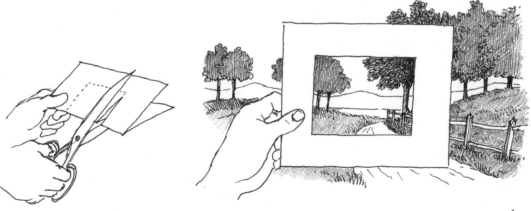

A framing device is very useful and often helps towards the better composition of the drawing that you are about to work on. From any small sheet of paper or card, cut out a rectangle that seems roughly the same proportion as your working surface. Then you can hold it up to your eye and view the subject matter through it. This will give you some idea of how your drawing should look on the paper. And it also eliminates all the unnecessary surroundings that might disrupt your concentration.

A rather more adaptable version of the cut-out rectangle is a pair of right-angled strips (L-shaped) that you can arrange to any proportion that suits you.

MECHANICAL DEVICES

Mechanical methods of producing drawings have been used by artists down through the centuries, and here I shall show you a couple of the most useful. Of course, tracing and copying are probably the methods that spring to mind most readily, but there are others. Let us look first at one time-honoured way of getting the correct perspective and shape in respect of objects that are not too big; this method may even be used for landscapes, if you can find a way of keeping a fixed viewpoint.

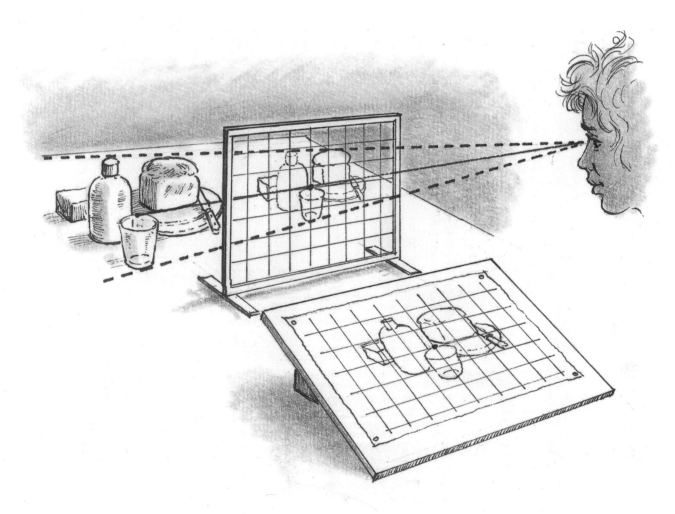

The frame shown here can be made either from wood with threads attached to form a grid or mesh, or by using a sheet of glass or acetate onto which you have drawn squares in black ink. You must make sure that the squares are regular or the method won't work. Choose a particular point where two threads cross as your marker, this point must also be marked correspondingly on the still-life group itself; then you can begin to reproduce your still-life arrangement on a sheet of paper drawn up with a similar grid. This way you should get a very accurate outline drawing of the objects.

Another method is to project a slide of the chosen object onto a plain wall, enlarging or reducing it as required. The only difficulty with tracing this way is that sometimes you will be unable to avoid blocking out the image with your shadow. Before photography, artists often used a device called a 'camera obscura', a darkened box with an aperture through which an image was projected onto an interior wall.

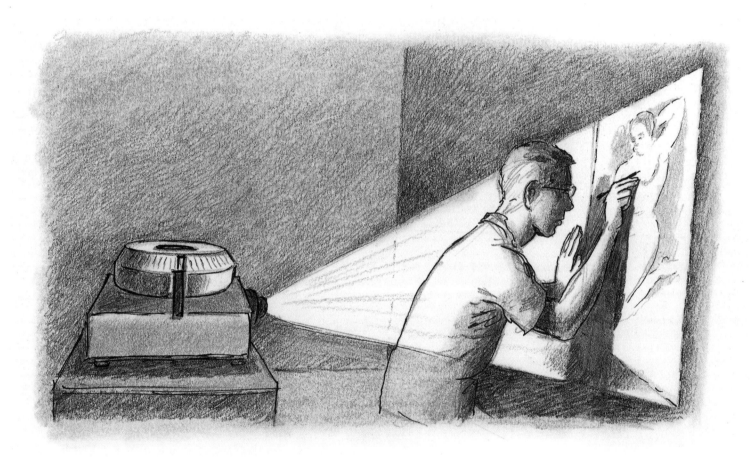

MATERIALS AND MEDIUMS 1

The next thing to consider before you start drawing is the choice of materials and mediums that you could use. There are many possibilities and good specialist art shops will be able to supply you with all sorts of materials and advice. However, here are some of the basics, which you might like to consider.

Pencils, graphite and charcoal

Good pencils are an absolute necessity, and you will need several grades of blackness or softness. You will find a B (soft) pencil to be your basic drawing instrument, and I would suggest a 2B, 4B, and a 6B for all your normal drawing requirements. Then a propelling or clutch pencil will be useful for any fine drawing that you do, because the lead maintains a consistently thin line. A 0.5mm or 0.3mm does very well.

Another useful tool is a graphite stick, which is a thick length of graphite that can be sharpened to a point. The edge of the point can also be used for making thicker, more textured, marks.

An historic drawing medium is, of course, charcoal, which is basically a length of carbonized willow twig. This will give you marvellous smoky texture, as well as dark heavy lines and thin grey ones. It is also very easy to smudge, which helps you to produce areas of tone quickly.

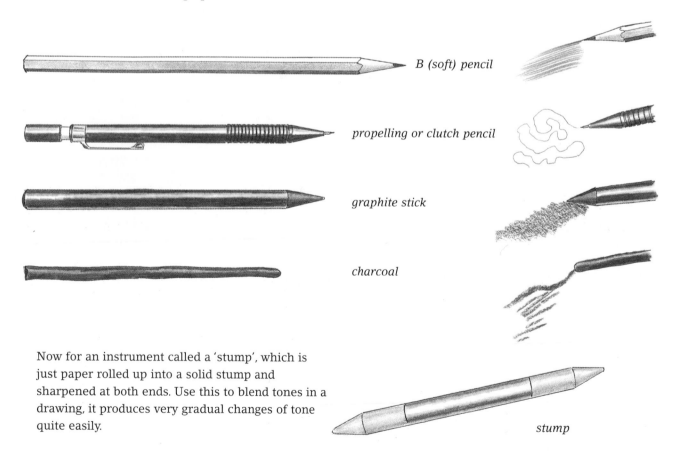

B (soft) pencil

propelling or clutch pencil

graphite stick

charcoal

Now for an instrument called a 'stump', which is just paper rolled up into a solid stump and sharpened at both ends. Use this to blend tones in a drawing, it produces very gradual changes of tone quite easily.

stump

Scraperboard

Scraperboard is a very distinct method of producing a drawing that has some of the characteristics of an engraving or woodcut. You work on special card coated with a layer of china clay that has either a white surface or a black one. The white surface is for the use of added colour, and the black surface for incised line drawing.

With an instrument rather like a stylus, you scratch lines and marks on the black surface which result in a white image on a black background. So it is very similar in effect to wood engraving or woodcuts. It is quite attractive and at one time was widely used in commercial illustration.

scraperboard tool

liquid concentrated water colour *Indian ink*

Pen and ink

Next, take a look at the various pens available for ink drawing, a satisfying medium for many artists. There is the ordinary 'dip and push' pen, which requires liquid ink and can produce lines both of great delicacy and boldness just by varying the pressure on the nib. With this you will need a bottle of Indian ink, perhaps waterproof, or a bottle of liquid watercolour.

dip or push pen

graphic pen

A modern graphic pen that uses interchangeable nibs in a range of thicknesses, is more like a fountain pen, with its ink stored in a cartridge, but it produces a consistent fine line.

MATERIALS AND MEDIUMS 2

Felt tips and markers

There are also felt tips, which are thicker than the graphic pens, and permanent markers that produce very thick lines in indelible colours.

felt tip

permanent marker

Brushes

You will also need a couple of brushes so that you can put on larger areas of tone when you need to; Nos 2 and 8 are the most useful. The best brushes are sable hair, but some nylon brushes are quite adequate.

No.2 sable or nylon brush

No.8 sable or nylon brush

Erasers and sharpeners

When drawing in pencil you will almost certainly want to get rid of some of the lines you have drawn. There are many types of eraser, but a good solid one (of rubber or plastic) and a kneadable eraser (known as a 'putty rubber') are both worth having. The putty rubber is a very efficient tool, useful for very black drawings; used with a dabbing motion, it lifts and removes marks leaving no residue on the paper.

putty or kneadable eraser *soft rubber eraser*

scalpel

craft knife

And with all this, you will need some way of sharpening your pencils frequently, so investing in a good pencil-sharpener, either manual or electric, is a must. Many artists prefer keeping their pencils sharp with a craft knife or a scalpel. Of the two, a craft knife is safer, although a scalpel is sharper. Scalpels can be used as scraperboard tools as well.

PRACTICE EXERCISES IN BASIC DRAWING

*Trying out various mediums, so that you will have some idea of
their capabilities, is a very useful thing.*

And I start here with what must be the easiest thing of all to draw…a dot.
Now, having put pencil to paper, you can carry on by adding to the
initial dot with others, but this time cluster them together carefully until
you have produced a circular shape in which all the dots seem to be the
same distance apart.

Next, try something a little more structured: having achieved a shape of some
kind on the paper, now visualize a square and, by lining up the dots carefully,
produce one made up entirely of equally spaced dots. This requires the
engagement of the intellect with the activity and is one of the first lessons for an
artist: that everything you produce is an illusion based on the brain's ability to
order and reform the universe about you. Nothing of course has really changed,
apart from your own view of how you see the world but that is what an artist
does. He or she interprets and represents experience in order that others may
also have a new experience.

Now there follows a whole series of simple marks to help you devote all your
attention to that place where the pencil actually meets the surface of the paper.

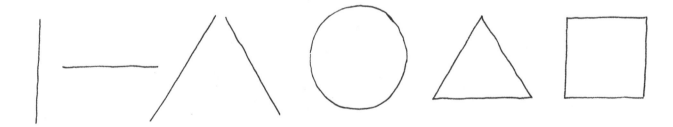

First draw a vertical line, then a horizontal line, then a
diagonal, and then another diagonal in the opposite direction.
Next, draw a circle without recourse to your compass, then an
equilateral triangle, followed by a square, and then – more
difficult – a five pointed star. Lastly in this series, try a spiral,
either from the centre out or from the outer edge coiling
inwards. You have begun to draw!

The next stage is also quite simple but requires your sustained attention, which is excellent training for an artist.

Visualizing a square, draw vertical lines all the same distance apart and as straight as you can make them. While doing this, concentrate your attention on the point of the pencil as it travels across the paper. This will focus your mind on the task in hand and bring an artistic touch to the way that you draw even the simplest of marks.

Go on to do the same thing with horizontal lines. Slightly harder? Try diagonals one way...and then the other.

Now, combining your verticals and horizontals, produce a chequered square.

Let us go for something freer but more difficult to get right, and that is a series of small circles. After these, make some more circles, twice as big. Then double the size again. Next, double up on that size and repeat the circles until they start to look a bit more circular. Don't rush this stage. Go as slowly as you like, then when you find yourself getting quite good at it, speed up a little but still endeavouring to keep the circles absolutely circular.

SHADING AND TONAL EXERCISES

Here are ways to improve your shading so that it doesn't look too crude and therefore unconvincing. You are trying to emulate the effect of shadow on a surface that may be curved or flat.

Starting with a well-sharpened pencil, do a series of closely packed straight lines in a diagonal pattern. It doesn't matter which diagonal you choose because you will be doing the opposite diagonal later.

Do the same with vertical lines over the top of the diagonals. Notice how this increases the depth of the tone. Next, proceed similarly with horizontal lines. Finish with a series of diagonals across the previous diagonals. You have now increased the depth of tone fourfold.

Now, with small groups of short lines, build up a tone by placing them together closely, so that there is not much space between them. Make sure that they go in all directions, as shown.

Do the same with random short marks, which cross over each other creating a tonal area. Next, build a tone from one single line without lifting the pencil off the paper but crossing it backwards and forwards in all directions.

Now have a go at smudging one of your former attempts at shading by rubbing it with your finger or a paper 'stump'.

Lastly try using the edge of the pencil lead or, even more effective, the edge of a graphite stick. This renders a wide smudgy mark quite easily.

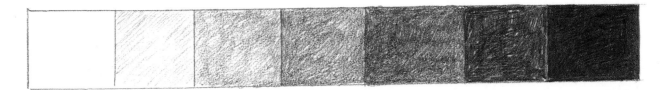

Next, try a rather more disciplined exercise in shading skill by constructing a 'grey scale'. This time you will have to be aware of how much pressure you are putting on the pencil as you do your shading.

Draw a row of squares, not too large. Leave the first one completely blank, so you start with plain white. The second square should now be shaded with as light a tone as possible. This might take several attempts. Then, in square three, shade a little more heavily. As you proceed along the row,

make your shading heavier and heavier until you produce a completely black square in the last one. Go for a scale of seven or eight squares, until you get really skilful, when you might make nine or ten. See how far you can take it but each square must be slightly darker than the former. Eventually you gain in confidence and this inspires you to emulate what Leonardo da Vinci and Michelangelo were able to do with their drawings, to achieve the effect of light falling on a three-dimensional surface.

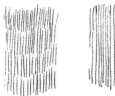

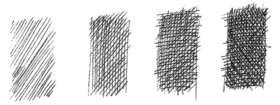

After these exercises, switch mediums and have a go using pen and ink. With a very fine-line pen do a series of vertical strokes, quite short but all close together making an area of tone as shown. Next, do the same thing again with longer strokes that cover the whole depth of the area.

Now, as you did with the tonal exercises in pencil, draw diagonals with verticals over the top, and then horizontals over those two, followed by more diagonals in the opposite direction. You will see how the illusion of shadow or tone is produced by these exercises.

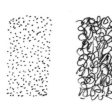

After that, try dots, and then a wriggling continual line that constantly crosses over itself rather like tangled thread.

And lastly, pick up a brush and put on a quick wash of tone in one brushstroke.

MORE SHADING

These exercises are designed to develop your skills yet further in the practice of familiarizing yourself with various mediums, and their different effects and looks. This will help you to become competent in handling your tools.

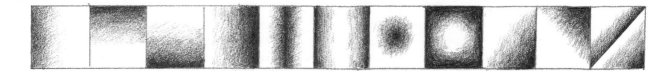

The shading exercise that possibly requires the most control is the series of fading tonal squares. There are eleven, and they produce varying effects of curved surfaces. Take your time over them; they are quite subtle.

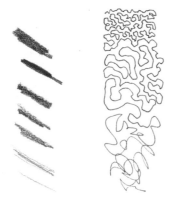

Test yourself in other mediums, such as a series of marks made with the graphite stick, or a series done with the fine-line pen in one long, uninterrupted line.

Try an angular version of the same with a pencil, and lastly with a loaded brush and dilute ink or watercolour.

Try a pencil line in a swirling, spiralling shape that crosses over itself continually rather like a cloud of smoke.

Then try a line that swings alternately from top to bottom producing a graphic set of curls, as shown.

Next comes a more angular line, which gently scribbles its way backwards and forwards over itself.

Now, take the same three sets of texture, and produce them in pen and ink…

…and then using a brush and diluted ink or watercolour.

These exercises are all designed to get your hand and eye in tune with each other and to give you practice, which helps you gain expertise.

THE ILLUSION OF THREE DIMENSIONS

The next stage is for you to move further into the realms of illusion and produce shapes that appear as if they exist in a three-dimensional space.

Draw a neat square. Then, to three of the corners, add three short lines all the same length leading diagonally away from it. Join the free ends of the lines up with two lines parallel to the nearest sides of the square. Eureka! A cube, or what appears to be a three-dimensional shape, on flat paper. The more carefully you draw it, the more convincing it will be.

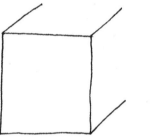

Now try another version of the game. This time, draw a diamond-shaped parallelogram with the longest side parallel to the horizon. Construct three vertical lines downwards from the three lower corners, all the same length. Once more, join the free ends of those lines with lines parallel to the lower two sides of the diamond. And once more, you will observe that you have created the illusion of three-dimensional shape. It's quite good fun, isn't it? And it has a lot to do with learning to draw. You start producing shapes that you first conceived mentally and have now made evident physically. A good start, and worth practising as much as you feel will be useful.

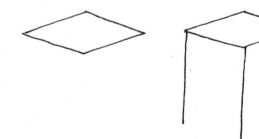

Having learnt to make a cuboid shape, lend it more verisimilitude by shading the two lower sides with an even, light tone. Next, select one of the shaded sides and shade it to an even deeper tone. Then finally, add an area of tone outside the shape of the cube to indicate a cast shadow. The illusion is now complete.

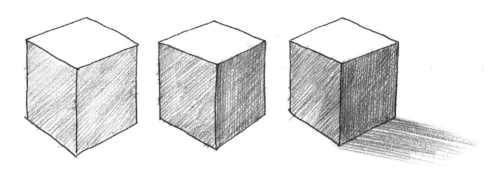

I shall take you now onto circular shapes, globes or spheres.

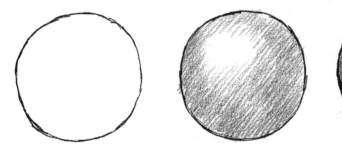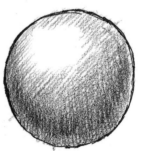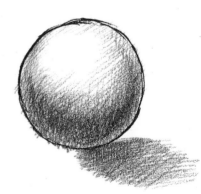

Start by drawing a circle as accurately as you can; the better the circle, the more effective the illusion. Then, with a very light set of pencil strokes, shade in an area of the circle leaving a small patch of unshaded space towards the upper left side, as shown. Having applied the first layer of shading, start another layer, rather smaller in area but deeper in tone, in a crescent around the lower right side of the circle. As you can see, it is beginning to look three-dimensional already. To add to the illusion, create a tonal area outside the circle to indicate a soft shadow, which the supposed sphere is casting on the supporting surface. All this helps to make your globe shape more convincing.

ELLIPSES AND CYLINDERS

Before starting on the last of these key three-dimensional shapes – a cylinder – we need to look at the way to construct an ellipse. An ellipse is the shape that a circle appears to make when it is seen from an oblique angle.

In the example, I show how a car tyre would appear as you move your viewpoint over and above it, so that you can see more of its circular qualities. Alongside is the elliptical shape that the top of the tyre makes when seen from an oblique angle. As you move from what appears to be a straight line, the shape begins to widen across its vertical axis, revealing the typical ellipse shape.

One of the properties of an ellipse is that each quarter is exactly the same as the others, only in reverse or mirror image (one quarter is shaded to indicate this). There is no foolproof way of drawing an ellipse, except to copy one and try to draw it as accurately as you can, time and time again. It does take a bit of practice but as you improve, you will find yourself able to create the illusion of depth more convincingly.

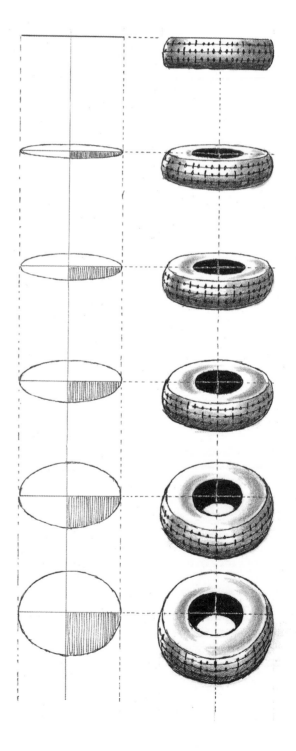

In order to draw a cylinder, first draw an ellipse as shown. Then project two vertical lines downwards from the narrow ends of the ellipse, keeping them parallel and the same length. Then at the lower end of the lines construct another ellipse, but this time you only need to draw the curved lower side.

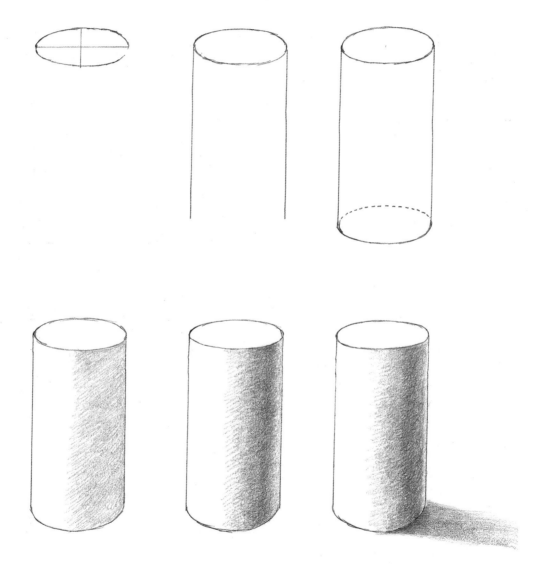

Having established the outline of the shape, shade the entire length of the cylinder on one side only, but not quite up to the edge. When you have one layer of tone on, making sure that it fades off towards the edges, put another narrower band of tone over the top in the middle of the previous tonal area, but slightly closer to the outside edge. Now, to complete the illusion, shade in an area projecting onto the surface that the cylinder is supposedly standing on, fading it out as it stretches away from the cylinder's edge. You now have the image of a free-standing cylinder.

BASIC DRAWING OF SINGLE OBJECTS

To draw well, you now know that you will need continual practice, but don't be put off because it can be made interesting.

Try first by looking at a straightforward object like a wine glass, which has an interesting shape, and its transparency enables you to see the structure more clearly. Begin by getting some idea of the proportions of the glass; calculate the ratio of stem length to bowl size. Next, draw a vertical ruled line to mark the centre line of the object. The shape of the glass is curved, and so the two sides should appear symmetrically either side of the central line. If they don't, it means that your drawing is out of balance. You have plenty of opportunity for drawing ellipses in this exercise so try and make them as accurate as you can. Check that none of the curves look odd or out of proportion.

Have a go at drawing the same object from a slightly different angle. This gives you both practice at drawing and familiarizes you with the shape of the object from all angles. Having drawn it a couple of times, do it again from another viewpoint, so that you get even more information about the object. All this concentration on one object boosts your knowledge of the world of 'form', which is essential for an artist. When you have done sufficient with the wine glass, you can repeat the exercise as many times as possible with different objects, knowing that the more you draw the better you will become.

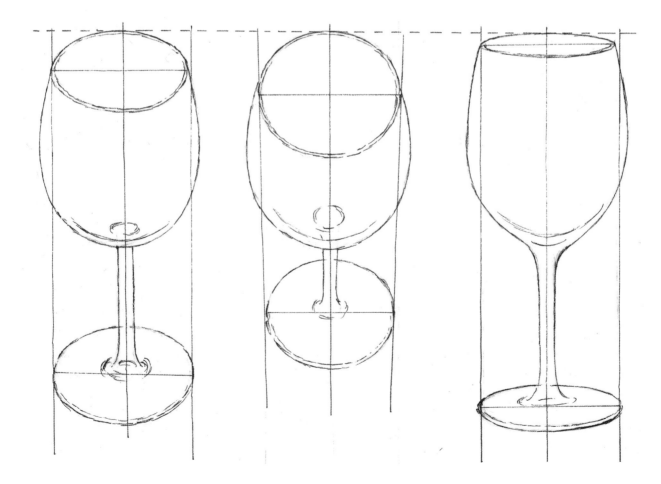

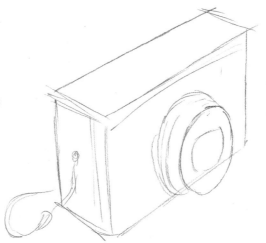

Another drawing exercise consists of choosing a solid mechanical object, like this small camera, and sketching a simple outline to start with.

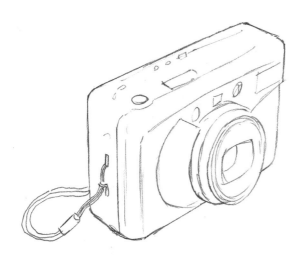

Then put in all the technical attributes, but without attempting more than to get their most obvious shapes right. The most difficult thing in this case is to achieve the correct proportions, but at least with a mechanical, mass-produced object like a camera, there will be a sort of logic to the shape.

Finish by putting in a bit of shading, keep it minimal, just enough to give it a feeling of substance. Drawings like this, without too much detailed work, can convey quite a bit of information if you get all the shapes right.

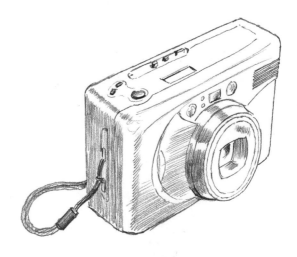

SINGLE OBJECTS BY ESTABLISHED ARTISTS

This is a series of examples to show how different artists have used humble, everyday objects to draw as a means to practise and hone their creative skills.

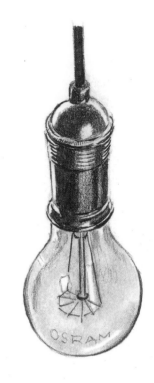

In this drawing of an electric light bulb, *Electric Light Bulb* (1928), based on a picture after the Swiss photographer Hans Finsler (1891–1972), the intention is to make it look as much like an object of glass and metal as is possible. Note the subtle shading on the glass of the bulb.

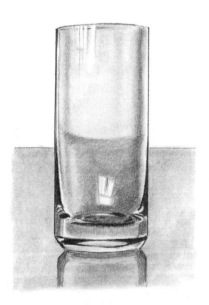

Day by Day is a Good Day (1997), after the German conceptual painter Peter Dreher (born 1932), is similar in its efforts to give the maximum glasslike look to the tumbler that is standing on a polished table top. The reflected light from the window and the curved view of the table top through the glass make you feel that it might be real enough to pick up.

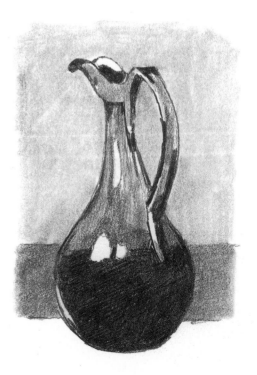

The next drawing, after Camille Pissarro (1831–1903) of a jug of wine, is less realistic in style, but the image still has considerable strength.

The bowl of fruit after Paul Cezanne (1839–1906) is even less detailed in execution, but the essentials of the pieces of fruit and the way that they appear huddled on the plate are convincing.

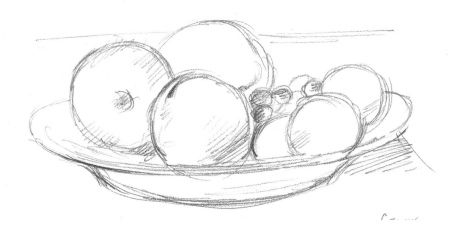

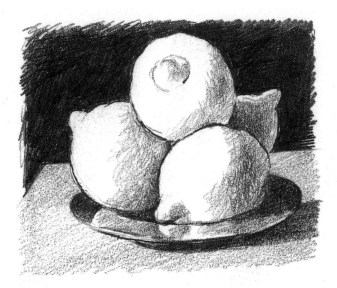

In his *Still Life* (1633) of a small metal plate with four lemons set upon it, the Spanish painter Francisco de Zurburan (1598–1664) gave a convincing account of their solidity and roundness of form.

And lastly, my own careful drawing of a spotted mug, shows evidence of study and practice enough to be a fairly good statement of a three-dimensional object.

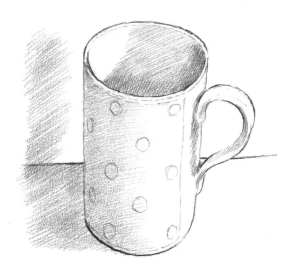

GEOMETRY OF COMPOSITION

Some idea of how to arrange or design a composition is necessary when you get on to drawing more composite pictures. Here are several approaches that can be useful when considering this situation.

The first composition is from a painting after the French artist Claude Monet (1840–1926), an excellent designer, of a simple coastal landscape. In *Walk on the Cliff at Pourville*, he has placed the horizon about two-thirds up the picture, which is defined by the line of the sea; only one part of the rocky cliff projects above it. The main line of the cliff top curves from the bottom left-hand corner of the picture, sweeping up towards that piece of cliff that juts above the horizon, on the upper right-hand side. Two small figures are placed on the part of the cliff that almost reaches up to the horizon, about two-thirds from the left edge of the picture. This provides a significant focal point to the whole scene.

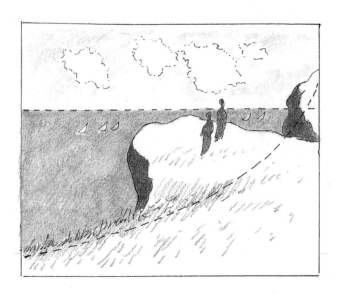

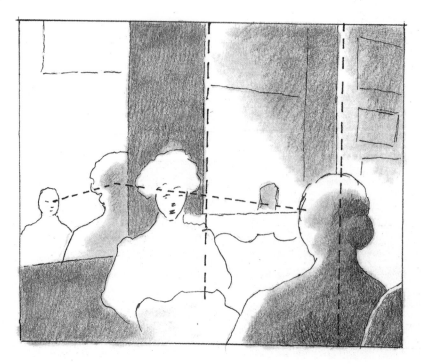

The next picture is after Edouard Vuillard (1869–1940). In *Lucy Hessel Visiting Madame Vuillard* (1904), two women confront each other in the lower half of the composition. Behind the figure facing the viewer stands a wall with two large mirrors on it and, in the mirror on the left of the composition, you see a reflection both of the back of the woman facing outwards and the face of the woman who has her back turned towards us. The strong vertical edges of the mirrors divide the room into four strips, while the line from the nearer head to the farther face, leading into the reflection of both heads in the mirror, gives an interesting impression of depth and complexity to the motionless scene.

In the next composition, *Jane Renouardt* (1926), Vuillard uses the device of the mirror on the rear wall again, but this time the figure of the seated woman is far more dominant. And the suggestion of the doorway leading through to another space behind the mirrors, creates an intriguing feeling of confusion between real and unreal space. This is primarily a posed portrait of an actress, so you can see why the illusion of real and unreal is most apposite.

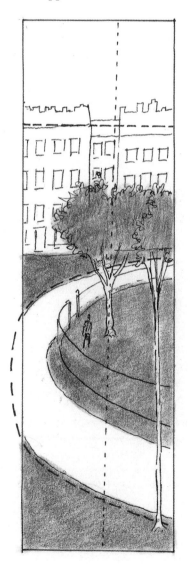

The last Vuillard drawing, *Place Vintimille* (1908–10), is in a tall, narrow format and features a square outside his house in Paris. At the top half of the composition are the rather blank-windowed walls of the far side of the square, slightly masked by the tops of the trees in the central garden. The curve of the railings around the gardens is matched by a curve of road that swings right across the lower part of the picture, sweeping from the lower right side upwards, touching the left side of the picture and disappearing off the right-hand side of the frame, about halfway up. This is an interesting way to render depth of field in a narrow slot-like composition.

FORMAL AND INFORMAL

*Next, I show two pictures after David Hockney (born 1937)
in which he uses certain compositional devices to produce
an informal and a formal setting for showing two figures.*

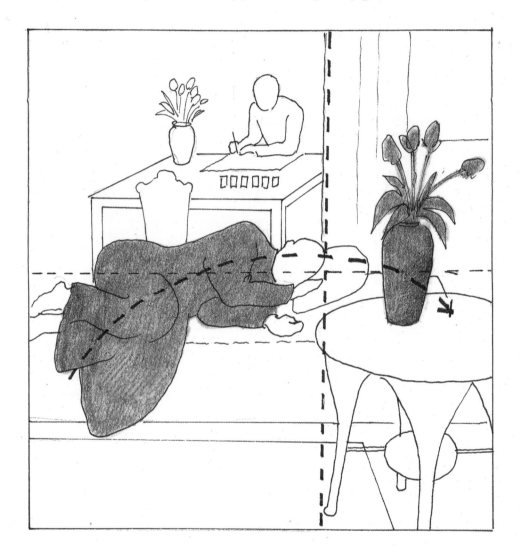

The first, *Model with Unfinished Self-portrait* (1977), is of an upright canvas in
the background depicting Hockney himself drawing while, in the foreground, a
model of his is sleeping on a couch by a table with a vase of flowers on it. The
composition is divided into four areas: vertically by the edge of a curtain and the
leg of the table; and laterally by the sleeping figure and the vase. There is also a
curved movement in the composition, following the shape of the sleeper, across
the vase to the table top. So, the shape is divided in quite a complex way but
with quite simple devices.

The second of Hockney's pictures, *Henry Geldzahler* (1969), is very much more formal in style. It places the main figure almost centrally on an enormous curved sofa, his position accentuated by the large window frame immediately behind him. The second figure placed to the right of the scene, appears almost incidental , as if he has only just appeared in the painting, an impression underlined by the fact that he hasn't yet taken off his coat. This arrangement creates an air of something about to happen in a situation that until just now was set and unremarkable.

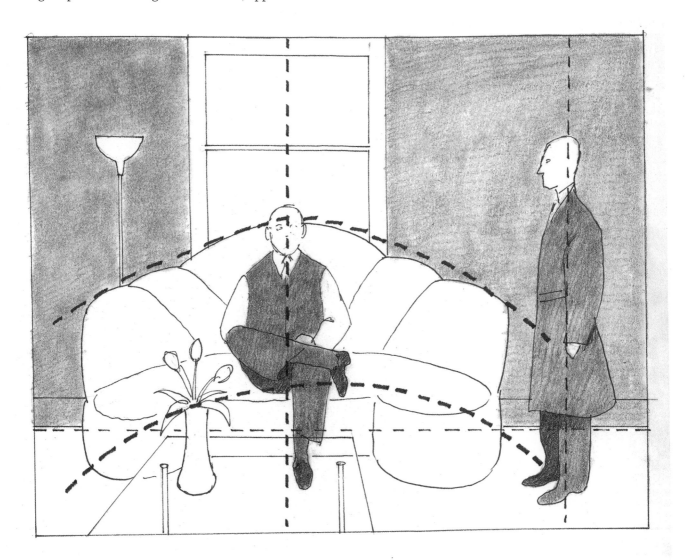

DRAWING OBJECTS AND STILL LIFE

The next section furthers our investigations into the area of real-life objects. The idea is to practise your drawing skills by setting up a multiplicity of objects found around your house and making an attempt at drawing them carefully.

Object drawing is frequently called 'still life', because the one thing you can rely upon is the fact that the subjects will not move of themselves while you are drawing them. Eventually of course, you will be drawing several objects arranged together so that they make some sort of composition. But before you get to the stage of composing a picture, it is best to draw as many individual items as you can manage, for – as I have remarked before – in drawing there is no substitute for practice. And at this point you should elect to draw directly from life because you will be practising observation as well as drawing. Drawing from photographs or other drawings is quite acceptable if you have no alternative, but it cannot teach you as much as drawing from life.

In order to make it easier for yourself, start with very plain objects. Look for things around you that are relatively simple in shape and texture. Flatter objects are less complex and so try things like knives and forks and spoons, or coins or medals, or even your pencil. None of these things have much of a three-dimensional quality and so you won't have too much difficulty in making them look convincing.

As you progress, try fairly straightforward things, such as cups and saucers, books, tools and jars. Then something slightly more complex – shoes, furniture, plants – and eventually, parts of the human body, such as the eye or hand. After all this, you might set your sights on something larger and more complex, such as a bicycle or car.

An important thing about all this practice is to draw what you find interesting, and to assume that most things can be interesting if you take the time to look at them. Anything that is capable of moving by itself is harder to draw, but worth the effort, if you have the determination to try it. Both animals and people find it difficult to keep still for very long, so don't expect them to be easy subjects. On the other hand, they are very much more attractive to draw, so you are bound to want to attempt them in due course. Plants are good subjects because they don't move much of their own accord yet are very graceful and have a natural element that man-made objects don't offer.

SIMPLE OBJECTS

Embark on your still-life exercise with something that is not too complex, like a coin or similar object.

Here is a pound coin.
First draw the circular shape as accurately as you can. This is an exercise in itself.

Next, draw the thickness of the coin, as you see it from one side. Then mark out the outline of the head of the monarch and indicate the lettering around the edge.

All you have to do after that is to introduce a little discrete shading around the thickness of the coin and on the face of it, to indicate some minimal relief.

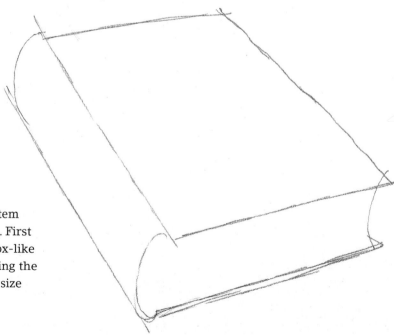

Next we look at a book, which is another item that does not present too many difficulties. First draw the simple structural outline of its box-like shape, creating a little perspective by making the farther end of the book slightly smaller in size than the nearer end.

Then block in the main areas of
shading, to give the impression of
three dimensions.

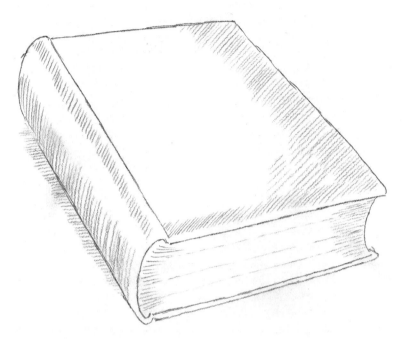

Lastly, put in details of the tone more carefully
and indicate the leaves, by drawing fine lines
where the edges of the pages show.
You now have a solid volume.

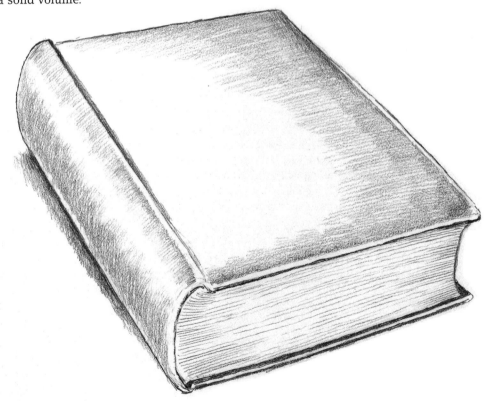

LESS SIMPLE OBJECTS

Now try drawing a single workshop tool, like this pair of pliers. Before you start, have a good look at them. Often, appreciating how something works helps your drawing of it.

First, draw the main outline as before. Don't use a viewpoint immediately above the pliers, or you can't produce a three-dimensional effect.

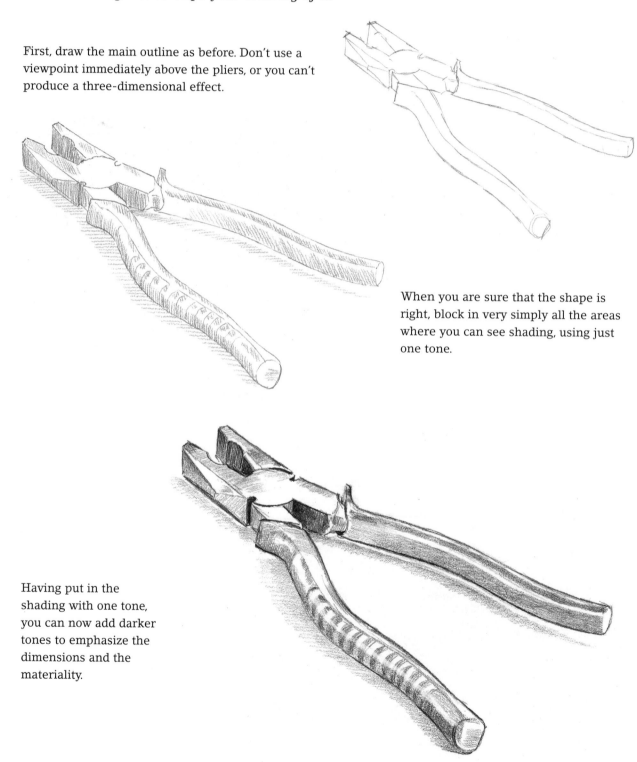

When you are sure that the shape is right, block in very simply all the areas where you can see shading, using just one tone.

Having put in the shading with one tone, you can now add darker tones to emphasize the dimensions and the materiality.

Next, something even more complicated, like this pair of
binoculars. Start with the main shape, making sure you get
all the parts the correct size in relation to all the others.

Again, block in the shadow using the lightest tone.
Now work up the darker tones, until it starts to look
more like the shape and material of the original.
Watch out for any reflections, which you should
leave white.

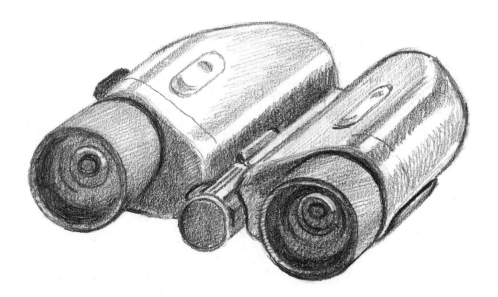

WORKING UP THE SIMPLE OBJECT

Next I have chosen a cup and saucer, because this pair of closely fitting objects is fairly simple but with enough complexity to be a good test of your newly acquired skills.

First draw the ellipses to show the top and bottom of the cup, and the main shape of the saucer. Draw the handle shape and the curved sides of the cup.

Put in the main areas of shade with, as before, one single tone. Pay attention to the inside of the cup and to the tones on the side of the saucer.

Lastly, work up the tones until you get a good likeness of the shape and reflections on the objects.

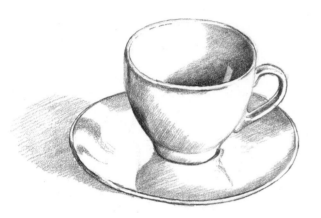

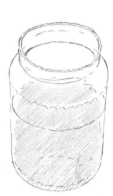

The next object is a glass jar containing tinted water.

As before, draw the ellipses and outside edges of the jar, not forgetting to indicate the level of the water as well.

Shade in the area that represents the tinted water. There will not be many other tones, due to the transparency of the glass.

Now indicate all the very darkest parts, also show the difference between the body of the water and the surface. Most of the darkest tones are around the lip of the jar and the indentations in the glass at the top and bottom.

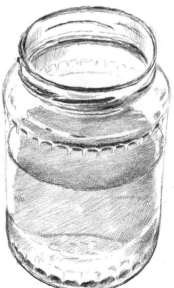

For your next object, take something like a shoe; it will be more complex because of its structure.

Once again, the initial task is to try and get a decent outline of the entire shape, with indications as to where the laces are and how the construction works. Keep it simple to start with.

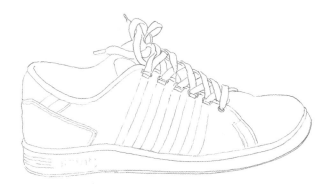

Now, put in sufficient details until the drawing resembles the actual shoe in front of you. The stitching is useful because it indicates the shape of the object as well.

Next, add the tone, only this time use a more textured way of shading, to give some indication of the material; it will be a slightly coarser texture than we have used so far.

Darken the spaces between the laces showing that there is space within the shoe.

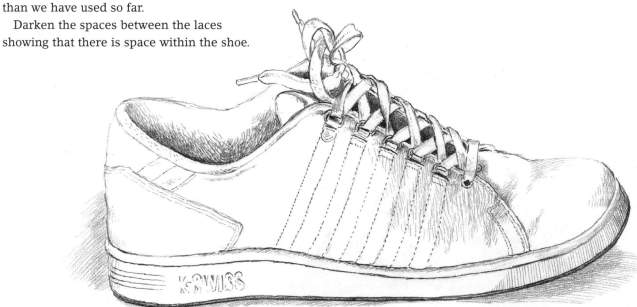

NEGATIVE SPACE

This next object is more difficult. This is a child's chair, viewed from an angle that reveals the spaces between the rungs and the back of the chair.

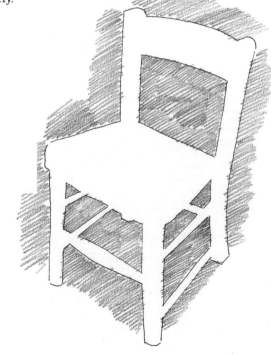

Drawing the first outline is in some ways easier than with a more solid object, because it is quite clear how the chair is constructed. Keep the drawing loose and open to start with, so that you can link the legs and rungs across the main structure.

Then, firm up the drawing by outlining each part more precisely.

The diagram shows the negative spaces drawn in: careful observation of the spaces between the parts of the chair will enable you to check your drawing; if the spaces are not correct then you know that you have some part of the basic structure wrong as well.

Having completed the shape to
your own satisfaction, put in some
simple toning to give it solidity.

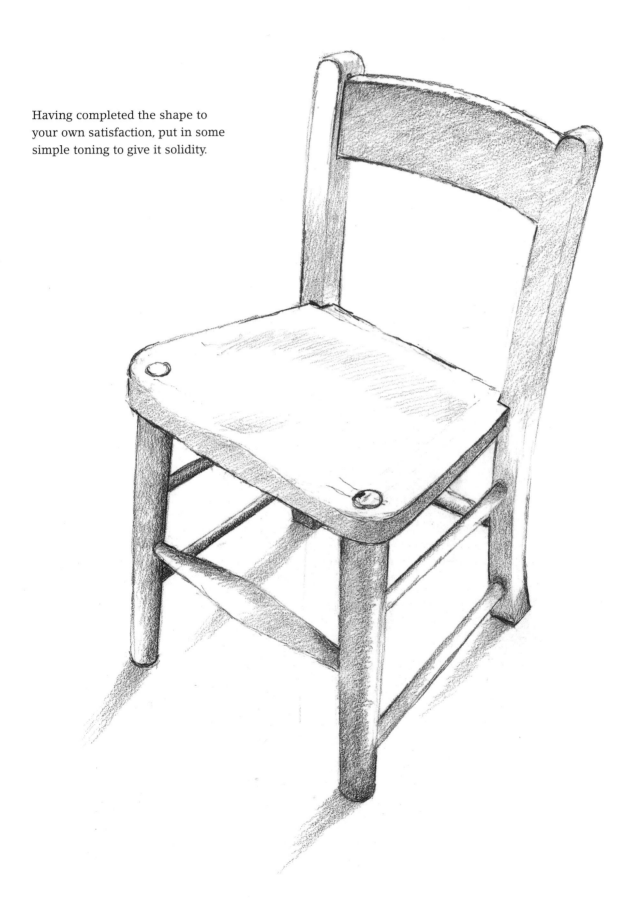

DRAWING GROWTH AND STRUCTURE: PLANTS

The drawing of plants poses a different kind of problem compared with inanimate still life, because the plant does tend to move around very slightly and gently rearranges its position in space. The important thing is not to try and draw everything exactly, but to convey a feeling of growth and sensitivity. Try and avoid using heavy lines, especially at the beginning.

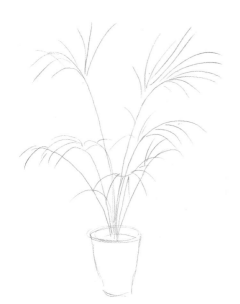

First of all, sketch the main structure of the plant, indicating the way its stems splay out and, in the case of the example I've chosen, the way that the long leaves fan outwards. Try and draw the initial line of the stems in one smooth go, to give yourself a better 'feel' of the way that the plant grows.

Having drawn the plant's main outline, the next stage is to express the floating, flexible quality of the long leaves. Some will appear stronger and darker in tone, while others will be far less distinct. Try capturing the character of these leaves by the way that you draw them. Nor does it matter too much if, when you look back at the plant, they seem to have altered. Total accuracy is not essential here.

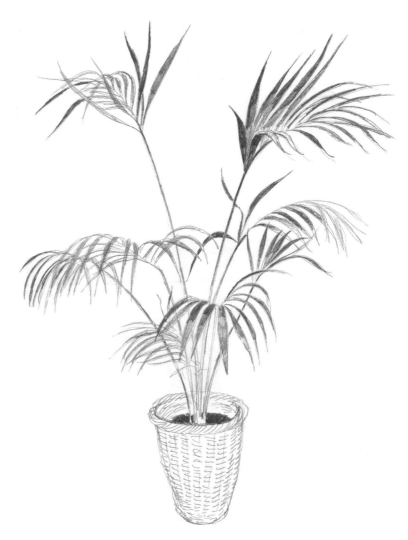

DRAWING GROWTH AND STRUCTURE: TREES

The key to drawing trees is to look at the overall shape first and sketch that in without concerning yourself over any of the detail. Note the way I have drawn this pear tree; I have established the outer shape of the foliage and included only the main branches. This defines the structure and makes a good basis for your drawing. Don't try to draw every leaf or even every branch, because you will soon lose track of what you are doing. Stick to the most visible branches and the larger clusters of leaves.

At this stage, put in all dominant areas of shade, leaving the top clusters of leaves highlighted in the sunshine. Make the farthest branches darker in tone so they appear to recede in space. Now, build up the tones on both the foliage and the branches, using a scribbled texture of leaf shapes for the former, and marks that shade in accordance with the contours of the branches for the latter.

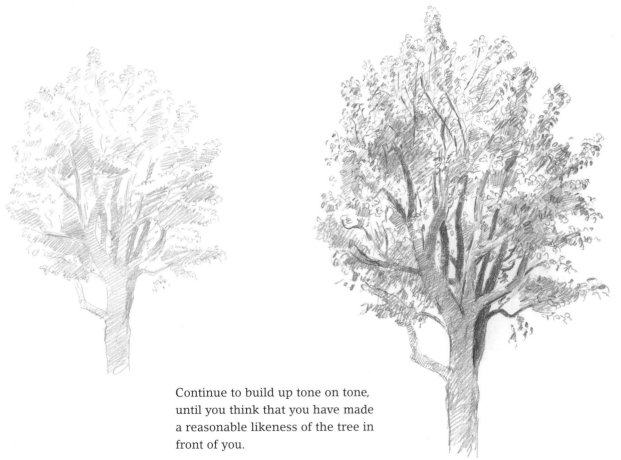

Continue to build up tone on tone, until you think that you have made a reasonable likeness of the tree in front of you.

HANDS-ON APPROACH

At this stage, there is no need to attempt the whole human body, which is probably the hardest thing that we artists ever have to draw. Instead, let us tackle just one part, such as the hand or foot. If this sounds daunting, absolute beginners can trace around the outline of their hands spread flat on the drawing paper. The tracing will give you some idea as to the correct proportions and shape of the hand, so when you come to draw it later from direct observation, it will act as a corrective to your drawing and show up any discrepancies.

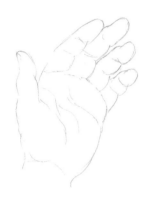

To draw the hand without tracing round it, make a start with the outline of the palm, fingers and thumb.

Now, indicate obvious creases on the palm and fingers.

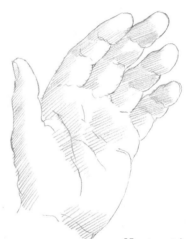

Next, put in the main areas of shade all over, in a light tone.

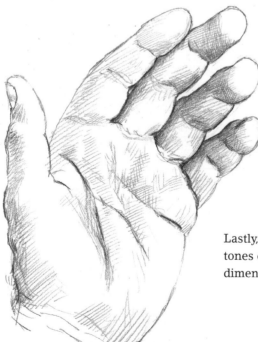

Lastly, work up the details of creases and the darker tones of shade, so that the hand starts to look three-dimensional. Do not overdo the tone.

KEEPING UP WITH THE JONESES

As a complete contrast, now try your hand at drawing one of our largest man-made domestic objects. There are plenty of cars around even if you don't have one yourself; I got tired of drawing my own, so I went and found the one with the most interesting shape in our neighbourhood.

First, pick a good angle from which to draw the car, which can be difficult if it's parked in the road. I chose an almost front-on view, but go for the one you think is the most interesting, or the easiest.

Get the main shape down first, defining the most obvious features of the vehicle, not forgetting the wheels. Take your time over this, it is worth getting a convincing shape reasonably correct and well-proportioned before you start adding the details.

When you are satisfied with the shape of your vehicle, simply mark out all the main sections and then you can begin to shade in the key tonal areas. This might not be too easy, as the reflections on the polished metal and glass can be very complicated to represent on paper.

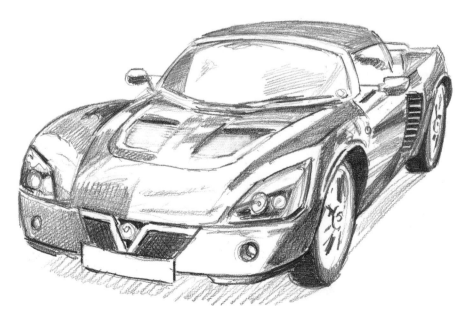

Once the main tonal areas have been accomplished, go for as many details of shape and tone as you can – for instance on the radiator grill, lights and wheel hubs – making sure that the full tonal range is included, from the very darkest to the brightest highlight.

All these objects should give you a fairly wide range to practise with, as you start to hone your drawing technique. The most insignificant items can have great value for object drawing. Have a go at as many as you can, in your efforts to become more and more proficient.

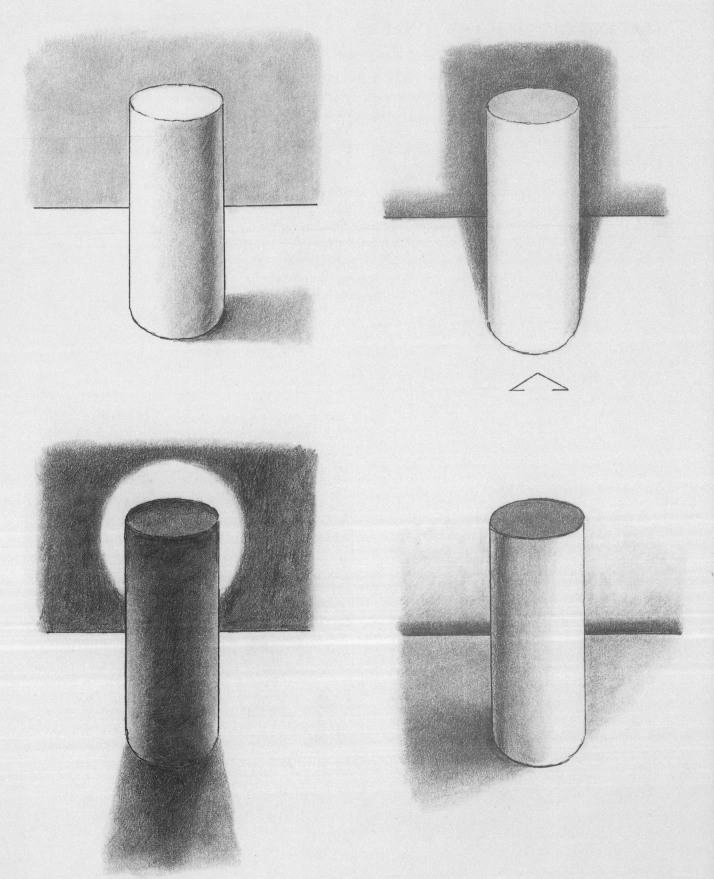

MATERIALITY, LIGHTING AND PERSPECTIVE

In this chapter, you will be looking at factors that – properly handled – will assist your drawings in becoming more alive and varied. It is a slightly more complex procedure than I have demonstrated so far, involving closer inspection of the world around you and how it appears to your eyes. It's hoped that you'll feel encouraged to consider what it is that you really see when you look at anything. A certain amount of analysis will come into play, and you will have to become more aware of and interested in absolutely everything. It has been said that the artist must not only know about his craft but has to know about everything. It is certainly true that any artist should understand how the world works visually.

Everything that you set eyes upon reflects light waves of varying lengths, which vibrate with varying intensities and allow you to discern the shapes and colours of objects. Remember that these light waves are the essence of everything that you perceive in physical terms, conveying the full range of texture, intensity and solidity to be found in your surroundings.

First, in this section we consider various kinds of materiality, that is the 'stuff' or material of which an object is made. So metal will not look like glass nor will cloth look like paper; your eyes will become trained to pick up on all those fine distinctions and make it possible to represent them accurately through your drawings. Obvious differences are to be found in the reflectivity of the surface of the object, or the texture of the material from which it is constructed. Both metal and glass can reflect the things around them, but they do so in different ways. The way that you draw something can tell you so much about its surface that the viewer feels he or she can almost touch it for themselves.

Although I tend to draw in a naturalistic style, this is not the only way to demonstrate the materiality of objects; a naturalistic approach just makes it easier to understand at a basic level. Eventually, you will encounter all sorts of drawing techniques capable of informing the viewer about an object without always looking like a photographic reproduction.

Lighting also has considerable bearing upon the artist's view of an object. Throughout our discussions you will see how much scope there is for producing an illusion of reality merely by making marks on paper. We will also look at perspective, the great discovery of the Renaissance artists of Italy, without which we could not communicate the idea of three dimensions on flat paper.

MATERIALITY 1

Anything that is drawn needs to show some evidence of awareness of its actual material constitution. There are well-known ways of drawing that make it quite clear, in the context, of the materiality of the subjects drawn. Here are some examples.

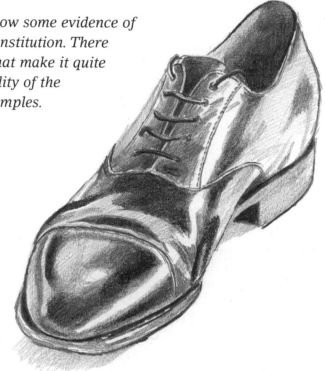

Leather – matt or shined

This particular shoe is dark and well polished, so there are strong contrasts between the light and dark areas. Study it quite carefully and observe how those light and dark areas define the shape of the shoe, as well as its materiality.

Notice how the very darkest tones are often right next to the very lightest, which gives maximum contrast.

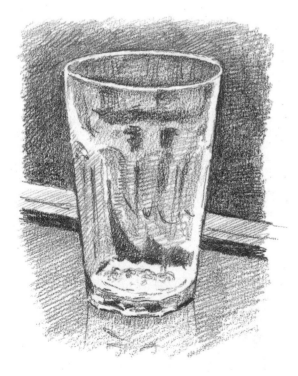

Glass – what makes this glass look convincing?

The shape of this tumbler, set against a dark background, is defined by the glass picking up all sorts of reflections from the surrounding area. Notice how a section of the straight edge behind the glass is visible but in a distorted (refracted) way, due to the thickness of the material and its curved surface. Make sure that when you draw the outline of the glass, it is well delineated, because this outer shape holds together the rather amorphous forms of the reflections. Also, note how the brightest highlights occur in only one or two small areas. Don't be tempted to put in too many highlights or the tumbler won't look so airily transparent.

Metal – strong reflections

The metal object I have chosen is also a highly reflective piece of hardware – a shiny saucepan. Once you have drawn the shape as accurately as you can, you have to decide how much of its reflectivity you are going to show. Reflections on this type of surface can become very complicated to draw, so it is a reasonable decision to simplify them to a certain extent. Make sure you represent all the main areas of dark and light and, as before, that the very brightest is placed next to the very darkest. The interior of the pan is not so clearly reflective and you should show the difference between the inside and the outside. The cast shadow is important, because that is also reflected in the side of the pan and helps to reinforce the illusion.

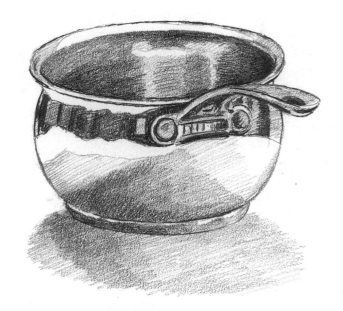

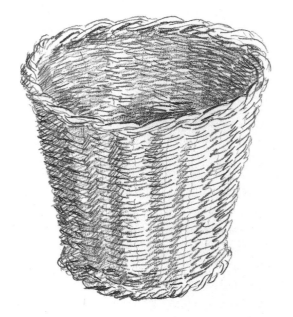

Basketwork – strong texture

This particular texture needs careful drawing in order to achieve the best general effect. On the plus side, the shapes of the woven strands of basket are quite repetitive in nature, so once you get the hang of it, it should not take you long. When the pattern of the basketwork has been completed, the shadow on the inner part and down one side should yield a three-dimensional aspect.

MATERIALITY 2

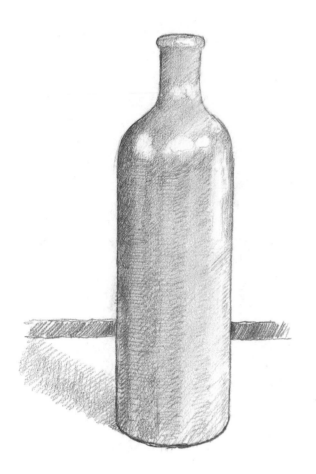

Pottery – hard and smooth

This pottery bottle shouldn't be too difficult because the surface is not as reflective as previous objects, and the shape is simple enough. Just make sure that the gradation of tone around the bottle doesn't look too harsh, and a little texture created by the pencil as you stroke it round the contours helps to mimic the striated surface.

Textiles: silk – soft surface

A silk handkerchief is the next item and, again, is not so difficult to draw, although it does require careful rendering in even tones. Folds occurring in silk fabric tend to be rounder and softer than in any other material.

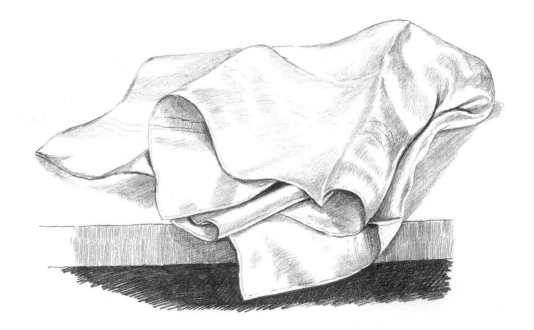

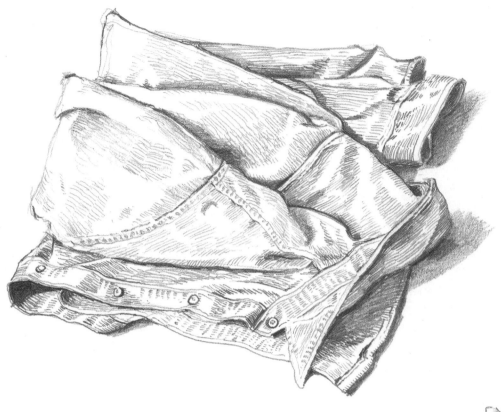

Textiles: corduroy – tough texture

This corduroy shirt is made of a fairly stiff material and that should show in the way that you draw the folds. It also has a distinctive surface texture, which makes it look very different from another, smoother fabric. Don't delineate every cord on the surface, just the shadowy areas where the tone is deeper.

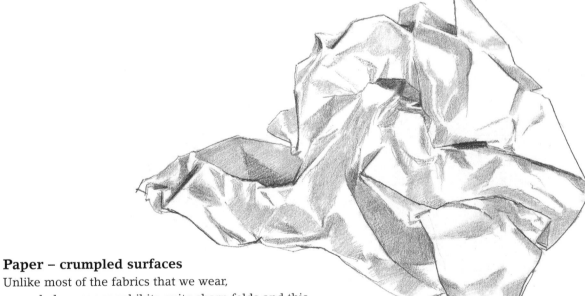

Paper – crumpled surfaces

Unlike most of the fabrics that we wear, crumpled up paper exhibits quite sharp folds and this will be the chief way to differentiate it from textiles. The other characteristic of the paper is that it reflects light well, and consequently there are very few deep shadows. Drawing crumpled paper is an interesting exercise and is often used in art schools.

NATURAL MATERIALITY

Vegetables – draw what you eat

Fruit and vegetables are great standbys for still-life artists, and here we show a couple of examples. The bowl of tomatoes gives an idea of the smooth shiny surface of the fruit, and the main aim is to balance the dark and light tones to give a convincing impression of the curved surface.

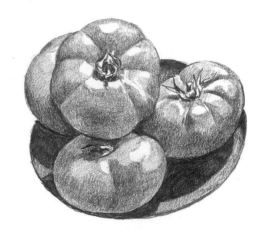

The cauliflower is an altogether different proposition, having strongly veined leaves and this creamy, lumpy 'curd'. So the surface of the vegetable is nowhere smooth and you need to capture the contrast between the dark leaves and the white flowers.

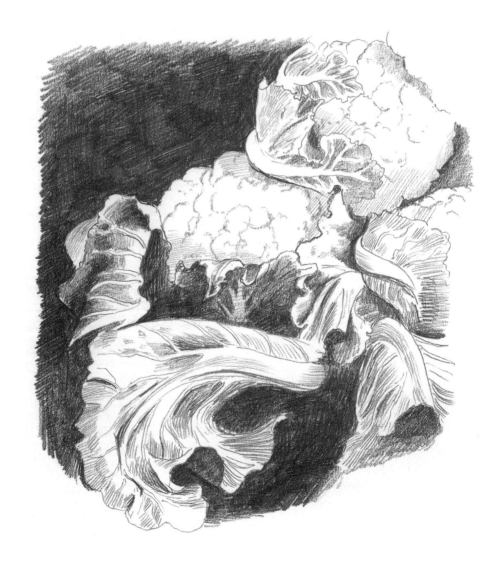

Flowers – different methods

Here are two approaches to try
when drawing plants.

For the first, take a big close-up
of a boldly shaped flower and
draw it in as much detail as
possible. Keep it big.

Then, for contrast, try something
like a vase of flowers, and draw
them in very lightly with sweeping
strokes, not worrying about the
details, but getting the flowing feel
of the growth and the fragility of
the flowers. Here less is more, in
that you don't want to overdraw
your subject, so keep your marks
very loose and impressionistic.

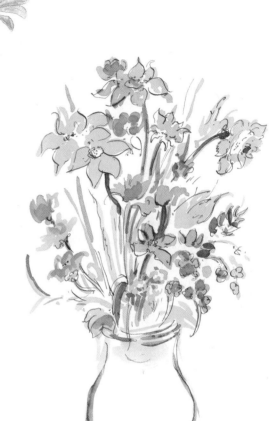

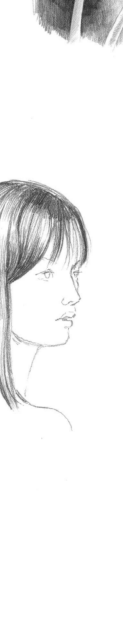

Hair – the soft option

You could spend some time drawing all the
different types of hair. Here I show long straight
hair with the ends curling a little. This is probably
the easiest to draw, so start with this.

ROCKS AND TREES

Having ventured into the area of nature we might as well go further and look at everything from the hardest to the softest of the elements.

It shouldn't be too difficult to find some rocky ridge to draw. If there is no such thing in your neighbourhood, then find a few stones and draw them instead, enlarging them to fill your paper. Notice the very sharp black shadows cast by the cracks in the rock, and the rigid angularity of the outline. Closer to, you would have to add more texture to the surfaces as well, but from this distance that is not so necessary.

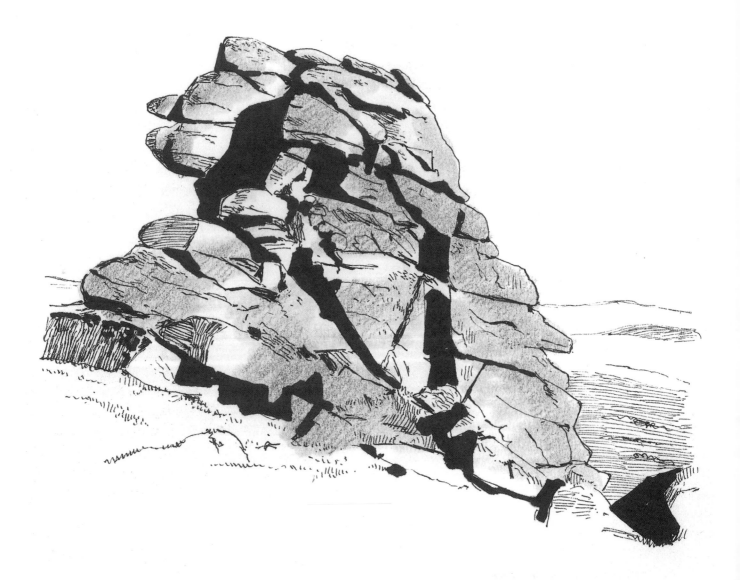

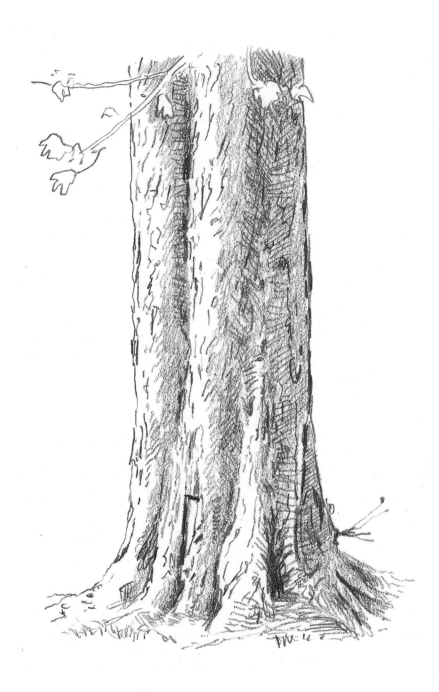

Next, examine the trunk of a large tree covered in rugged bark. With a subject like this you probably can't overdo the texture, so carry on until you think you've got a convincing impression of the surface.

WATER AND AIR

Water shows many different qualities from the very textured to the very smooth.

The first example is of water so calm that you can scarcely see a ripple on the face of it. The main observation is that there is very little to draw, unless there are things close by that are reflected in the surface. When the water is as calm as this, it is like drawing two pictures, the lower one a mirror-image of the one above.

Now, take a look at water that has been very slightly disturbed. Again, you get the reflections but they are broken up with so many tiny wavelets that you can see nothing clearly. The dark and light tones are there, but any sharp definition is missing.

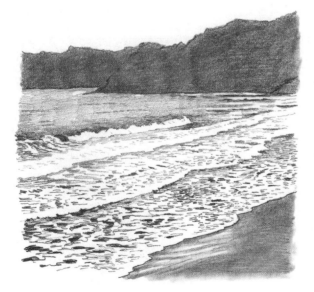

Now, take one step further, to water that is in constant motion, thereby preventing any reflections at all. Waves breaking on to the seashore consist of a very fragmented texture, with occasional bands of thicker white surf at the edges. To draw this will be extremely demanding, not least because of the number of marks you have to make in order to convey the right effect.

Finally, on to the element of air or at least clouds in the sky, which is principally how we observe the movement of air. The shapes are vague enough, since no cloud retains its shape for very long. However, make the clouds in your picture the softest shapes you are capable of producing. Avoid making them look too solid and hard-edged.

These two examples are fairly similar, but it should be possible to differentiate between cumulus and stratus clouds, and any variations in between.

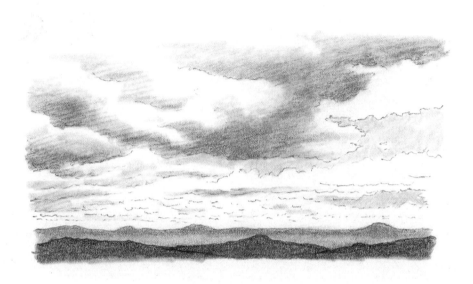

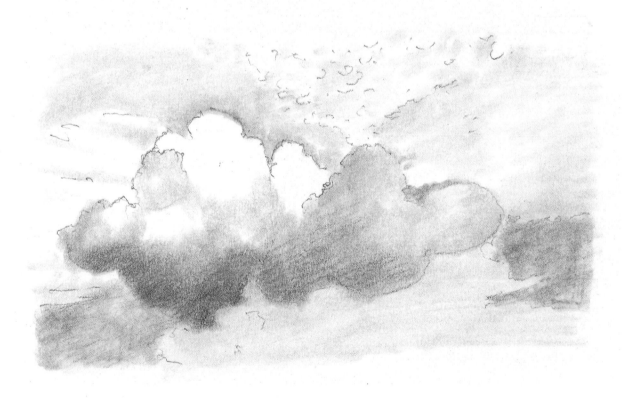

LIGHTING EFFECTS

The effect of lighting on objects can be quite dramatic, and so it is worth looking in detail at some of the things that you should apprehend for yourself. Probably the most important thing is the direction from which the light is coming, since this can alter the mood and appearance of a scene more than anything else. A good even light is used over and over again by the portraitists and landscape painters who strive for a 'normal' realistic effect.

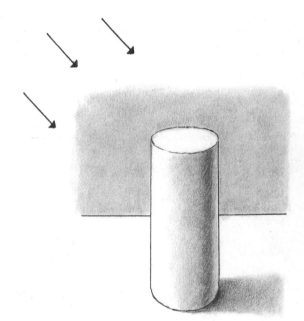

Let's see what happens when we experiment and try lighting the same object in different ways. I have chosen a cylinder as the trial object, because it consists of curved verticals and a flat top. This means that the light catches it in varying ways.

The first view is with the light falling from above and to the left of the object. This is the 'normal' type of illumination you get in many pictures; the sort you see on an ordinary bright day. I have not used any natural light in these examples but this is the nearest to it. Note the way it extends smoothly around the shaft of the cylinder, and how the top is uniformly illuminated. The shadow cast on the right also helps to give an effect of solidity. Notice that the background is a neutral tone, neither dark nor pale. This helps to throw the object forward in the space thus defined.

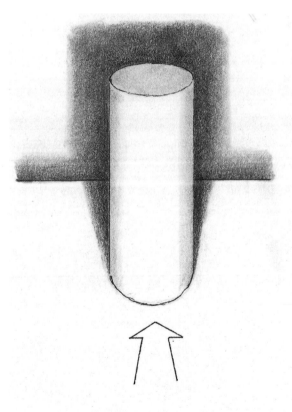

The second view is illuminated directly from the front. This means the source of light is actually sited in front of the observer, or perhaps above the observer's head. Note the dark shadow behind which we can see over the top of the cylinder. The cylinder is brightly lit with just a little shadow at the edges, and the top is half lit. If it weren't for the shadow around the edges, the cylinder would look very flat.

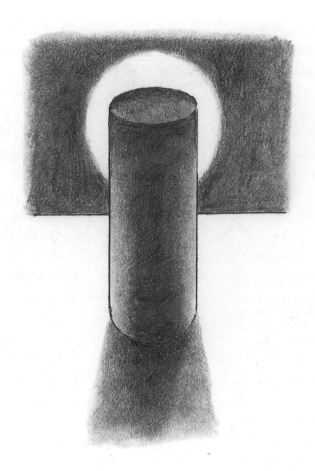

The third view is of the light coming from behind the object, so that the cylinder stands almost in darkness. This 'backlighting' silhouettes the top of the shape and casts a large fuzzy shadow in front of it. As in the previous picture, the cylinder has lost a lot of its three-dimensional quality, and the light behind seems to bring it closer to the viewer. The strong light and dark background are the only things that give it any depth.

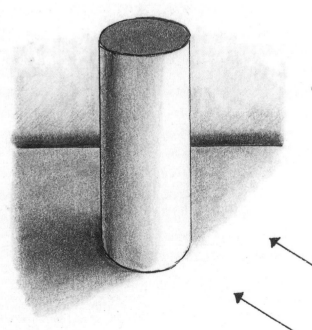

The last version is almost a reverse of the first one and so does have an air of 'normality' about it. But because the light source is lower, it appears more dramatic than the first and grabs our attention more immediately. Note the effect of the darker table-top and the lighter background, an additional dramatic element.

So you see that creative lighting, over even a simple object like a cylinder, can produce a wide range of different effects.

LIGHTING THE HEAD

This series, involving two faces, advances the investigation of lighting effects by showing what happens when you light a face deliberately in order to draw it.

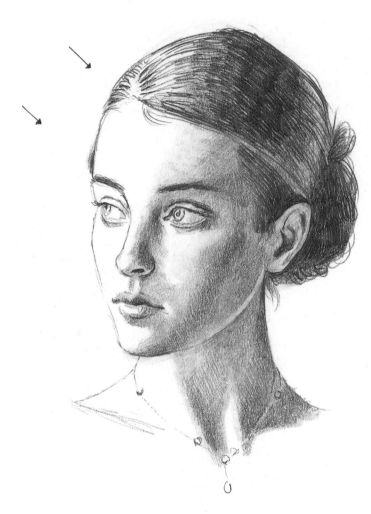

The young woman's face demonstrates the most 'normal' method of lighting an individual, with the light falling from above and to the left of her head. It results in what is ordinarily expected of a portrait; the face is well defined but quite gently lit, it is a classic three-dimensional head viewed in a clear light.

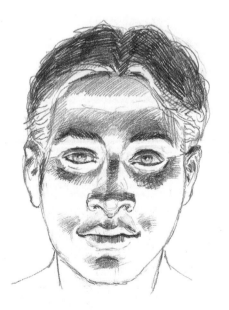

The second head shows what happens if you reverse everything. 'Uplighting' is the familiar method of showing a 'sinister' face, with which everyone is familiar from horror films. The light emphasizes the cheekbones below the eyes, the nose is shown with bridge and upper nostrils darkened, the top of the head is in shadow and the lower jaw is lit up. It looks scary because it subverts all our expectations of a normal, friendly human face.

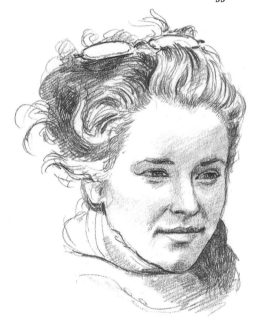

The next two pictures show the difference between what is assumed to be natural or daylight and the effect of more artificial light.

The daylight example comes, in fact, from a picture taken outside in strong sun, which is very diffuse and tends to give an even distribution of light, with no single element being lit more strongly than any other.

The second example shows a strong directional light that could only come from an artificial source, delivering some strongly illuminated portions and deeper shadows on the other side. However, there is a certain amount of reflected light on the shadowy side, which is probably due to the light bouncing off other surfaces in the room. The dark background is a useful device for making the head more prominent.

And so, as you can see, the lighting in a picture can be manipulated just as much as any other part of the drawing.

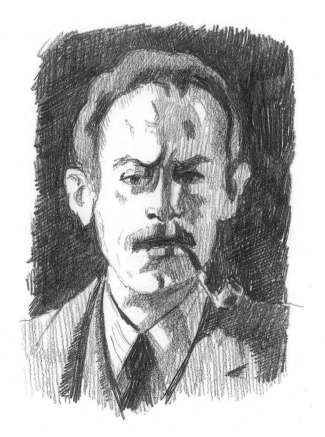

PERSPECTIVE

This is the technique of making a two-dimensional drawing – with length and breadth – appear to acquire a third dimension – that of depth. Perspective was the great discovery of the Italian Renaissance artists, based upon mathematical principles. The renowned architect and engineer, Filippo Brunelleschi was the man generally considered to be the prime tester and discoverer of the laws of perspective. He painted a picture of the Baptistry in Florence according to his own system of horizon lines and vanishing points.

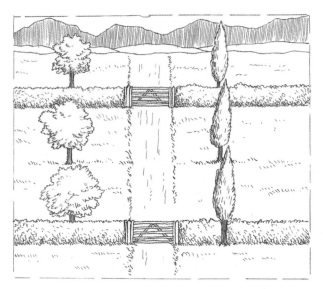

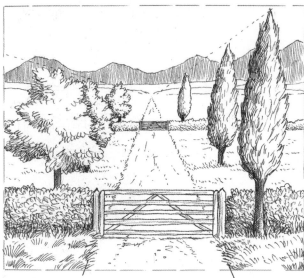

In very simple terms, you can see the difference between the two pictures shown above, one drawn without much attention to perspective, and the other based on the system of single point perspective, which tricks the eye into thinking that it is seeing depth and space.

Note how the trees and gateways are all the same size in the first picture, whether they are close to the viewer or far away. Also, look at how the road stays the same width even as far as the horizon; nor is there much difference between the texture of the nearest trees and hedges and those further off. The result is the effect of a rather flat landscape.

The second version shows what happens when you devise a method of interpreting the same landscape seen in terms of space. The nearest objects are both larger and more textured than those further away, and already this gives a sense of depth to the picture. The road appears to narrow as it recedes into the distance, eventually disappearing to a single point far off on the horizon. Although this is a fairly simple drawing the effect is immediate.

So, how do you achieve it?

THE CONE OF VISION

*This diagram demonstrates the theoretical way that
this system works.*

When we look at any view, there is a field of vision surrounding us that can be
divided into the area where we see things clearly and – at the periphery –
another area where we can hardly define anything at all. The overall effect is to
create a 'cone' of vision, within which we can see objects clearly, and outside
which we are aware of nothing except light and darkness.

In the diagram, a figure is standing at a point in space called the 'station
point'. From this point, the figure looks straight ahead at the centre line of
vision. The horizon is naturally at eye level, and where the line of vision cuts
across the horizon is the centre point of an area that includes everything one
can see of the space in front. The circle of vision is that part of the cone of
vision that meets with what is known as the 'picture plane'. And this is the area
upon which all your images are to be drawn. It is usually perpendicular to the
ground plane of the surface on which you stand. The picture plane covers an
area containing all that could go
into your picture. Of course, you
might choose to crop down your
picture area, but it is possible to
draw anything within the focus
of this space.

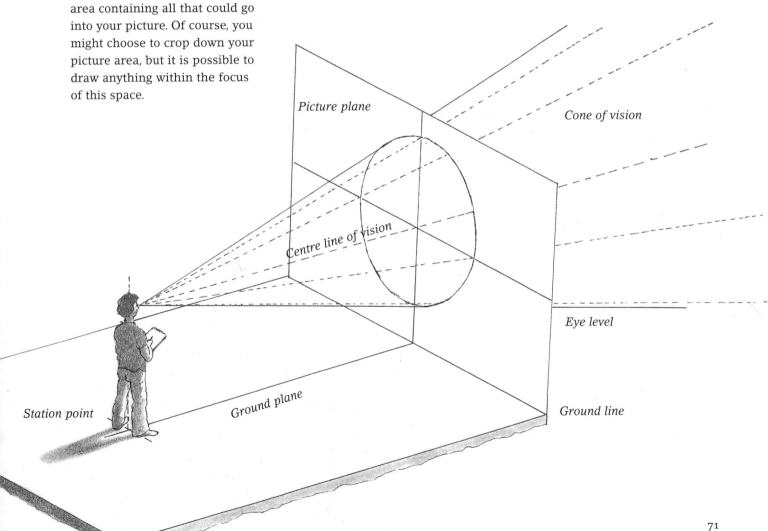

Picture plane

Cone of vision

Centre line of vision

Eye level

Station point

Ground plane

Ground line

ONE-POINT PERSPECTIVE

When you come to construct a picture based on this theory of vision, in a way, you reverse the process and construct a series of shapes based on the centre point, which now becomes the 'vanishing point'. This means that everything in the picture is dependent on the central point of your vision, and you can then go ahead and construct forms that are all connected to it.

To construct these forms you will need a ruler because straight lines are essential. Create an image that has a single point on the eye level or horizon to which all lines of depth will be related.

Draw a horizon from one side of the paper to the other and place a point in the centre of it. Then construct three rectangles in the space of the picture, one being entirely above the horizon, one entirely below, and one partly above and partly below the horizon.

Now trace straight lines with a ruler from each corner of those three rectangles, to join at the centre point on the horizon.

Having done this, you can now go ahead and construct cubes from your rectangles, by drawing a smaller rectangle further along the lines that join the vanishing point, thus forming a three-dimensional cuboid. In the one above the horizon, you will see the side and underside of the cube, which appears to be

floating up in the air. In the one below the horizon you get a similar effect, except that the cube shows its upper surface and side, and appears to be on the ground. The third cuboid is similar to a building viewed at eye-level, because apart from the front, the only visible part is the side, and it looks as if it is towering over your head. This, of course, is all an illusion, but it is a very effective one.

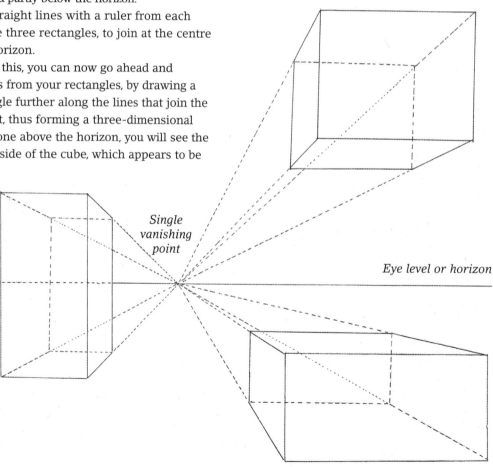

Single vanishing point

Eye level or horizon

TWO-POINT PERSPECTIVE

To take this three-dimensional illusion one step further, you need to add another vanishing point to the horizon so that, this time, there is one at each end of the line.

The next step is to draw a vertical line, which will form the nearest corner of a large block shape that you are about to construct. From the top and bottom ends of the vertical line, draw ruled lines to meet both the vanishing points. Then decide upon the length and depth of your block shape and draw two more verticals that indicate the two corners of the block, making sure that they stop at the lines which join the original vertical with the two vanishing points. Now you have two visible sides of a three-dimensional rectangular block, seen from one corner. I have assumed that your

original vertical, like mine, projects above and below the eye level line. You can see how the object is even more convincing than that constructed on the one-point diagram. Now, try and produce the second block in the diagram by yourself. I've shaded the sides of the diagrammatic block, in order to give it more solidity.

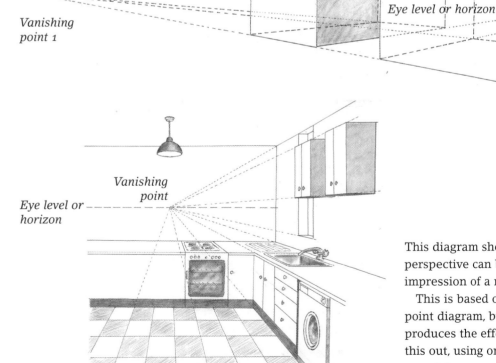

Vanishing point 1

Eye level or horizon

Vanishing point 2

Vanishing point

Eye level or horizon

This diagram shows how the theory of perspective can be used to produce the impression of a room in a house.

This is based only on a one-vanishing-point diagram, but you can see how it produces the effect of an interior. Try this out, using one of your own rooms as a model.

THE BIRTH OF PERSPECTIVE IN PAINTING

*The diagram in our section on perspective is an account of
Alberti's system for creating spatial depth, purely geometrically,
from a ground plan. Leon Battista Alberti (1404–1472) was a
great Renaissance architect who wrote down Brunelleschi's rules
of linear perspective especially for artists to follow.*

You see a man in Renaissance clothes standing on a
level surface, looking at a series of tile units that are
visible on the floor, edge on. Lines of vision extend
from his eye to the tiles on the floor. Then, you have
to imagine a picture plane that is perpendicular to
the centre line of his vision. This indicates what the
man will see once the lines have been projected
horizontally, as transversals, across to the next part
of the diagram.

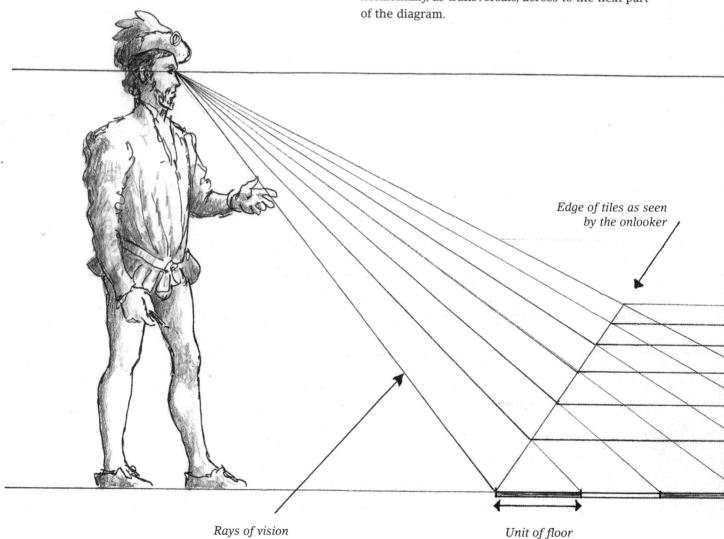

*Edge of tiles as seen
by the onlooker*

Rays of vision

Unit of floor

With these transversals and the same measure of the flat tiles, you can now construct what the man will see when he looks at the floor. From the floor level divided into units, draw ruled lines to the vanishing point on the eye level line. Where these cut across the transversals, you will create a grid which gives us an impression of what the man is looking at. To make sure it is accurate in scale, just draw a diagonal stretching from the lower left corner of the bottom row of tiles to the upper right corner of the top row. If the line crosses all the intervening tiles from corner to corner then it is accurate, and does indeed show what the man would see.

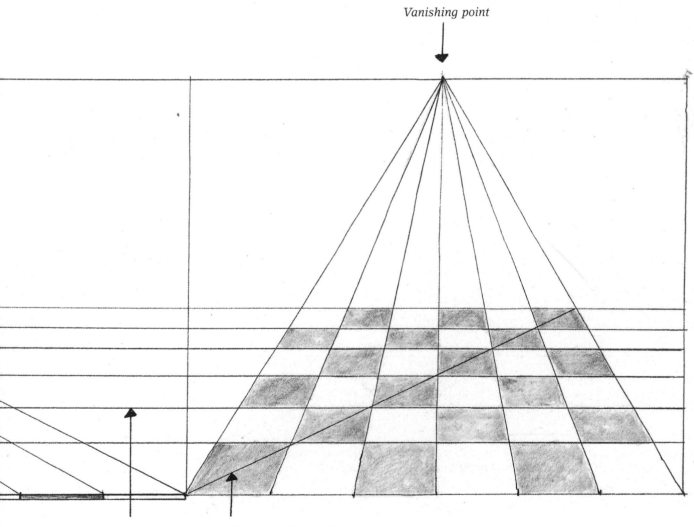

Vanishing point

Transversals (horizontal lines connecting rays of vision from picture plane to perspective construction)

Checking diagonal (to ensure integrity of grid)

OBJECTS IN PERSPECTIVE

Having been introduced to the theory of perspective, the next thing is to look at it in some detail. First of all, we shall examine its relevance to the drawing of normal, everyday objects; I have selected a knife, fork and spoon for our purposes.

Beginning with the knife drawn straight on, so to speak, trace around it as carefully as you can. You will probably have to make adjustments here and there, as the outline of a three-dimensional object made in this way is always a little out of proportion, especially in terms of thickness.

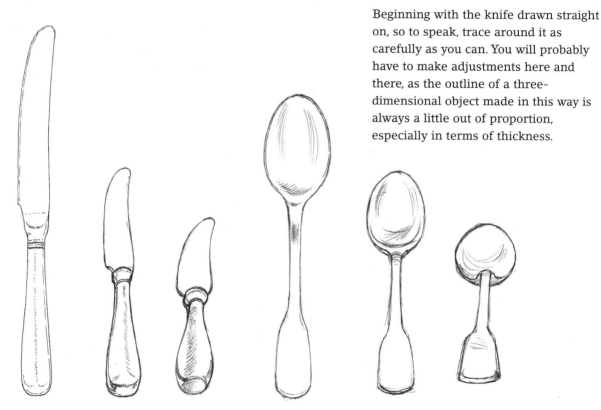

Having produced a drawing which is fairly accurate with regard to size and shape, this time place the knife on a surface that lies at an oblique angle from your point of view, therefore giving it some perspective.

As shown in the example, your new drawing will now appear decidedly different in proportion; it will be shorter than the original outline, although similar in width.

Once more, lay the knife on a surface, this time choosing one nearer your own eye level. You will become aware that in order to represent precisely what you see on this occasion, you must draw the shape much shorter in length but just as wide, and even wider at the end of the handle nearest to you.

Take a look at all three drawings and note the proportional differences between them.

Next, treat the spoon in the same way; there will be a slight difference owing to the curvature of the handle. First, trace the spoon so that you have an accurate outline of its length and shape.

Lie it on a surface at an oblique angle from your viewpoint and draw what you can see. It will be shorter than the first drawing but of a similar width.

Once again, draw the spoon lying upon a surface closer to your own eye level, and in particular notice not only the foreshortening but also the altered contours of the bowl. Each time, you will notice that the part of the utensil closest to you appears wider in proportion to its remaining length.

Drawing in perspective is also called foreshortening.

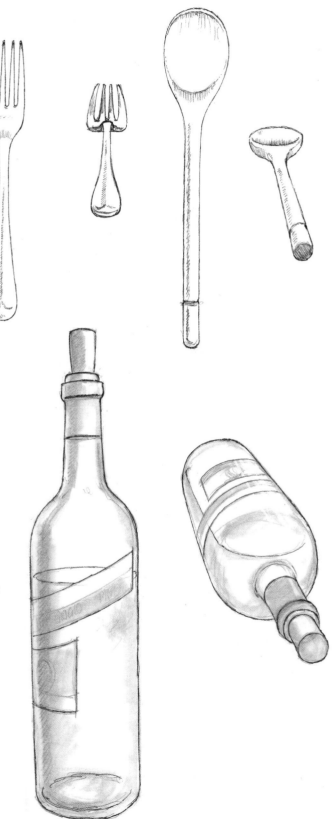

Do a similar exercise with a fork, this time two views will be enough. Then try it with a wooden spoon, which – with a flatter bowl – is a much simpler shape than a metal one. Notice how the handle of the spoon gets gradually wider towards the eye.

The same exercise can be carried out with something larger, like a bottle of wine. Draw around the shape as accurately as you can, making whatever corrections are required. Now turn the bottle so that you are looking at it from one end only, in this case the neck, and you will see immediately how dramatically the proportion of length to width has been altered. Note also how the bottle appears to get narrower towards the base, evidence of the foreshortening effects of perspective.

FORESHORTENING THE BODY

A rather more demanding exercise is to draw a human arm or leg in perspective. Study the examples below carefully.

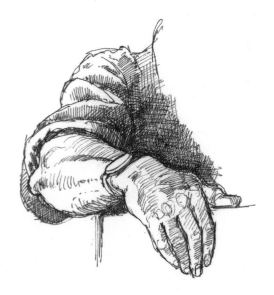

The first example shows an arm pointing towards the viewer with the hand resting on a surface close by. This makes the hand look quite large in relation to the rest of the arm. See how the rounded folds in the rolled-up sleeve help to make the arm appear wider in comparison with its length.

Another example shows an arm stretched out towards the viewer in a gesture of greeting. Foreshortening has the effect of making the arm from the wrist to the shoulder look very short in comparison with the width of the whole limb. The hand appears to be very close to the shoulder.

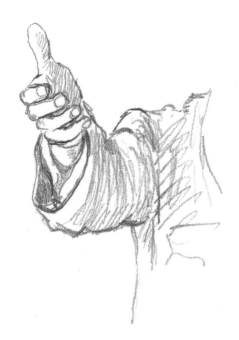

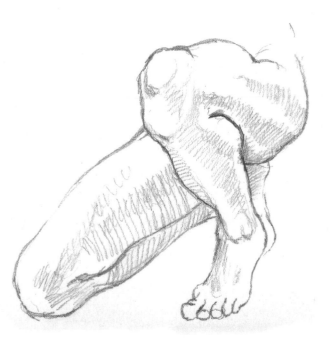

Next, we examine the effects of foreshortening on a pair of legs whose knees point towards the viewer. The nearer knee appears to be large and solid, while the lower leg and the thigh seem to be very short and wide. The contrast between the length of the thigh angled towards us, and the other one which is seen more in profile, is significant enough to convince our eyes that we are indeed looking at one leg more foreshortened than the other.

Lastly, look at the whole human figure from an oblique angle, with the head nearer to the viewer than the feet. This shows clearly that the upper part of the body, including the head, shoulders and chest, should be drawn larger than the lower part that includes the torso, legs and feet. Of course, you know that in reality the legs account for about half the total height of the adult human, and that the proportions you see here are the results of foreshortening. If you were to turn the body the other way around, the legs would appear much larger in comparison with the torso, and the head would almost be lost to sight. Artists learn to observe and interpret the varying proportions of familiar things when seen from different angles.

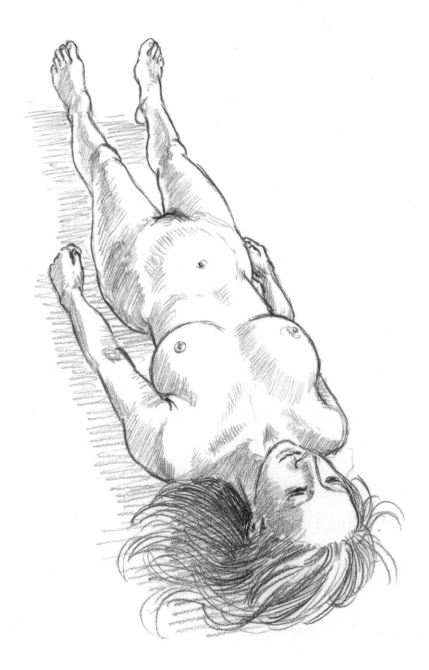

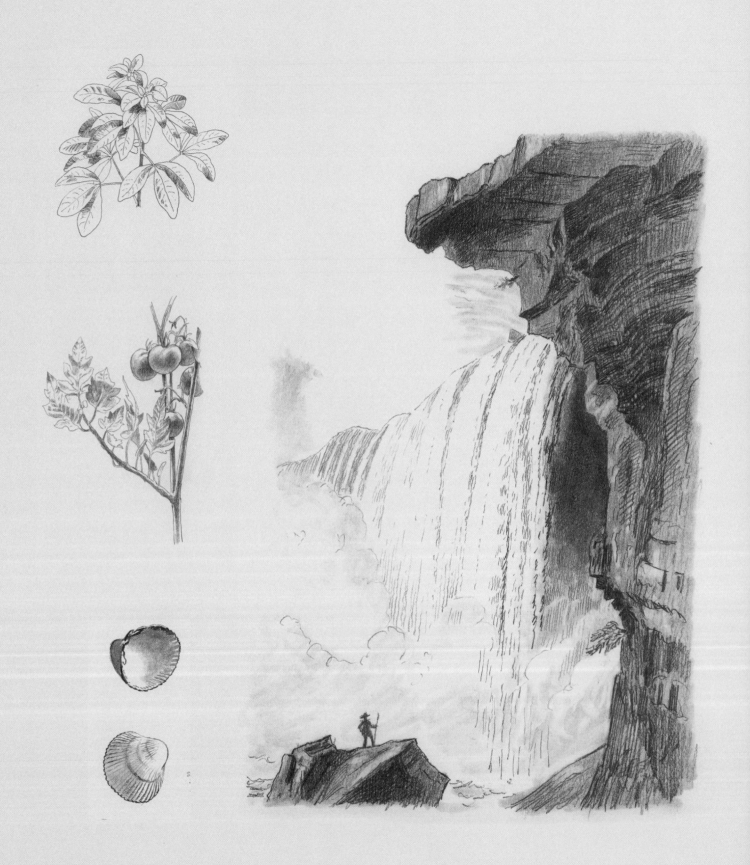

THE NATURAL WORLD

This section will deal with the world of nature and the considerations you have to take when drawing things that are not man-made. Nature is easy enough to find, wherever you are, because even in the centre of a city, you can usually see the sky or find some form of vegetation. This section aims to teach you how to observe the elements, and the earth in particular, from mountain to seashore, also including the animal kingdom.

Even a small suburban garden can hugely increase your store of knowledge about nature. Many times it has been said that whereas most experts only need to know in depth about one sphere of knowledge, the artist needs to have some knowledge of absolutely everything. Of course, the artist's world is primarily visual, but to draw it accurately does require a thorough understanding of the structure of things, and how they grow and develop.

The elements also include water, fire, air and space, however, one common factor in nature is that everything keeps changing and moving, and so you will also appreciate the necessity of creating an illusion of movement in your drawings. There are various techniques for achieving this and you will be shown some of the most effective and interesting of them, and also be encouraged to develop your own methods.

The world of plants, upon which both humans and animals rely so greatly for their existence, constitutes a vast area of work for the artist, which might be said to culminate in the execution of an entire landscape. They can be of great variety, although the first piece of scenery you attempt will most probably be the one closest to where you live. However, before you get round to that, you must take a good hard look at a range of plants and flowers, in order to understand the rules of growth patterns and how they are repeated. Once you have observed these at close quarters, it is much easier to draw the plants so they actually look as though they are growing.

Admittedly, some things in the natural world are so difficult to draw that you will have to study them over and over again in order to understand how they could work as drawings. One example is the element of fire, which you may have to study from photographs, as well as from life, in order to establish how you can represent the form. Water is another fascinating element. It produces myriad conditions, which you need to learn to render convincingly. There is enough to draw in the natural world to keep you busy for the rest of your life.

STONES, ROCKS AND BOULDERS

*To make a start on the study of natural objects, the best idea is to
go out into your garden and find some stones or pieces of rock.
Pick larger stones to draw first, because this will be easier than
masses of small pebbles or fragments of earth.*

The example shown here is a piece of
'pyroclastic' rock, picked up on the edge of a
volcanic area. Notice its overall solidity and
low tonal range, it is a rather dark, non-shiny
rock. The large cracks across its surface are
quite dramatic, and its several facets make it
a good chunky shape and not too difficult
to draw.

The next example is also an igneous
rock, but lighter in colour and weight.
This is a piece of pumice stone, often to
be found in bathrooms, where it is used
to smooth rough skin. Notice how the
surface is covered with holes both large
and small that penetrate the whole rock.
It is also a light colour, so that the holes
look much darker by contrast. There are
fewer clearly defined facets on the
surface, because being a soft rock,
pumice tends to become smooth all over.

 These contrasting pieces give you
some idea of the variety that exists even
in the humble rocks beneath your feet.

Next, turn your attention to a stony surface made up from pieces of worn rock heaped together. The main thing to notice here is how the different shapes lie in all directions, thrown together in no particular order.

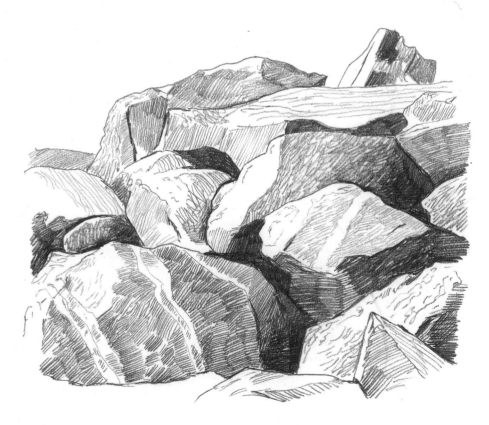

There follows a more large-scale version of the heaps of stones, but in this case, the size of the boulders shows the varying shapes more clearly, and with more surface texture. When rendering this type of stony composition, indicate the lines of texture according to the way the various geological layers are arranged.

MOUNTAINS

To draw a mountain area will not be so easy if you inhabit a rather flat part of the world; but if you ever get the opportunity to visit any mountainous region on holiday, don't forget to take your sketchbook with you. Failing that, you will have to have resort to taking good photographs of this sort of terrain.

This is a view of Crib Goch, on the slopes of Mount Snowdon. Note how some of the surfaces appear in dark shadow, which defines the great crags and edges of the mountain most effectively. Everything here is bare rock, which makes it easier to draw.

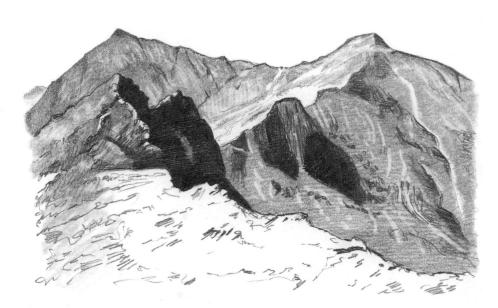

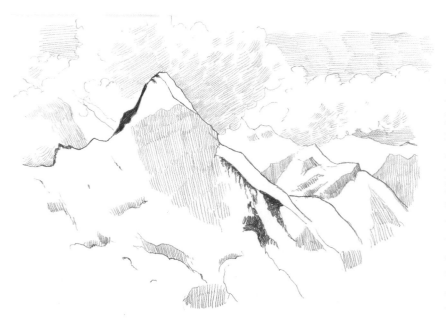

The next move is to visit the topmost mountain peaks, which have snow on them all the year round. Your drawing should leave a fair amount of untouched white paper to represent the snow. However where the rocks show through on those points where the snow and ice cannot hold, they will appear much darker by contrast. Avoid overdoing the texture on snowy surfaces, otherwise it will look as though the snow has melted.

SHELLS, CONES AND NUTS

Here is a scallop shell, which is in actual fact the external skeleton of a sea creature.

On the shell's outer surface, tiny grooves radiating around it help to define the shape of its dome. On the inside, the shape is much smoother, the grooves and indentations are only just visible around the edges. These are fairly simple shapes and if you get them right through your drawing you will have successfully conveyed the sharp yet fragile appearance of the shell.

This pine cone is an excellent example of the spiral growth structure that is found throughout nature, and which we saw less obviously in the sea shell. Viewed from the stem end, the cone's scales grow out in spiral formation from a central axis, presenting a very well-defined set of shapes, which you may have to draw more than once in order to get them absolutely right.

Seen from the side, the cone's scale pattern is not so obvious, but the strong contrast between the dark inside edges and the lighter outside ones creates a very well-defined set of shapes that should be a pleasure to draw.

The walnut and half walnut shown in the next picture also make very clearly defined shapes but with a much gentler texture on the surface. They should present you with very little difficulty for drawing.

Just to provide some contrast here, I felt a bunch of grapes would make a pleasant change from the rigid, hard-cased characteristics of shells, cones and nuts. Strive for the smooth round form of each grape in your drawing and remember not to overload the surfaces with too much tone. Each grape, except for the ones in deepest shadow, should have one spot of white paper left showing, indicating a highlight. Try to avoid making the rest of the grapes too dark, or you will lose the illusion of translucency.

VEGETATION

The first example that I have chosen is the remarkable Large Tuft of Grass *after the German Albrecht Durer (1471–1528). This is not quite so easy to draw as you might think, because at this proximity an artist is obliged to differentiate between the thin stalks of cultivated grass and the wider-leaved versions that grow in fields and meadows. This is not grass from a croquet lawn or bowling green, but a coarser, wild version.*

A little care and attention will enable you to produce a similarly detailed drawing, from life if possible.

Now, on to the sort of flowers that you might find in any garden: the first is a rose-type blossom, which looks very decorative and is relatively easy to draw because there is no great contrast between the dark areas and the light. The main endeavour of this drawing is to capture the delicate edges of the petals in as much detail as possible and to leave out most of the tone, except where a few soft strokes of the pencil are employed to show the edges of some inner petals. It is almost like drawing a diagram.

In the next picture, the flowers themselves are very simple to draw without much tone, but the background has been rendered as dark as possible to throw forward the light colour of the petals. This helps to show their fragile qualities to some advantage.

In the next two examples, the amount of detail is reduced in order to produce a drawing that conveys more of the feeling of the growth of the plant. This is done by drawing fairly rapidly, and making sure that the main shape and growth pattern is clearly shown. This means that your drawn lines will give a good impression of the general appearance of the flower but not much in the way of detail.

Both these examples give a very dynamic view of the plant, with enough of its characteristics to ensure an overall impression of the flower from a fleeting or general view.

This view of an entire herbacious border, seen from the height of the tallest flowers, gives a very good idea of what variety of blooms can be gathered in one spot. The larger flowers are clearly outlined, especially those closest to us, and this contrasts with the more impressionistic aspect of the flowers situated further back. The general idea is to produce enough texture by drawing the tops of each plant and thereby avoid having to build up any darker tones to create depth.

VEGETATION EXPANDED

The next groups of flowers are rather different. When you start drawing plants it is always a temptation to put in every detail. That can be useful as long as you know when to stop and leave something to the imagination of the onlooker.

The nearest blooms are carefully outlined and left with the minimum of shading, in order that they should contrast with the plants in the background, which are placed under a thin screen of tone in order to make them appear to recede. The outline of the nearest flowers are crisp and precise, while the rest are less distinct, melting into the background tones.

The generous appearance of these large cabbages provides a very decorative effect in a garden, with all the outlines clearly drawn and the vein structure and tonal areas put in with carefully graded lines that follow the contours of the leaves. This is the proper way to build up a strong group of textures that produce an almost tangible sense of the plants' large fleshy foliage. It also demonstrates that you can create a attractive plant image without the help of any flowers.

In these next two images,
I have included quite a lot of detail, but at
certain points have left the eye of the
viewer to fill in the rest.

The first one, of a tomato plant, selects a couple of stems with a
few fruits attached, all of which are drawn up in some detail,
specially in terms of shading. This approach concentrates the
viewer's attention on to the texture and 'feel' of the plant, so that
one can believe it actually exists in a spatial dimension. The
shading around the stalks and on those parts of the leaves facing
the viewer back up the tones on the fruits.

The second picture does things
slightly differently, because by
carefully drawing every outline of
every leaf, you produce a pattern of
the growth of the leaves around the
stems of the plant. Then, with
absolutely minimal indication of tone
or shade, the effect of some depth is
achieved, which is reasonably
convincing in the context. It doesn't
try to be too realistic, but there is
enough in the way of visual clues to
help the illusion.

TREES IN THE LANDSCAPE 1

The next group of drawings has been assembled to show trees treated in different ways by different artists, demonstrating the variety of approaches possible in this genre.

Applying shape

This example after the British artist Ramsey Richard Reinagle (1775–1862) from *River Brathy near Ambleside* (1808), is in that tradition of landscape drawing where the artist draws in a refined sort of scribble, whereby Reinagle has produced a texture that resembles foliage seen from a distance. Notice that, except for the dark lines of the trunks and main branches of the trees, the rest is constructed from a closely repeated pattern of scrawling lines, rather similar to knitting. He occasionally makes it heavier but in the main he has effected a similar texture all over.

The example here, based on a work called *The Valley Farm* (1835) by the painter John Constable (1776–1837), is rather more substantial and has been produced in its copy form by first drawing the darker background trees in charcoal – smudging them to give a smoky effect – and then later drawing out the lighter shapes of the closer trees with a kneadable eraser (putty rubber). This method has produced a ghostly etched-out shape, which has then been strengthened by applying darker edges to trunk and branches, to give more apparent depth to the picture. It is a very effective technique.

Formality and decoration

The next drawing shows a Persian miniature of a tree in blossom, executed in the fifteenth century. The method seems almost childlike compared with the style of Renaissance drawing, but it is very effective in context. This version had to be made with considerable care, and the balance of leaves and blossoms spread along the branches had to be very well organized in order to work well.

This drawing after Hendrick Goltzius (1558–1617) from *Landscape Tree* (1592) demonstrates a carefully organized method of formalized textural marks, which give the eye an illusion of both solidity and depth. Note how the lines trace the shapes of the tree trunks in varying ways; and how the marks that indicate the foliage repeat a feather-like texture, different from the solid parts of the trees but in the same idiom. This helps to create a harmonious effect in the drawing.

91

TREES IN THE LANDSCAPE 2

Tonal impressions

These two drawings after J.M.W. Turner (1775–1850) and John Constable bring us to the forerunners of Impressionism.

In his detail from *Crossing the Brook* (1815) Turner put his trees in with a brush and the entire picture was copied one tone lighter, with all the trees and the skyline being drawn first. Then, using increasingly darker tones, the picture was built up until the trees in the foreground stood out clearly from the softer-looking background. There are about three layers of watercolour or diluted ink here.

This copy of Constable's impressionistic sketch of trees, taken from *Stoke by Nayland* (1810) was done in pencil and heavily smudged to produce a general grey tone. Then, very heavily and fairly loosely, the darker tones were built up over the main tone. If you are outside, drawing from life, do not attempt to put in any detail but just indicate the broad clumps of tonal shape.

Pattern realizing form

These two drawings of trees after Vincent van Gogh (1853–1890) take pattern-making with marks to a new level.

The first drawing is of a fruit tree in Arles (1889), and here Van Gogh has drawn the trunk and main branches quite distinctly and surrounded them with a pattern of loose, scrawled marks to indicate the tree's leaves and blossoms. You cannot see the foliage in any detail at all yet, somehow, the whole effect is of blossoms and leaves lit up by the strong sun.

The second example is even more dramatic in its use of pattern to create the impression of foliage. Here is one of the cypresses of the Midi (St Remy, 1889) that Van Gogh made so famous, reduced to a simple repeat pattern of swirling brush marks that seem to grow out of the ground and leap upwards into the air like flames. This reduction of shapes into a repeated texture of marks can be very effective when the artist has seen the essential quality of the object.

LANDSCAPE COMPOSITION 1

Putting all these elements together, it is time to consider landscape composition.

Framing

This typical meadow after Claude Monet (1840–1926) was apparently drawn at the height of summer (*Meadow with Poplars* 1875), with all the trees in leaf and flowers scattered across the grass. There is a stretch of long grass and flowers that curves round in a wide arc from the foreground of the picture and disappears behind a row of poplars. The whole picture has been produced in a softly defined style, so that everything seems to blend into everything else. The gentle harmony of shapes and tones makes the view very attractive.

The second example, after *View from a Window* (1832) by Friedrich Wasmann (1805–1886) shows a favourite device used by artists, that of framing the landscape in a window frame, so that the viewer appears to be on the inside looking out. This feeling is reinforced by the dark edge of the window so that one's gaze is directed through it to the landscape beyond. The landscape itself is not unusual, however, the device of framing it so strongly makes catching a glimpse of the outside world so much more interesting.

By contrast, the drawing of a
part of the Niagara Falls, after
W H Bartlett's *View from Table
Rock* (1837) seen from below
Table Rock, is a splendid
evocation of the great outdoors.
The drama of the dark rock
face hanging over, and framing,
the right half of the picture
makes for extreme contrast,
both in darkness and light, and
between grim solidity and wild
movement. To underline the
massive size of this natural
phenomenon, the artist has
placed a tiny figure on the rock
in the foreground, to give a
sense of scale.

LANDSCAPE COMPOSITION 2

Nature as drama

The landscape above, after *Ravenscar* (1997) by Joe Cornish, also demonstrates quite a contrast between darkness and light but this time there is a distinct lack of drama, because it shows a beautiful empty beach, without any event to disturb it. A setting or rising sun appears behind the headland, which stretches across the skyline, and the sea reflects the light of the sky. Most of the land lies in shadow and there is very little detail except for the ripples of sand where the tide has marked it.

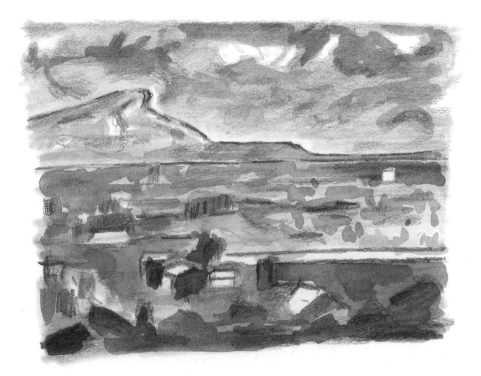

Cezanne's *Mont Sainte-Victoire* (1902) has considerable drama, mainly thanks to his way of structuring the solid shapes of the land and the clouds in the sky. The textural effect of his marks on the canvas makes this a very powerful, brooding image.

The next picture, after *Sikya and Corinth* by the German artist, Carl Rottmann (1797–1850), builds drama into the landscape by means of the harsh rocky surfaces revealed by the raking sunlight. Notice how the artist has hidden most of the detail beneath the dark shadows that stretch over the scene. The block-like way he has shown the rugged terrain, works wonderfully to convince us that this is a remorseless desert.

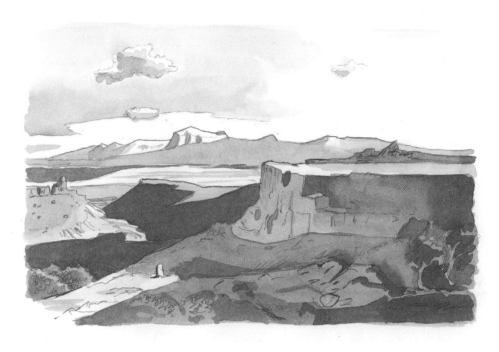

In the last view, after Thomas Cole's *View from Mt Holyoke* (1836), we see the landscape from on high and it appears almost like a map below us. Half of the view is obscured by an enormous rainstorm, sweeping across the left-hand side of the picture. With just a little detail added to the stunted tree in the foreground, the plain is laid out below us with the enormous river winding around it.

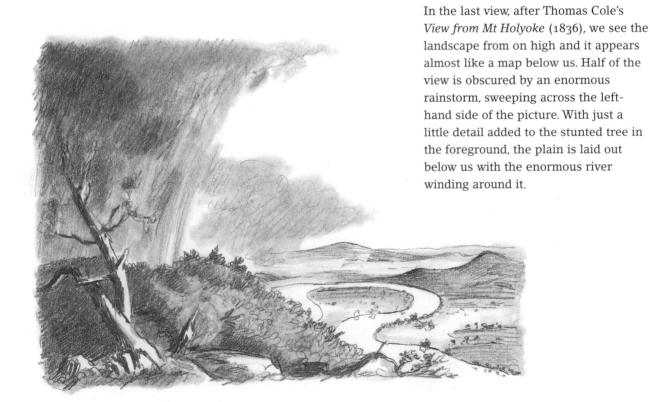

FINDING A VIEWPOINT

You must consider the viewpoint from which you would draw your landscape, because it won't necessarily occur to you by happy accident. First, you will have to decide what sort of place you want to draw, and then go about finding the best possible vantage point to work from.

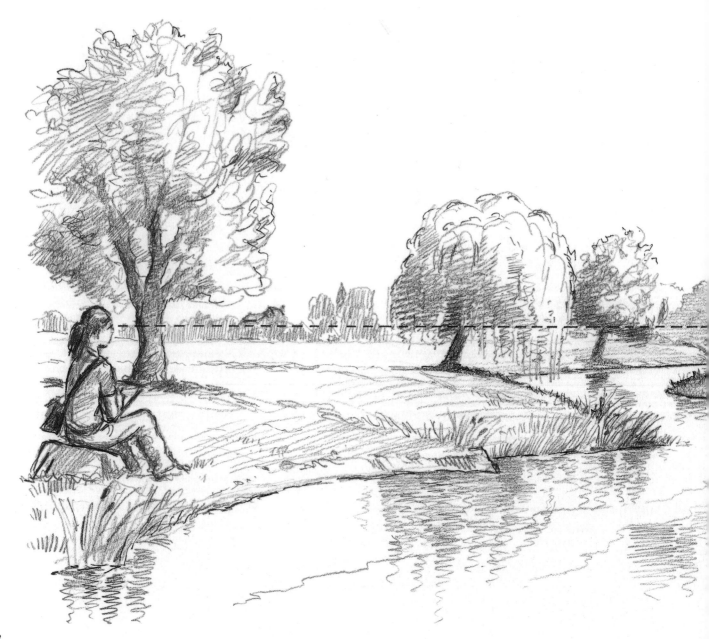

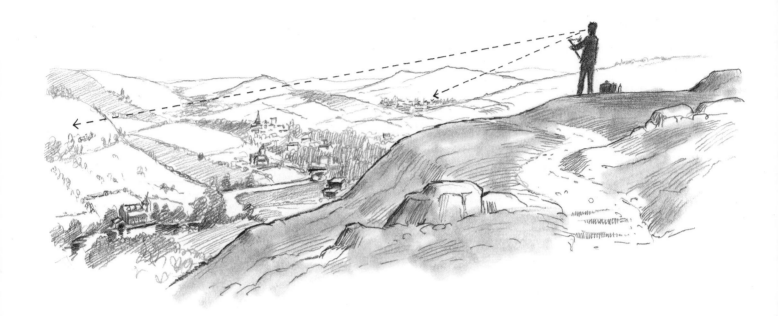

A high spot is a good choice, where you can get a good overall view. But then you will have to decide which direction to face and how much of the landscape to include. The dotted lines in this diagram indicate the amount of scope that you may have from a high vantage point.

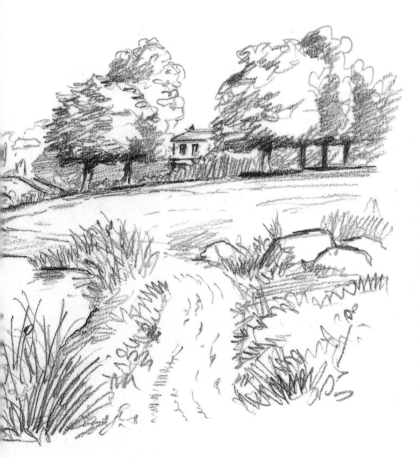

Sometimes you might be seeking a more gentle or intimate landscape. It is a good idea to position yourself beside a road or river, even a ditch, making use of some extended feature that will draw your eye into the picture. In fact, any device which helps the eye to respond to your drawing, by tempting it to explore your composition, is a good thing. So look for a focal point somewhere in the scene before you.

DIVIDING UP YOUR VIEW

Even when you have found your vantage point, you may be faced with a number of possibilities in terms of composition.

In this drawing, based on work by the Russian painter, Ivan Shishkin, (*Young Oaks* 1886), there is already a well thought-out limit to the landscape. Nevertheless, you could go one step further and divide this scene effectively into three different landscapes.

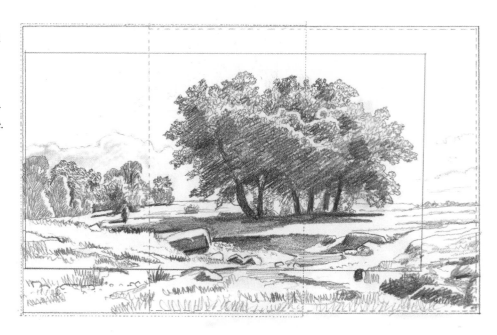

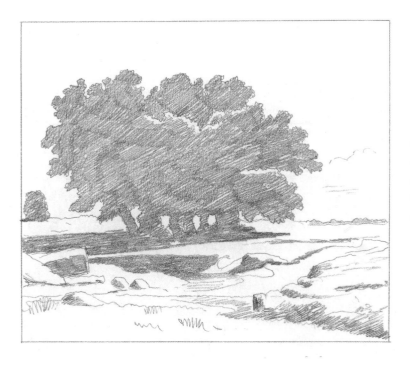

Taking the middle frame first, you would end up with a very strong centralized view of this copse of trees, with just a little foreground to draw the eye into the scene.

The second version would give you a nicely balanced landscape, with the trees of the copse acting as a dark framework on the right-hand side of the picture. Once more, the foreground would serve to pull your eye in.

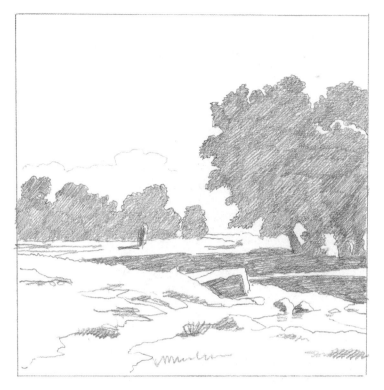

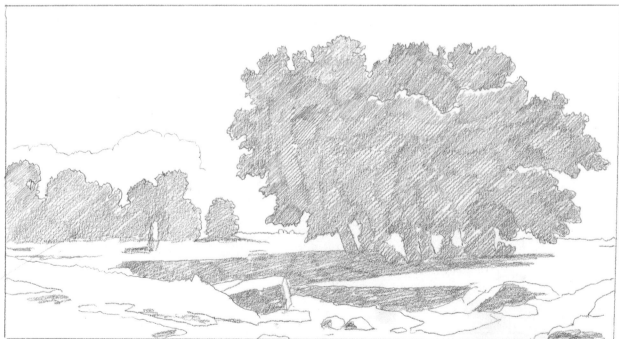

The third version gives us the whole copse again, but this time we have lost a bit of the foreground and most of the space to the right of the trees.

The important thing about this little exercise, with three versions of the same landscape, is that all three would work and produce interesting pictures to look at. So it is always worth taking your time at the outset to consider alternative ways of looking at the landscape.

SMALL FORMS

Now for a quick jump out of the world of plants into the world of animals of all shapes and sizes.

This is a difficult area for a beginner, because animals so rarely allow you to observe them for long without moving. So this is where some careful study is needed, and that can be supplemented by the study of photographs of animals. However, observing live animals is still the best way to understand how their bodies are constructed and how you can make your drawings come to life. If you live near a museum with a natural history section, that would also be a good place to augment your knowledge of animal form.

Starting with the world of insects, you may have more or less luck depending on the area that you live in. Here I show a tiger beetle, which is a fairly straightforward insect shape, but large and easier to draw. The main thing in this case is to get the basic shape right and there won't be much need for subtle details.

Next, we have a frog which is small, but more solid and compact, and the texture or colour of the animal will help to give a more convincing feel to your drawing. Achieving a good outline is most important in order to convey the character of the creature through your drawing.

Next, a bird with distinctive markings. This lapwing also has a nice crest, which lends it further character.

A field mouse is basically a little furry ball with ears and a long tail. I see these sometimes in our suburban garden; when our young cat catches one to play with, and I have to rescue it and put it back in the flower beds.

These two birds are quite common around my home area. The crow can be drawn almost as a silhouette, with just a few lighter patches showing highlights on its glossy feathers.

The sparrow is not so dark as the crow, with clear markings. The outline shape and the main colour change does it all.

LARGER CREATURES

Many of us have pets and they are undoubtedly a very good source of animal study. They will often oblige the artist by lying down for a while and keeping still, and this is obviously the best time to use them as models. Of course, there will be occasions when you will want to draw them in action, and the easiest way is to photograph or video them for yourself, and to draw the animal later. You then have the maximum benefit both of images of the moving form, and your model close by to check out the details.

Here is a pair of cats, one after the Belgian artist Henriette Ronner-Knip (1821–1909) from *Bit of Cheese* (c. 1860) and the other after my artist daughter, Elizabeth Knight.

This terrier dog, entitled *Jacko* (1828) originally by the British animal painter Edwin Landseer (1802–1873), gives us a very good idea of the liveliness of the animal, without too many distracting details.

Ronner-Knip's black and white 'moggy' stalking towards us was drawn using a fuzzy technique that gives the effect of the fur on the animal's body. The shape is contained in the textured black and white pattern with a bit of tone to help with the dimension.

The second drawing is from an etching. The image was created with quick loose strokes, which produced a very loose outline to create the impression of a furry coat.

William Holman Hunt (1827–1910) drew this marvellous bloodhound (1853) in brush strokes, loosely defining the shape of the animal with just enough detail to make it look lively. You can almost feel its tail wagging.

Larger animals are interesting to draw but you may not get so many opportunities to see them, so once again you will have to refer to other artists' work or to photographic sources.

Some of the earliest artists, from around fifteen thousand years ago, who have left work that we can see to this day, were the marvellous draughtsmen who painted the pictures in the caves at Lascaux, in France. This example was drawn with great confidence, almost in one continuous line, and with enough detail for us to be able to recognize the breed of cattle, still alive in the world today. Not only has the drawing great elegance, but the line was actually incised into the cave wall, so it cannot have been a quick sketch.

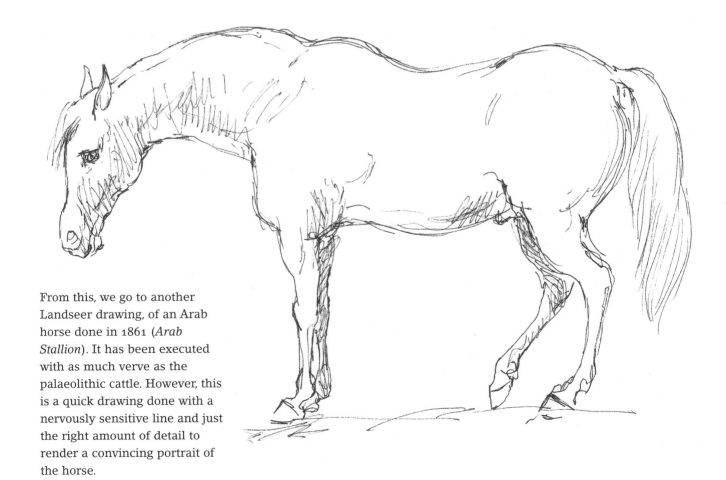

From this, we go to another Landseer drawing, of an Arab horse done in 1861 (*Arab Stallion*). It has been executed with as much verve as the palaeolithic cattle. However, this is a quick drawing done with a nervously sensitive line and just the right amount of detail to render a convincing portrait of the horse.

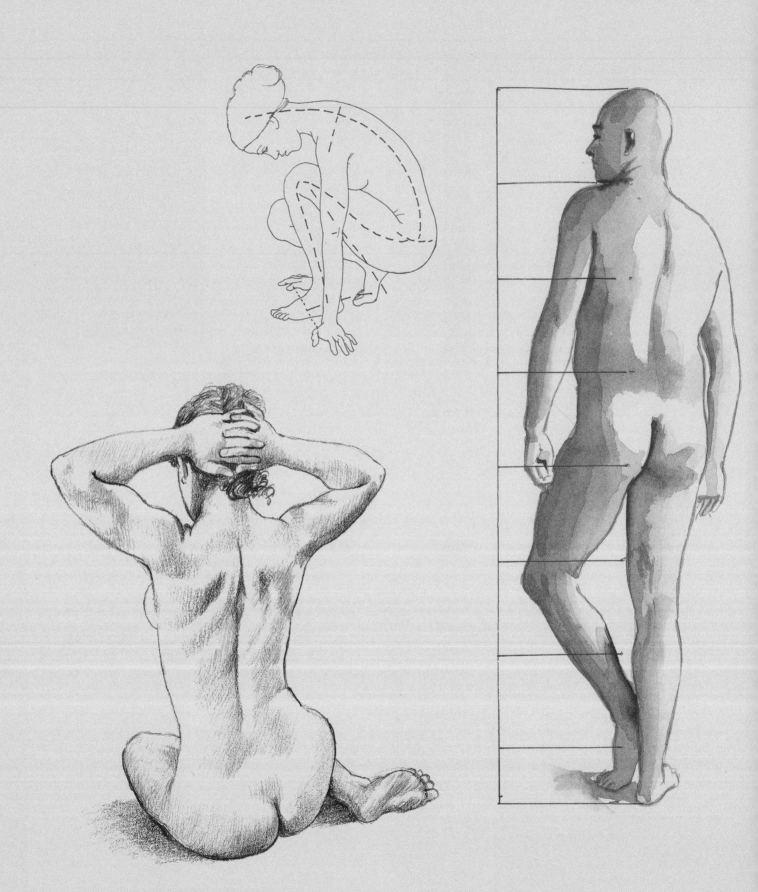

LIFE DRAWING – THE HUMAN FIGURE

When you have tried everything else, it is time to have a go at drawing the human figure, which is both the hardest and the most satisfying subject for any artist. To start with, in this section you will be studying the proportions of the human frame, as well as getting some idea of the dimensions of the head. I have provided basic anatomical diagrams to indicate what lies beneath the surface of the skin, moulding the contours that we recognize from our own bodies and those we observe on others. A certain degree of scientific information is most helpful for understanding how the shape of the body becomes altered with – for example – the movement of the limbs and torso. Without at least a little knowledge of anatomy, it is difficult to impart a sense of flow and movement to your figure drawing.

You will also be learning how to arrange a figure inside a composition, remembering that the picture as a whole is more important than any single item that occupies it. This means that you must think carefully about how you place your figures within the picture, which one should be more dominant and which should be less so. You will find it necessary to enter into a certain amount of detail on some parts of a figure because if, say, the hands or feet are not convincing, it could spoil an otherwise decent drawing. Looking at the ways different artists have drawn the human form, you will see how varied your own approach might be to rendering figures in different poses. Not all artists are realists with regard to life drawing; they can and do interpret the figure in many interesting and remarkable styles. It is also necessary to consider how you intend treating the limbs and torso so that the flat drawing appears to have depth and weight; the use of shading or tone is not the only way to achieve this.

Motion can also be shown in various ways; there are numerous methods of making figures look as though they are moving. When it comes to faces, then the emphasis on facial expression can enliven an otherwise ordinary portrait. All in all, there are many enjoyable aspects of life drawing and for a lot of people, this is their main goal. Being able to depict human beings, as well as objects and landscapes, does increase an artist's range of subject matter enormously and most of those who embark on learning how to draw are keen to be able to make pictures of their friends and relations. So I wish you good luck with your efforts, and please don't imagine that you will have exhausted all the possibilities by the time you have worked your way through this book, because an artist never runs out of opportunities.

BASIC PROPORTIONS

You will see that I have divided up this diagram of the human figure into seven and a half units; these are not precisely everyone's proportions but represent an average.

It is generally accepted that the length of the head from top to chin, will fit more or less seven times into the length of the whole body. The classic proportion was traditionally regarded as one head going into the overall height eight times and, although this was originally used to depict god-like figures or heroes and heroines, it is often the way modern photographers manipulate their fashion images to elongate and make them look more slender and graceful than they actually are. However, the proportion of seven and a half to one is closer to reality.

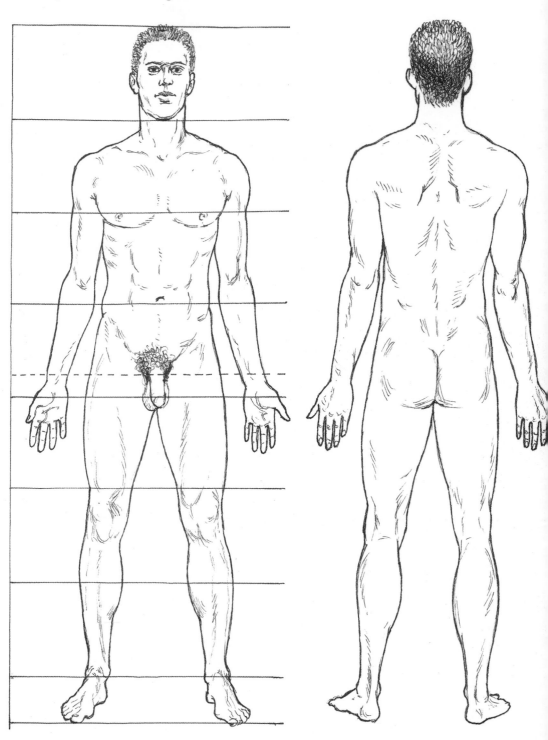

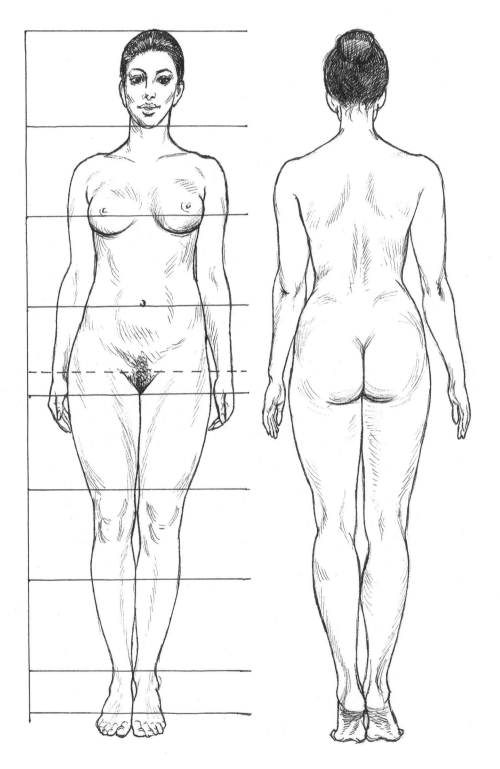

Note how both the figures shown here are the same height; in reality the female is probably shorter than the male but the proportion of head to height would remain the same. The halfway mark, shown by the dotted line, occurs at the base of the pubic bone. Surprisingly, the differences between the sexes are fairly minimal. The male figure is usually heavier in build, the skeleton often being significantly more solid than the female's; this is reflected in the fact that you will need to draw the female limbs, features and so on, much more finely than you would for the male version. The female form also has a layer of subcutaneous fat that the male form lacks, so that she usually looks softer and rounder than her male counterpart. There are occasional exceptions to these rules, but these diagrams are a good starting point.

THE SKELETON

The skeletons of men and women are basically the same, with some variations in the width of the shoulders and hips, and that of the female will usually be finer and lighter.

One regular difference is that the bones of the male forearm are generally longer proportionally than those of the female; and their feet tend to be larger as well. There are some slight differences in bone structure in terms of racial characteristics, but not enough to show in a drawing, unless it is very large in scale. So, this version of the human skeleton will do for general purposes, unless you choose to study the subject in greater depth.

The first diagram shows the proportions of the torso, with its complex structure of rib cage and pelvic girdle, and the much simpler structures of the arms and legs. The head looks simple too, but in fact it is amazingly complex; it is only the solidity of the shape that makes us think it is uncomplicated.

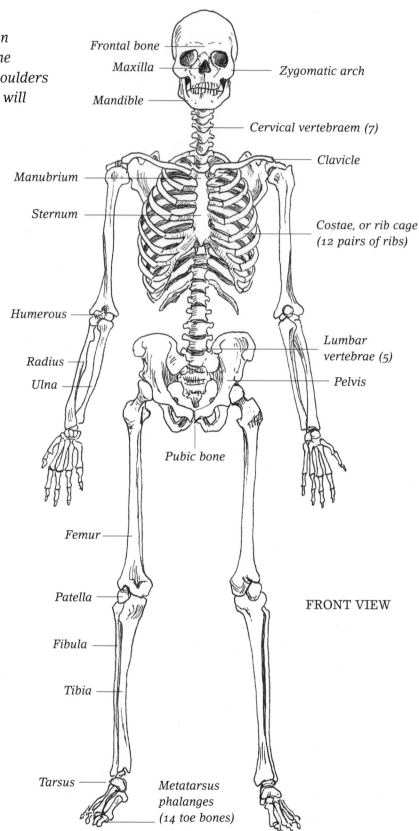

Frontal bone

Maxilla

Mandible

Zygomatic arch

Cervical vertebraem (7)

Clavicle

Manubrium

Sternum

Costae, or rib cage (12 pairs of ribs)

Humerous

Radius

Ulna

Lumbar vertebrae (5)

Pelvis

Pubic bone

Femur

Patella

Fibula

Tibia

FRONT VIEW

Tarsus

Metatarsus phalanges (14 toe bones)

The rear-view diagram is included to demonstrate how the shoulder blade forms part of the shoulder joint and slides over the upper portion of the rib cage; it also shows the rear view of the pelvis, which is quite different from the front. You may not remember all the correct names for the bones, but you are bound to familiarize yourself if you consult the skeleton plan often enough.

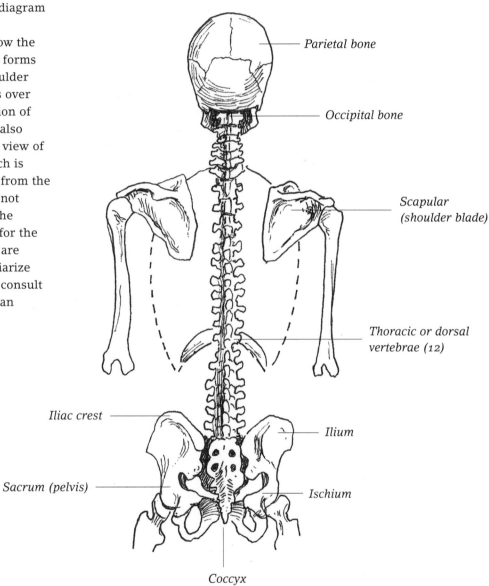

Parietal bone

Occipital bone

Scapular (shoulder blade)

Thoracic or dorsal vertebrae (12)

Iliac crest

Ilium

Sacrum (pelvis)

Ischium

Coccyx

REAR VIEW

MUSCLE STRUCTURE

The following diagrams illustrate the musculature that lies beneath the surface of the skin, moulding the contours that we recognize from our own bodies and those we observe on others; it is made up of both large and small muscles together with various ligaments and tendons.

You will see only the muscles that constitute the top layer; however, this is sufficient because artists are chiefly concerned with the ones that show up just under the skin. Again, you probably won't remember all the names, but as you get used to referring to them, the principal ones will begin to stick in your memory. Most of the major muscles are connected with the way that we move about, pushing or pulling on the bone structure and coordinating with other muscles.

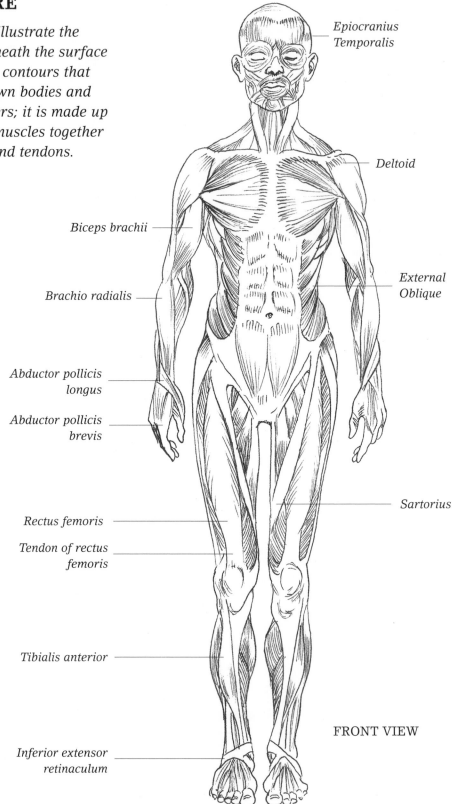

Epiocranius
Temporalis

Deltoid

Biceps brachii

External
Oblique

Brachio radialis

Abductor pollicis
longus

Abductor pollicis
brevis

Sartorius

Rectus femoris

Tendon of rectus
femoris

Tibialis anterior

FRONT VIEW

Inferior extensor
retinaculum

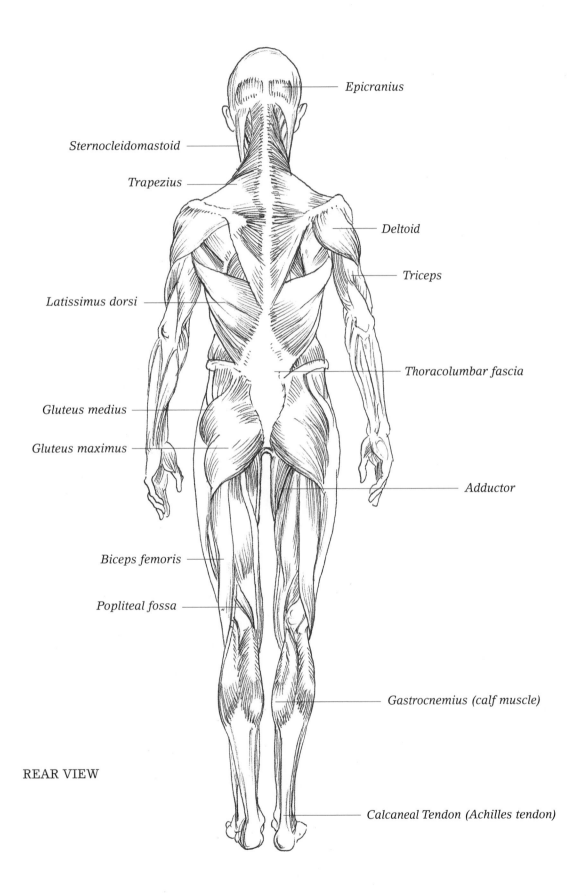

Epicranius

Sternocleidomastoid

Trapezius

Deltoid

Triceps

Latissimus dorsi

Thoracolumbar fascia

Gluteus medius

Gluteus maximus

Adductor

Biceps femoris

Popliteal fossa

Gastrocnemius (calf muscle)

REAR VIEW

Calcaneal Tendon (Achilles tendon)

THE HEAD IN PROPORTION

Treating the head separately is rational, because this is the part of the body that everyone relates to most strongly. Begin by making a note of its basic proportions, which are simple and not too difficult to remember, although if this is the first time that you have measured a head, you may find them a little surprising.

The first diagram shows that the general proportion of the head, viewed straight on, is in the ratio of 2:3; that is, the width is about two-thirds of the height. Something that most people find difficult to believe at first, is that the eyes are situated halfway down the face; the distance between the top of the head and the eyes is the same as the distance between the eyes and the tip of the chin. The reason is that most people look at the face alone, and don't take into account the portion of the head that is covered by hair.

The second diagram shows the side view or profile of the head, and this measures as much from front to back, as it does from top to bottom. The only part that projects beyond the square is the nose, which is obviously variable in size and shape.

Other useful measurements are: the length of the nose is rather less than half the distance between the eyes and the chin; the spaces between and either side of the eyes, when seen from directly in front, are equal to the horizontal length of the eye. The mouth is somewhat nearer the nose than the chin, so don't leave too big a distance between the base of the nose and the mouth. The ear, seen in profile, lies behind the halfway vertical that bisects the head; it is roughly centred on the length of this line, but the way to check is to see that the top of the ear is level with the eyebrow, and that the lobe is level with the tip of the nose. Generally speaking, in the case of most younger people, the lips of the mouth project in front of the line between the forehead and the chin. For the elderly, especially those who have lost their teeth, this may not always be so.

THE SKULL AND ITS MUSCLES

We should now look at the anatomy of the head in greater detail, so here are two diagrams that explain the structure and name the various parts.

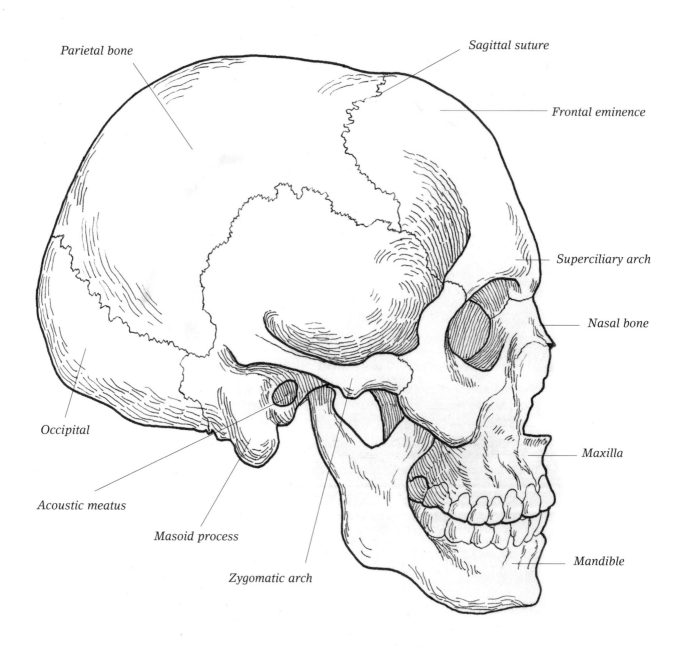

Parietal bone

Sagittal suture

Frontal eminence

Superciliary arch

Nasal bone

Occipital

Maxilla

Acoustic meatus

Masoid process

Mandible

Zygomatic arch

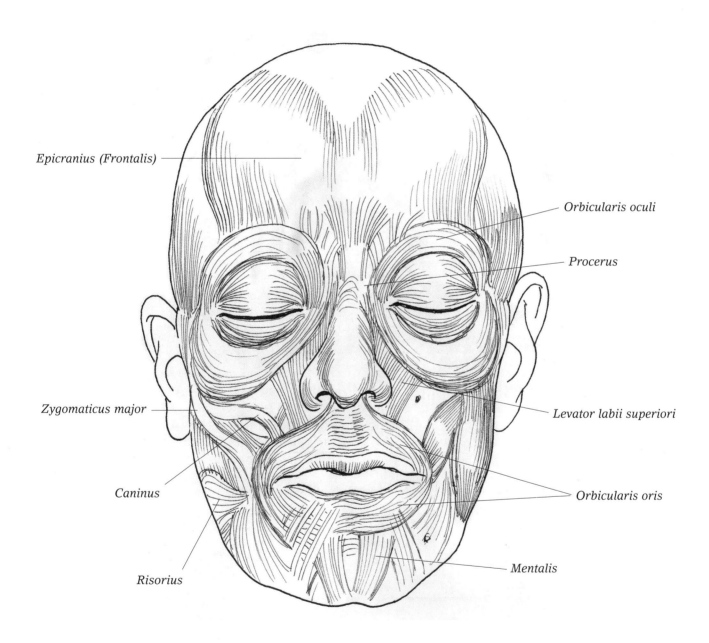

Epicranius (Frontalis)

Orbicularis oculi

Procerus

Zygomaticus major

Levator labii superiori

Caninus

Orbicularis oris

Risorius

Mentalis

MALE AND FEMALE FEATURES

Male head

The head and features tend to be more angular and harder-looking than the female. The hair is usually shorter and less luxuriant. The nose is often both long and strong looking. There is usually a smaller distance between the eyebrows and the eyelid, the eyes are often narrower and the eyebrows thicker. The male jaw tends to be heavier than the female and the mouth straighter, with thinner lips.

Female head

The female face shape is generally softer and more rounded than the male. The hair is often longer and less coarse in texture. The female nose tends to be smaller. There is probably a greater distance between the eyebrows and eyelid, and the eyes themselves will be larger with shapely and often smoother eyebrows. Female lips are fuller and the face ends in a rounder, more delicate chin.

Of course, these are only generalizations and there will be exceptions, but going by average appearances, this list of characteristics holds true. In reality, there is nothing better than seeing for yourself, and in the world of art and drawing, your own powers of observation are your best guide. Nevertheless, keep asking yourself , 'Am I actually seeing what I think I am, or am I deluding myself with preconceived ideas about what I am looking at?' Every so often in the history of art, someone decides that they've seen something new, and often that is when we all wake up to a fresh interpretation.

LEONARDO DA VINCI'S HUMAN PROPORTION

Leonardo da Vinci demonstrated the proportions of the human body in what was originally an illustration for a book on the work of Vitruvius, the Roman architect.

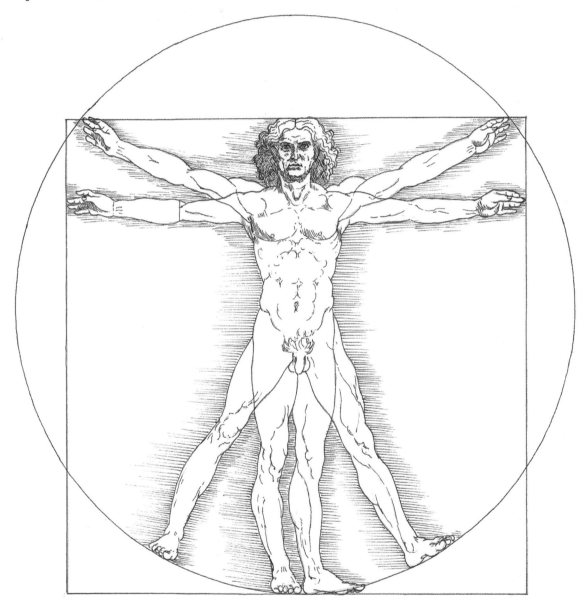

Among a variety of other things, Vitruvius noted the proportions of the human figure. However, Leonardo was more pragmatic than most of his contemporaries and didn't just take Vitruvius at his word. He made detailed measurements and produced this iconic diagram, in which the body is related to both the circle and the square.

The figure, with arms outstretched at shoulder level and feet together, fits neatly into a square, and when the arms are lifted above the horizontal and the legs are parted, the figure fits into a circle, with the navel as the centre. Leonardo's curiosity, practicality and absolute dedication to drawing from observation set him miles above all his contemporaries.

EXAMPLES OF FIGURES

Here are works by both Leonardo da Vinci and Michelangelo, which display their methods of drawing the human figure in all its perfection.

It is heartening to see that in both drawings, which are justly famous, there are a number of lines that have been tentatively sketched in, suggesting that these great artists were just as likely to change their minds about where to put their marks as any of us lesser talents might be. This goes a long way to convince me, at least, that the process of drawing is not a finite thing, but something that progresses and develops. So don't be too worried about your own superfluous lines – the ones that you think are inaccurate – because it is all part of the process to see these and yet not be concerned. The viewer's gaze automatically goes directly to the most acceptable lines in a drawing, and it is consoling that our eyes can be so astute that they inevitably pick out the correct lines to look at.

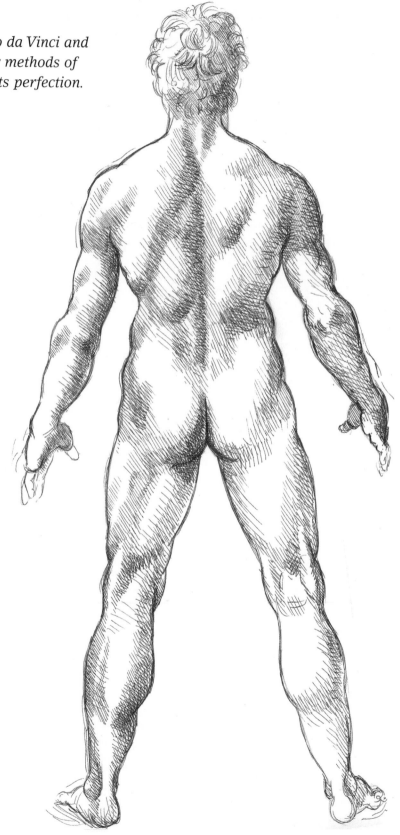

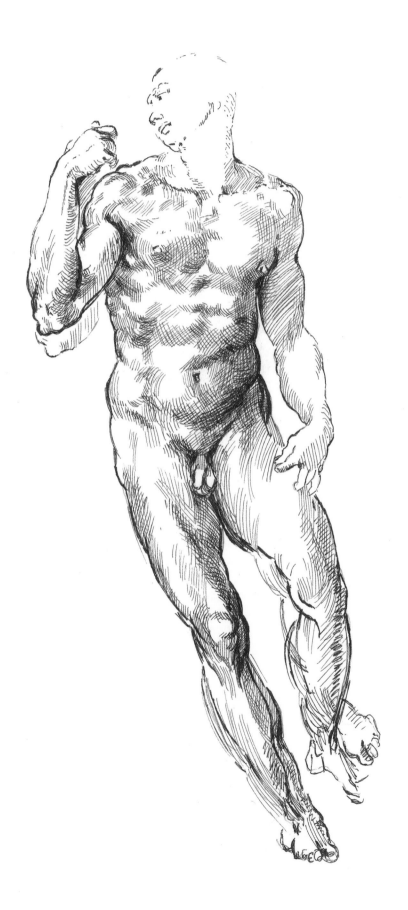

EXAMPLES OF FIGURES IN PROPORTION

Look at these examples of figures drawn from models who were very carefully photographed so that there was no significant distortion of their shape or pose.

Having traced them as accurately as possible, so as not to change the proportion at all, you can see that our notional average is working quite well. The first one is just seven and a half heads into the full height. The second is only seven heads into the height, which means either that the model has a larger head than normal, or that she is rather small in build, perhaps both.

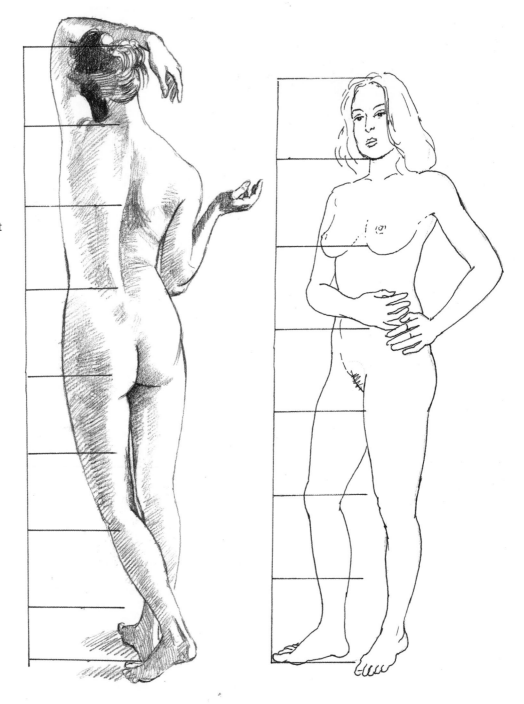

The third is around seven and one-third head lengths. And the last one is also seven and a half head lengths into the full height. So that is not a bad average, considering that these models were chosen at random.

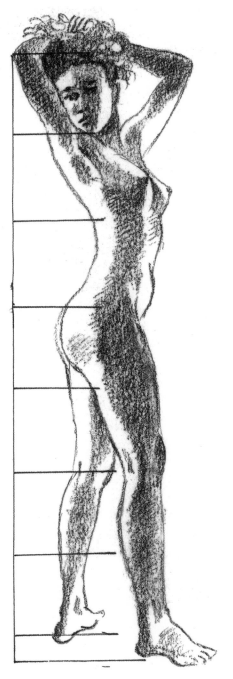

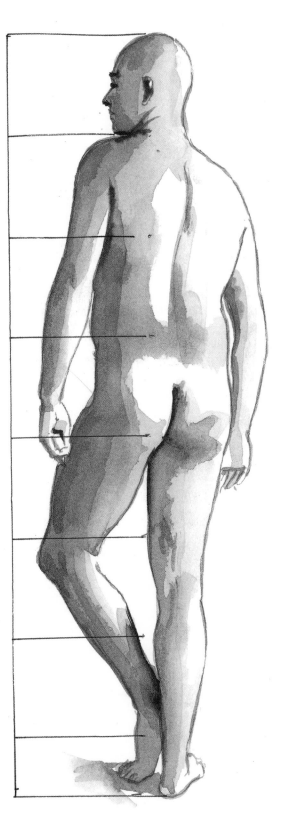

DRAWING FOR EFFECT

The next few examples are of models in poses that don't afford an easy way of seeing the proportions, so you have to devise a method whereby you can still get them right without measuring. Think about that while you study these next drawings and we shall come back to the problem later (see pp 140–141).

This set of figure studies, all from life models, are to give you some idea of the variety of ways that you can show a figure to convincing effect. They use different techniques, attempting to echo the feeling of the particular pose or model. The first model is drawn in pencil and the approach has been fairly fluid; meaning that although there are some strong lines, the way they have been repeatedly sketched around, in order to find the best line to describe the model's pose, gives a very soft feel to the edge of the figure. With this style, you get quite a bit of information about the way parts of the body curve around out of sight. The idea is to keep the actual drawing process to the fore, so that you don't imagine that there is only one edge to the figure.

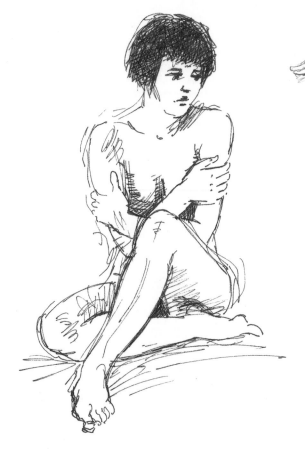

The next drawing is more tentative in one way, but also very definite when the main shape has been detected. The wiry pen line sometimes suggests that an edge has not yet been clearly seen, and at other times is put down so strongly that there is no doubting its position. This results in a certain assurance, because we do actually tend to view things like that, sometimes sure about the image and sometimes uncertain.

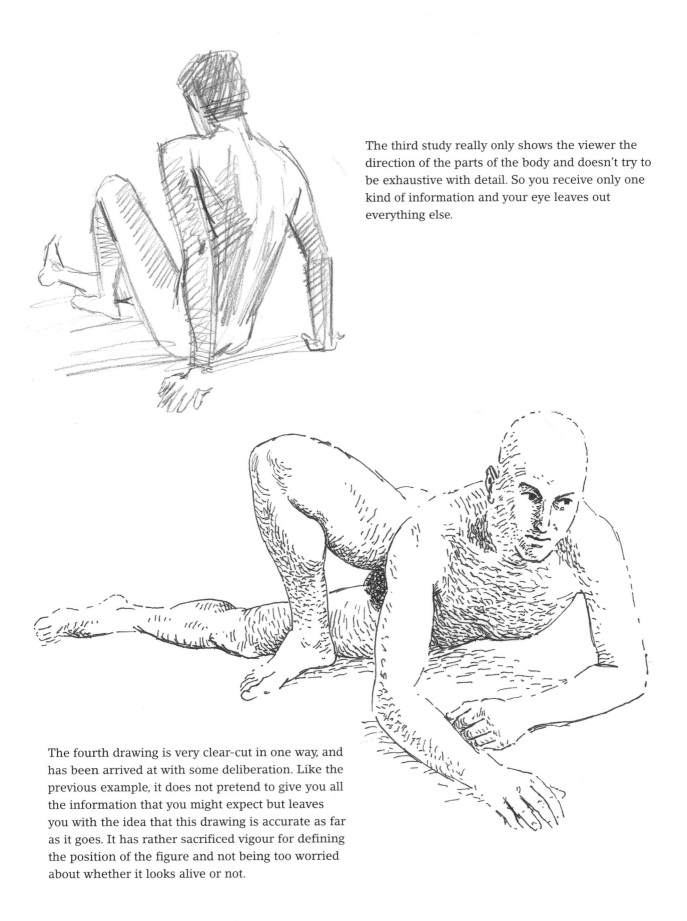

The third study really only shows the viewer the direction of the parts of the body and doesn't try to be exhaustive with detail. So you receive only one kind of information and your eye leaves out everything else.

The fourth drawing is very clear-cut in one way, and has been arrived at with some deliberation. Like the previous example, it does not pretend to give you all the information that you might expect but leaves you with the idea that this drawing is accurate as far as it goes. It has rather sacrificed vigour for defining the position of the figure and not being too worried about whether it looks alive or not.

DESCRIBING FORM

One of the greatest problems with drawing is the need to indicate the three-dimensional qualities of the figure, so that the eye is convinced that what it is seeing has mass and volume. There is no fixed methodology for this and artists down the ages have tackled the question in many different ways. Here are just a few of the most obvious.

The first example shows the classic method of shading in pencil, which the majority of artists use at some time or another, and it is probably one of the most effective methods of showing solidity. What artists rely upon here is the fact that we cannot see anything without sufficient light both to illuminate one surface and throw another in the shade. Traditionally, the way to illustrate light and shade is to move your pencil across the paper in regular, close-set lines to affect an area of shadow. This has to be done in a fairly controlled way and the better you become at it, the more convincing is the result. Leonardo da Vinci was famous for laying on shadow in this way, using a technique called sfumato, meaning that the result was so subtle and soft that the gradation of tone looked almost like smoke. Our example doesn't claim to be as expert as Leonardo's, nevertheless you can see how by very careful progression with the shading, the impression of a solid body with the light falling on it from one side is convincing, and gives roundness to the limbs and torso of the model.

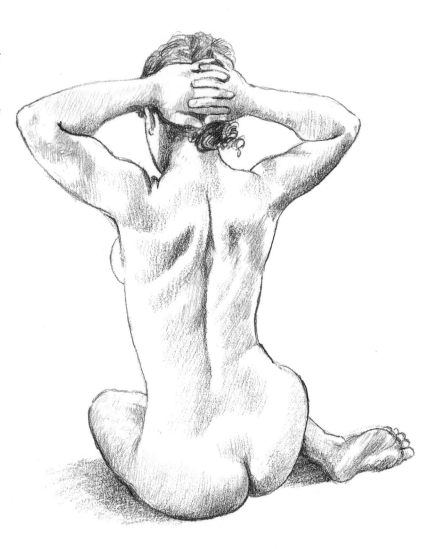

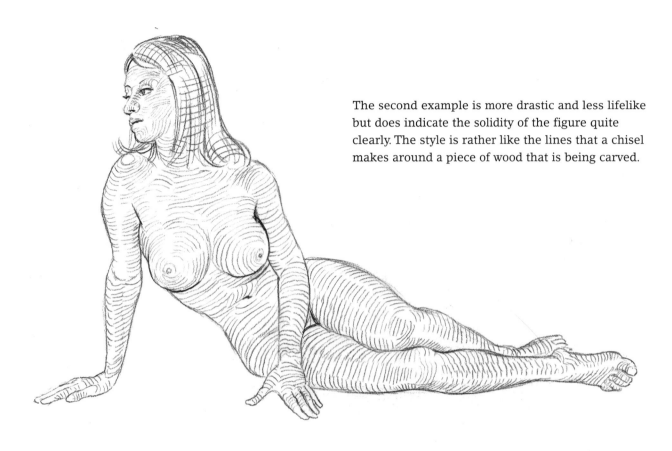

The second example is more drastic and less lifelike but does indicate the solidity of the figure quite clearly. The style is rather like the lines that a chisel makes around a piece of wood that is being carved.

The third one is simplified and rather angular; it works by describing the planes of the body in very clear-cut terms. This method has the tendency to sacrifice subtlety for the conviction of the main shapes and surfaces. It can give a dramatically strong look to a drawing but might well miss out on the detail.

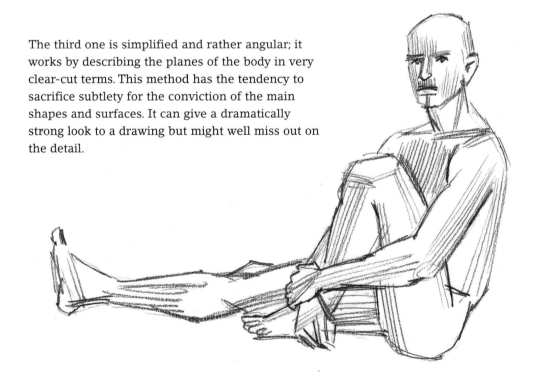

OTHER FORMS

The next method sacrifices everything in an attempt to describe form purely by the outline.

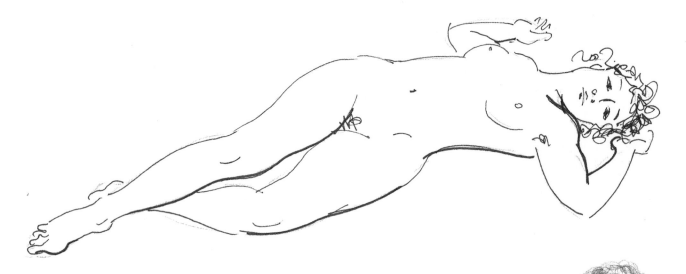

This means that the viewer has to do rather more work than some people are prepared for when simply looking at a drawing. However, to someone truly interested in art, this method can be most rewarding, because it enables the eye to read into the picture a great deal that is, in fact, only hinted at. In the hands of a master like Matisse the impact is extraordinary because as you study the sparse outlines, you wonder how it is that there seems to be solidity and depth without any obvious way of showing it.

This next drawing is somewhat similar in style to the first but, in fact, is even more of an exploration by the artist of where the final lines might be. This technique never finalizes the image and is, in reality, the expression of an ongoing process. All the lines suggest the limits of the figure without actually defining it, leaving the viewer with the idea that there was another possibility that might have been drawn in, if the artist had had the time to go on. So what you are observing is a well-informed suggestion of the probable shape of the figure and a sort of movement across the surface, hinting at a bit more of the form than is visible.

The final figure in this section shows how, when using watercolour or ink with a brush, you get the immediate sense of a rounded, almost soft-surfaced body, suggesting all the qualities expected of the human form. The tonal quality of the grey wash is now and again defined by sharper marks of the darker tone, but the main area is quite fluid in effect, thanks to the technique involved.

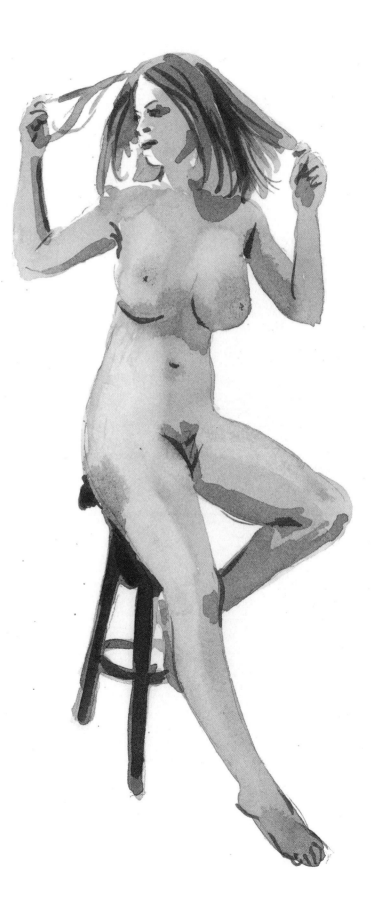

FORM IN MOVEMENT

Now let us explore what happens when trying to show the human body in motion, which is by no means easy considering that you are working on a static image. Even so, artists have always found ways of conveying the idea of movement and there are several stratagems designed to bring action drawings to life.

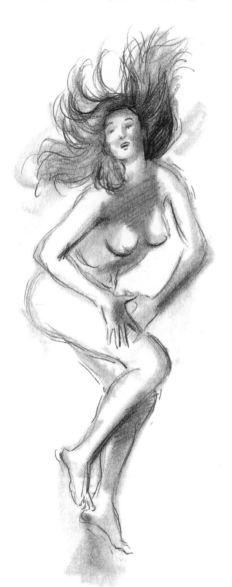

The first uses two artistic devices, one of which is based on a photographic technique. When photographing a moving figure at a slow shutter speed, the result is a deliberate blur. In this drawing, the artist has blurred the form significantly in order to produce the same effect. Not only that, he has chosen a pose that, from the positions of the legs and arms, suggests that the model must be jumping in the air; hair does not look like this otherwise, and even the expression on her face adds to the illusion.

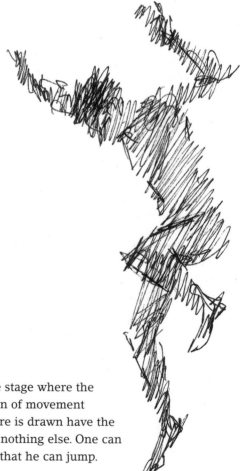

The second is taking the technique of drawing to the stage where the figure hardly looks real at all, except as an expression of movement through space. The oblique lines with which the figure is drawn have the effect of making the viewer aware of movement and nothing else. One can tell it is a man but not any details about him, except that he can jump.

The Michelangelo drawing of the risen Christ is very clever in the way that he manages to suggest movement. He has drawn the figure with a rather meandering line at the edges that suggests the figure is in constant motion, and furthermore the pose is such that you cannot help associating it with a body that is rising upwards. This effect is partly due to Michelangelo's technique and partly to the actual balance of the pose. The successful evocation of movement is what you might expect from one of the most brilliant artists of all time.

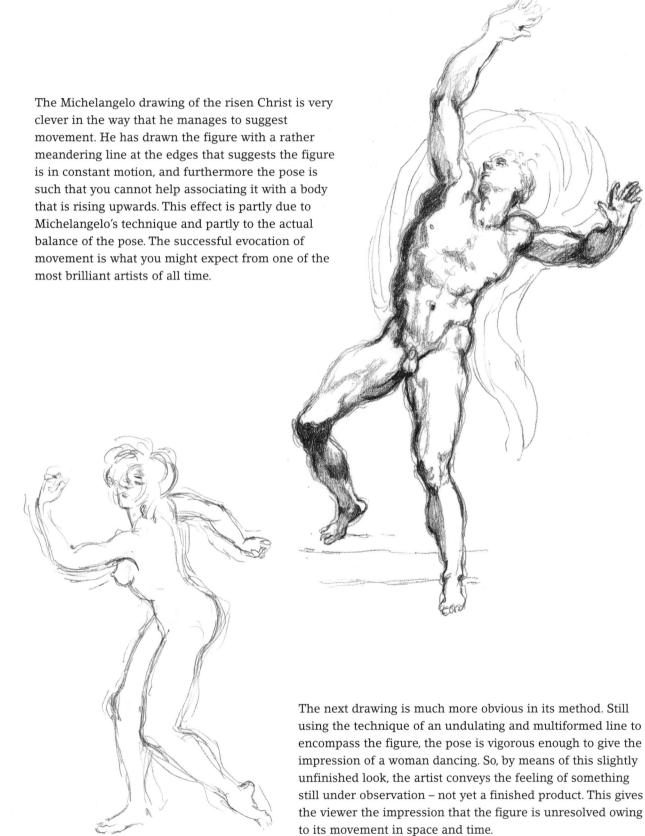

The next drawing is much more obvious in its method. Still using the technique of an undulating and multiformed line to encompass the figure, the pose is vigorous enough to give the impression of a woman dancing. So, by means of this slightly unfinished look, the artist conveys the feeling of something still under observation – not yet a finished product. This gives the viewer the impression that the figure is unresolved owing to its movement in space and time.

ANALYSING BALANCE AND POSE 1

The next group of figures demonstrates how to observe the human form and simultaneously to analyse what is happening to the placing of the body as you draw it.

Start off by visualizing a line from the top of the head to the point between the feet where the weight of the body is resting – this is its centre of gravity. Our system labels this line (from head to ground) as line A.

Next, take the lines across the body that denote the shoulders, hips, knees and feet. The way that these lines lend balance to the form tells you a lot about how to compose the figure. The system labels these as follows: the shoulders, line B; hips, line C; knees, line D; feet, line E.

Then, note the relationship between the elbows and the hands although these are not always so easy to see. The system here is: the elbows, line F; hands, line G.

So now, as you glance down the length of the figure, your eye automatically notes the distribution of these points of balance. Concentrating your observations in this way, you will find it much easier to render the figure realistically.

The first figure is standing and the distribution of the various levels of balance can be seen quite clearly. The only one that is a bit difficult to relate to, is line F, linking the two elbows.

The second figure is also standing, although the shoulders and hips are different from the first. Nevertheless, it is still fairly easy to see how the points relate to one another.

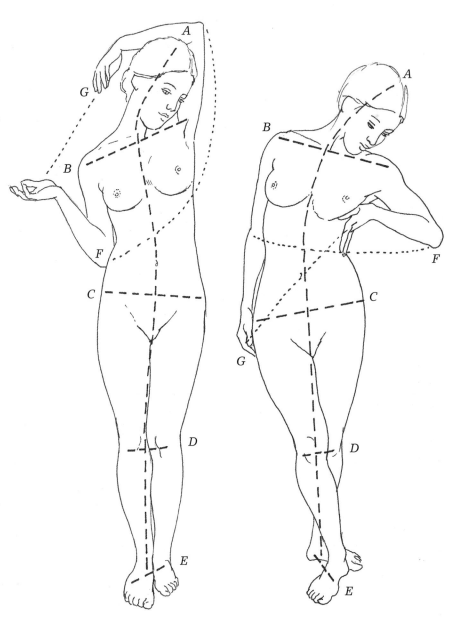

The third figure, still standing but sideways-on this time, makes some of the balancing points less significant. The hips, for example, are one behind the other so they don't register much. The hands are together, so that simplifies that aspect. But the remaining points are important to observe, in order to give the right kind of balance to the figure.

The last standing figure uses all of the points, except for the hands and the knees, which are one behind the other in both cases.

Now, we have a sitting figure in which the main line A is shortened to cover the upper part of the body only, because this is where the balancing line stops. However, the rest are obvious enough, although the lines connecting hands and elbows actually cut across each other in this pose.

ANALYSING BALANCE AND POSE 2

In the reclining pose, the main balance lies between the line that goes as far as the hip, and a line from shoulder to elbow. I have not indicated the latter in order to avoid overloading the diagram.

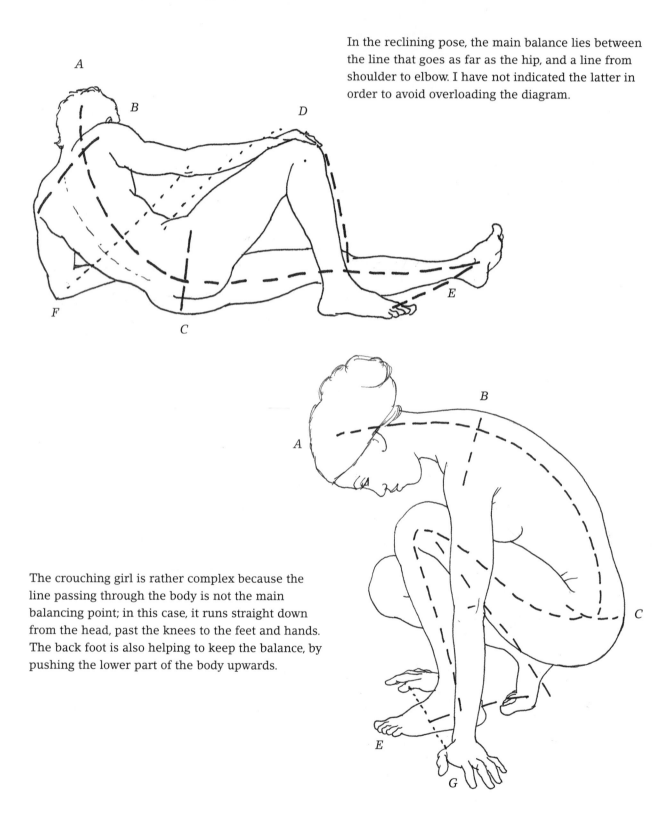

The crouching girl is rather complex because the line passing through the body is not the main balancing point; in this case, it runs straight down from the head, past the knees to the feet and hands. The back foot is also helping to keep the balance, by pushing the lower part of the body upwards.

This bending figure illustrates the principle of the cantilever, where the feet planted apart and the position of the arm on the knee, supporting the back, combine to keep the figure upright despite the horizontal angle of the upper body. But
to draw the pose convincingly, it is still important to register the balancing points and the positioning of the other pairs of limbs.

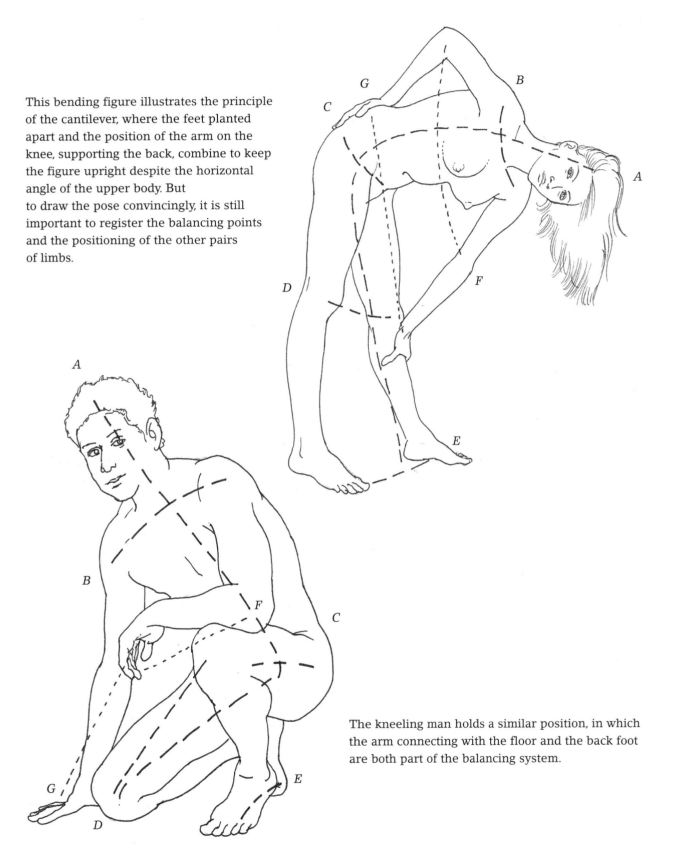

The kneeling man holds a similar position, in which the arm connecting with the floor and the back foot are both part of the balancing system.

BODY DETAILS – TORSO

Before going any further, it would be a good idea to look at those body details that are too often glossed over in figure drawing.

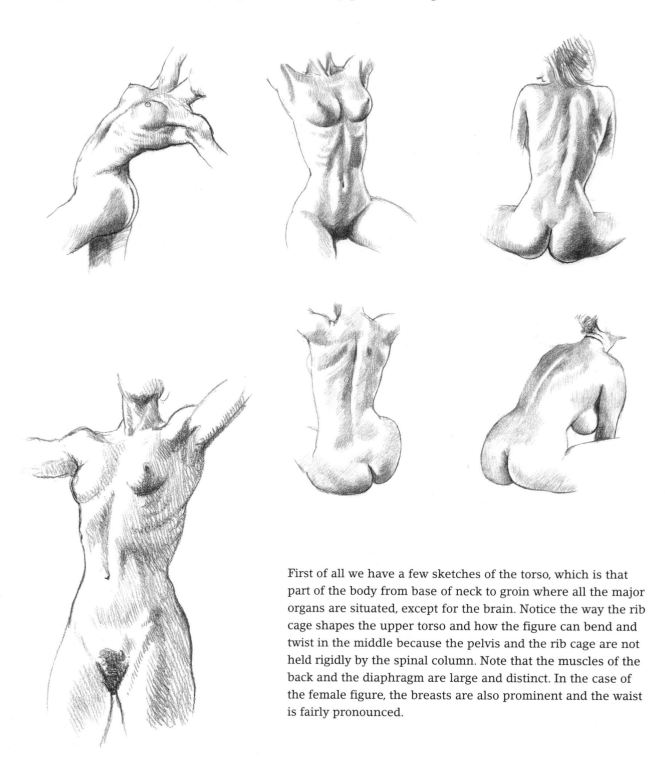

First of all we have a few sketches of the torso, which is that part of the body from base of neck to groin where all the major organs are situated, except for the brain. Notice the way the rib cage shapes the upper torso and how the figure can bend and twist in the middle because the pelvis and the rib cage are not held rigidly by the spinal column. Note that the muscles of the back and the diaphragm are large and distinct. In the case of the female figure, the breasts are also prominent and the waist is fairly pronounced.

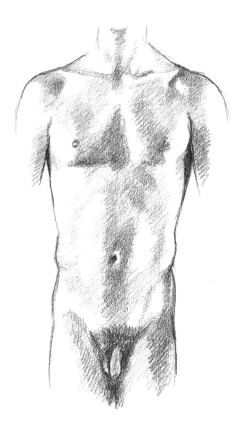

The male torsos of the next group are similar to the female, in that they have the same flexibility and the large muscles show up clearly, but the chest is more compact and the waistline less obvious. The shoulders call for more emphasis as a male characteristic.

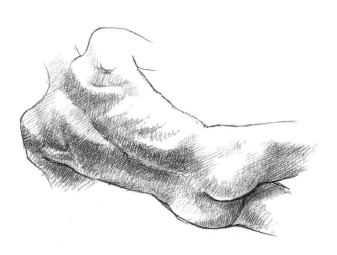

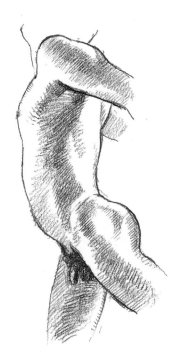

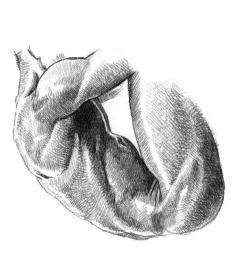

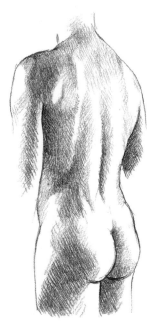

BODY DETAILS – HANDS AND FEET

I have often heard people saying, 'Oh, I can't draw hands and feet.' Unfortunately, this is why their drawings leave a lot to be desired. Yet, with the right approach, hands and feet are not any more difficult to draw than the rest of the body and do make the figure so much more convincing if they are put in properly.

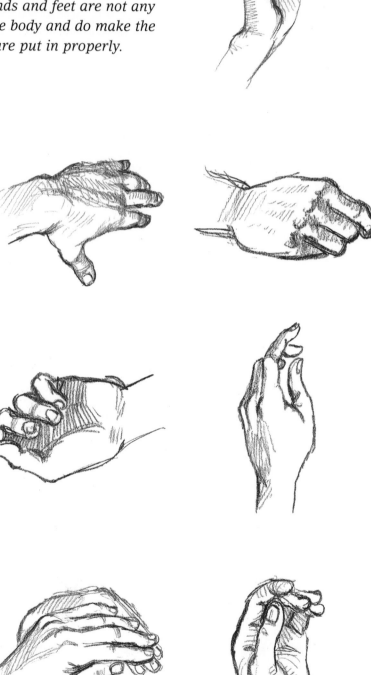

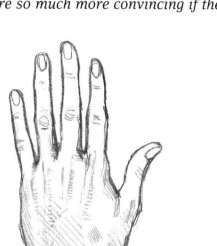

Hands

Look at hands in all their flexible poses; you will need frequent practice to be able to incorporate them into your drawing with ease. Practise on your own hands first, both directly and in a mirror. Try sketching them from as many angles as you can. Approach them as though you were engaged in depicting a whole figure, with the palm as the torso and the fingers as the limbs. This way, when you do come to draw a full-length figure, you will not dispatch the hands with some vague, feathery marks.

Feet

Feet are generally easier to draw but, because people rarely pay much attention to them, they tend to be quite unlike what they imagine them to be. The slightly wedge-shaped quality of the foot is refined by the way it joins the ankle and by the disposition of the toes. It is strongly recommended to practise drawing feet from the front, in order to work out the shape of the toes. Once again, frequent practice can save the extremities in your figure drawings from looking like unformed lumps of clay.

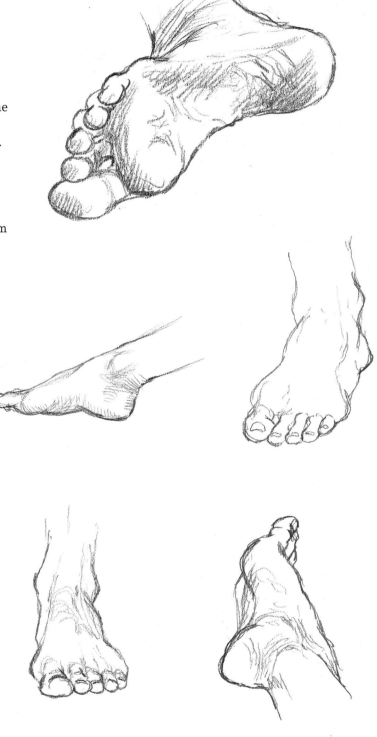

THE BODY IN PERSPECTIVE

Quite often, the model will be lying down in a position that shows either their head or their feet receding from your point of view. This means that the proportions of the body will not be those with which you are most familiar, and it is helpful to pause and analyse what it is you are actually able to see.

In these two diagrams, you are shown one body from the foot end and one from the head end. In these diagrams, the grid patterns clarify what is happening to the shape and proportion of the body.

These two drawings, based on paintings by Lucian Freud (*Naked Girl Asleep II* 1968), graphically illustrate the effect of perspective on the relative sizes of different parts of the body. Notice how much larger the legs and feet are in relation to the torso and head area. Note also the diminishing width of the figure as it recedes from the viewer.

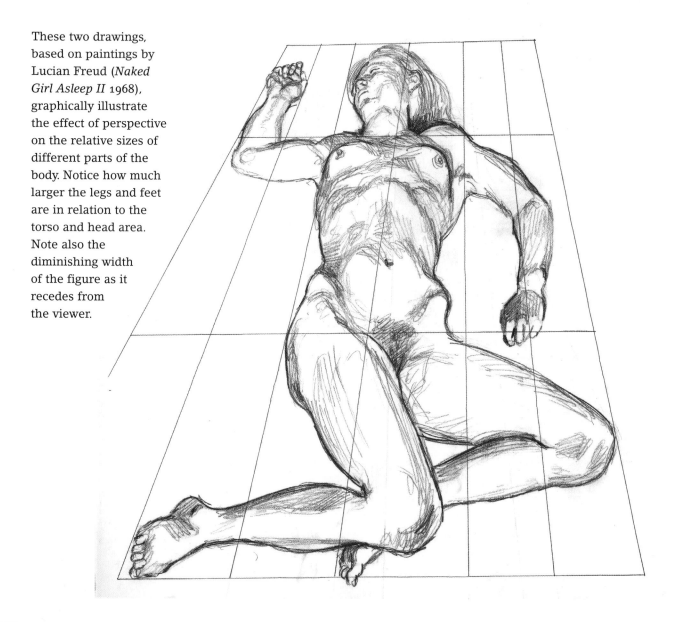

In the second drawing (*Night Portrait, Face Down* 1999), the area of the head and shoulders is far larger than you may have expected and the legs and feet are much smaller. Again, the diminishing width, though not as dramatic as seen in the first example, is still giving a clear indication of the effect of perspective.

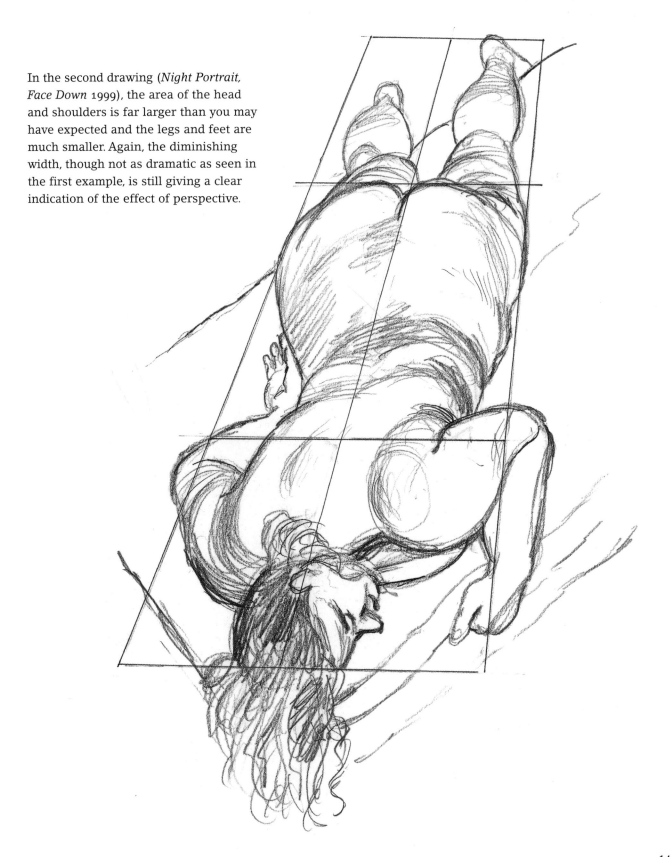

MASTER DRAWINGS OF THE RECLINING NUDE

I would now like to show you some of the finest studies ever made of the human figure and they are all on one particular theme. Since the Renaissance, the female nude has been a favourite subject for artists and here is a selection for comparison.

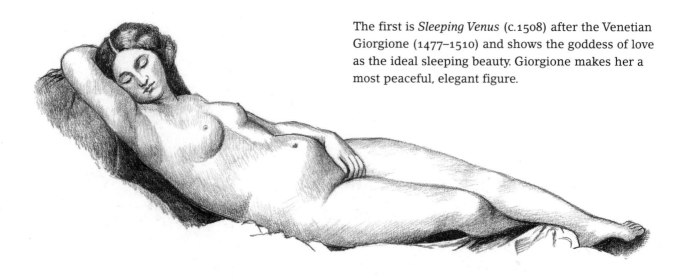

The first is *Sleeping Venus* (c.1508) after the Venetian Giorgione (1477–1510) and shows the goddess of love as the ideal sleeping beauty. Giorgione makes her a most peaceful, elegant figure.

The second picture is after Giorgione's famous pupil and collaborator, Titian (1488–1576), another great Venetian painter. Titian pays tribute to his master in the *Venus of Urbino* (c.1538). He closely follows Giorgione's pose, but on this occasion the beauty is wide awake and looking directly at us. For the time this was very unusual because the female nude normally posed modestly with downcast eyes. But Titian was no ordinary painter and he draws us into the picture with a strong element of seduction in the portrayal of his Venus.

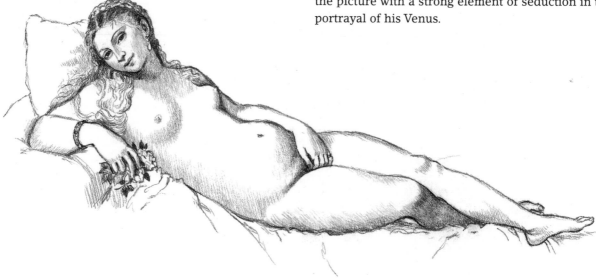

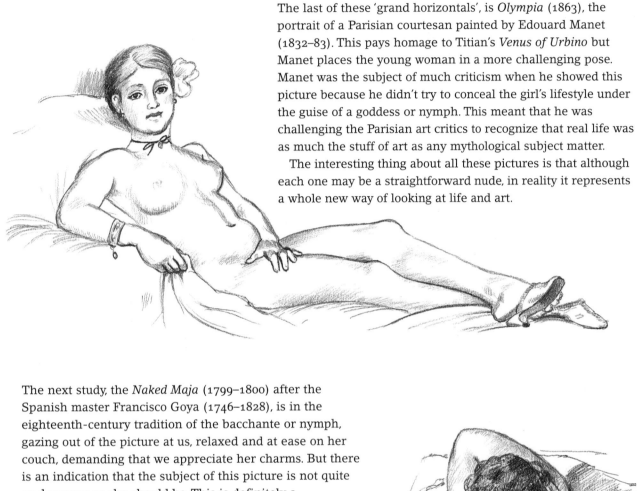

The last of these 'grand horizontals', is *Olympia* (1863), the portrait of a Parisian courtesan painted by Edouard Manet (1832–83). This pays homage to Titian's *Venus of Urbino* but Manet places the young woman in a more challenging pose. Manet was the subject of much criticism when he showed this picture because he didn't try to conceal the girl's lifestyle under the guise of a goddess or nymph. This meant that he was challenging the Parisian art critics to recognize that real life was as much the stuff of art as any mythological subject matter.

The interesting thing about all these pictures is that although each one may be a straightforward nude, in reality it represents a whole new way of looking at life and art.

The next study, the *Naked Maja* (1799–1800) after the Spanish master Francisco Goya (1746–1828), is in the eighteenth-century tradition of the bacchante or nymph, gazing out of the picture at us, relaxed and at ease on her couch, demanding that we appreciate her charms. But there is an indication that the subject of this picture is not quite as decorous as she should be. This is definitely a challenging portrait, and one that was painted for a notorious libertine at the Spanish court, Manual Godoy.

Don't worry that any pose you might choose has been attempted before: it is what you do with the standard human figure in a particular situation that will make your drawing significant or not.

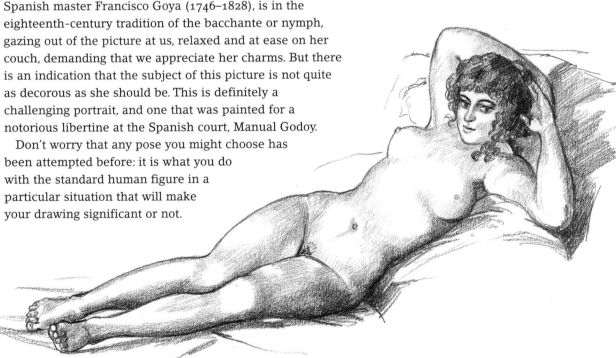

CLOTHING ON FIGURES

Among the earliest recorded clothes are the tunics, robes and togas of the ancient worlds of Greece, Rome and Egypt. Most early clothing was draped rather than tailored or cut to fit the body closely.

Ancient world

The first example (above) is just such a figure, an ancient Greek statue showing exactly the type of draped robe that I have been talking about. On this funerary image from the fourth century BC, the material is draped around the woman's head and shoulders and gathered under her arms. It both reveals and hides the figure at the same time, depending on the action of the body under the drapery.

The second figure (left) is similar in some ways, but it originates from wall paintings near Naples in Italy, executed at about the same period as the previous example. This illustration gives a clearer idea of how the clothing draped the figure, and how part of the drapery was twisted around itself to act like a belt or girdle. People also wore brooches, which attached the robe to the shoulders, and could be adjusted to create the effect that the wearer wanted. As you can see from this example, it could be a very graceful form of dress, even though we might not consider it so practical now.

The Middle Ages and the Renaissance

The next drawing (right) is taken from a fresco by the Florentine painter Giotto di Bondone (1267–1337), showing two shepherds in contemporary dress. It is very practical for the work that they do, consisting of hoods and hats to ward off the sun and rain, and short cloaks to keep them warm in cold weather. They also appear to have rather more robust footwear than people wore in earlier periods.

This example (left) comes from one to two hundred years later, showing some influence of the style of costume current during the Renaissance period. Their draped cloaks and full skirts are very similar to the classical forms of dress shown earlier, but there are more tailored features, particularly the bodices and sleeves. Also, men of this period wore tight-fitting hose.

CLOTHING AS DECORATION

The Far East

The date is the eighteenth century, but their clothing is more classical in form than the European styles of the day. This example does not so much show the evolution of costume as illustrate a different approach to the use of decorative elements. The patterns displayed on the surface of the fabric are drawn up in a manner that does not take any account of the folds in the material in any way that we might have expected. This happened, not through lack of ability on the part of the artist, but because the flat presentation of pattern on cloth was more attractive to the sensitivities of the time.

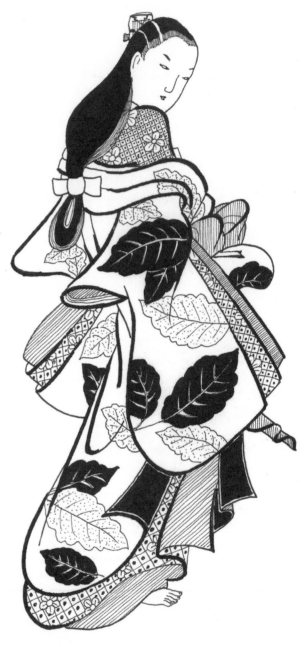

Notice how the second example, which also comes from the eighteenth century, is more softly patterned, and the drapery is shown to curve around the body. This may have had something to do with the influence of Western artefacts that were just beginning to make an appearance in the life of the Japanese (who lived through two centuries of National Seclusion).

More decoration

The English Tudor dress of Queen Elizabeth I has been drawn in a similar spirit to the two Japanese examples. The pattern of the brocade and the display of jewellery are equally as important to this picture as the impressive dress itself. Various parts of the gown were carefully tailored to mould the queen's body to a particular shape, however, the decorative aspects have been taken just as seriously as her fashionable silhouette.

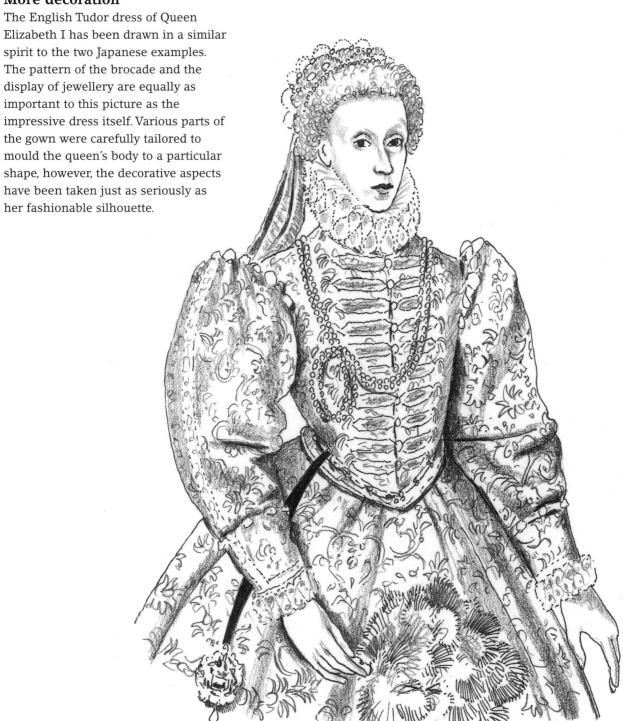

CLOTHING MADE TO MEASURE

The tailor's art

Once we reach the eighteenth century in Europe, the actual cut of the clothes becomes more important than the decorative elements.

The figure, from a picture of Warren Hastings, by Sir Joshua Reynolds (1723–1792), is fitted neatly into his closely tailored breeches and coat. Although there are still many elaborations, such as the lace at his throat and wrists and the embroidery on the coat and waistcoat, the most important thing about this sort of clothing was the way it fitted the wearer.

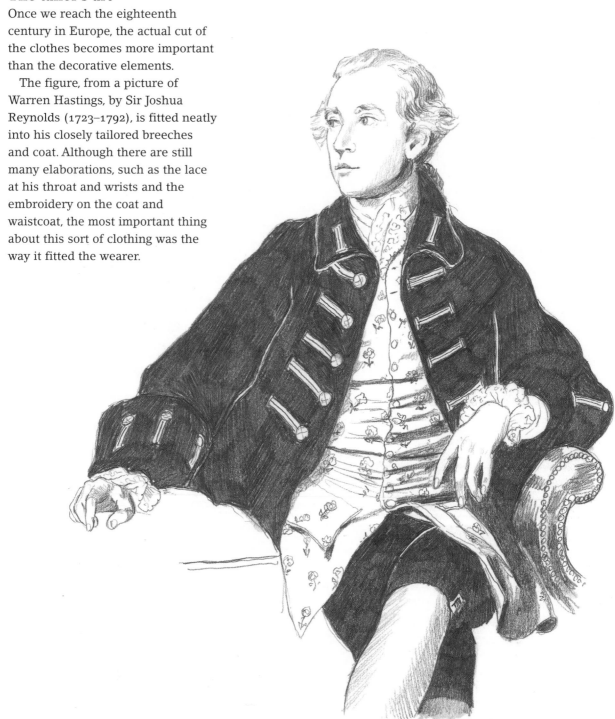

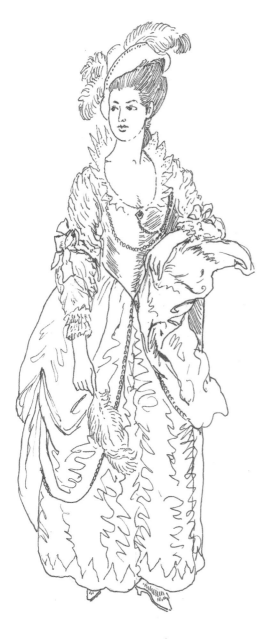

When we turn to a woman of the same period, the complex tailoring of her dress to make it look classical, in some respects, as well as form-fitting meant that the dressmaker's skills had to be of an extremely high standard. There are still many decorative features, but the main point of this sort of garment was that it had to fit well.

By the time we reach the nineteenth century, male attire was predominantly about tailoring and the fitting of well-made cloth to one's body and limbs. The more decorative elements of clothing were subordinated to the overall appearance of the cut. The British architect and engineer, Isambard Kingdom Brunel (1806–59) is wearing a top hat, fitted jacket, waistcoat and trousers, which by this time was typical daywear for men.

After the turn of the twentieth century, all over the world, the three- or two-piece suit became the male uniform that many businessmen still wear to this day. Here, the English poet and writer W. H. Auden (1907–73), is depicted wearing the typically box-shaped overcoat and wide, straight trousers that most men would wear in cold weather. Under the overcoat, no doubt he was wearing a fairly loose-fitting jacket that both covered and defined the limbs.

MODERN DRESS

Worldwide, throughout the past century, clothing has settled into an easier, more casual version of the formal styles that originated in the Western world. Stiff collars, corsets and severe tailoring have now given way to softer, looser-looking garments. With synthetic fabrics, zip fasteners, lycra and velcro, most of our clothes incorporate comfort and convenience factors undreamed of in past times.

These two examples of female attire show how much easier it is to live in modern dress than it would have been to wear the fashions of a hundred years ago.

The first girl has a skirt and jumper that fit her without being constricting, partly due to the materials they are made from.

The second girl wears a feminine-looking top but that is teamed with trousers, which until the twentieth century were worn only by men. These two young women are dressed both casually and comfortably, without loss of any decorative elements, now provided chiefly by cut and fabric.

Young men also follow the modern trend of dressing for comfort, so that even rather more formal clothing is relaxed in style these days.

The first man wears a pair of loose-fitting, workman-like trousers, made from a light material, that resemble army battle-dress. He wears them with a printed tee-shirt covered by a fleece for warmth. His shoes would probably be trainers.

The second man appears slightly more formal in that he is wearing a normal button-up shirt. His trousers are straight and narrow legged. His shoes are more formal than trainers, but still fashionable, in a soft casual style.

So, when you are drawing people, it is interesting to see how the clothing can describe, in different ways, the shape of the body underneath.

FACES AND THE HEAD

Having considered the human figure clothed and unclothed, it is time to see how the head can alter in appearance. Most changes present themselves because of the various angles that the head can assume, and the way that the hair is arranged. However, it is a person's facial expression that we notice the most, and that the artist observes all the time.

I will start by looking very simply at the shape of the head as it changes position and what effect this has on the features from the artist's point of view.

The first diagram is a simple example of what happens when a person's head is held quite still while you view it from different angles. In this diagram I've drawn horizontal lines across the three positions of the head which connect:

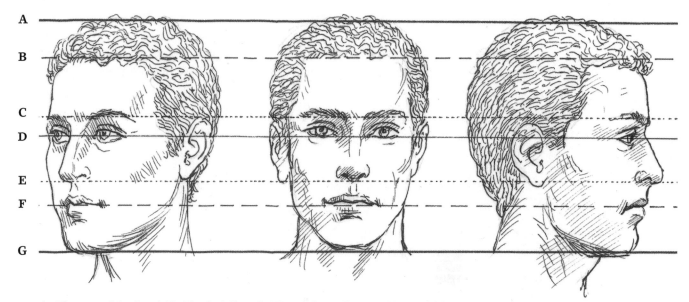

A *The top of the head;* **B** *The hairline;* **C** *The eyebrow line;* **D** *The line of the eyes;* **E** *The end of the nose;* **F** *The line of the mouth;* **G** *The bottom of the chin*

Although seen from several viewpoints, the angle of the head is the same, and so these features are all level with each other. These three viewpoints are the most commonly used in portrait work, probably because this is how we recognize people's faces most readily.

The three-quarter view is one generally favoured by portrait painters, because we can see the shape of the nose clearly and also both of the eyes. Note how the farther eye is not quite the same shape as the nearer one, but more of this in a moment.

The full-face view gives us a recognizable version of the head, but it is difficult to see what the shape of the nose is like, despite the eyes and mouth being clearly displayed.

The profile view is probably the easiest to draw, and the nose shape is fully visible. However the face is not quite so recognizable from this angle because we can only see one eye and half of the mouth.

Now take a closer look at the details of the features in these three positions.

Fig. 1 shows the eyes and mouth at three-quarters view: you will notice that the sides of the eyes and the mouth farthest from you are not the same shape as the nearest. The nearer eye is the usual shape that everyone thinks of when imagining an eye. But the farther eye, because to some extent it disappears with the curve of the head, looks much shorter horizontally. Also the farther side of the mouth appears shorter than the nearer side because, again, it is curving away from view. This little detail makes all the difference as to whether the face looks convincing or not, so you have to be aware of it.

Fig. 2 shows the eyes and mouth as they appear when you are looking at them straight on, and should not give you any problem. But just notice how the pupil of the eye sits in the space between the eyelids, with quite a bit of the top half of the iris under the upper lid, and the lower edge of the iris just touching the lower one. If you don't show the eyes like this they will appear to be stretched in surprise. When you come to the mouth, remember that the defining line is where the two lips part. Don't make the outline of the lips as strong as this centre line, or they will look as though they have been coated in some outrageous kind of lipstick.

Fig. 3 shows the profile view, and here you need to take note of precisely how the eyeball sits between the eyelids, both of which project beyond the surface of the eye itself. The mouth in profile is less than half the length it is when seen from the front. You will have to be careful not to make it overlong horizontally.

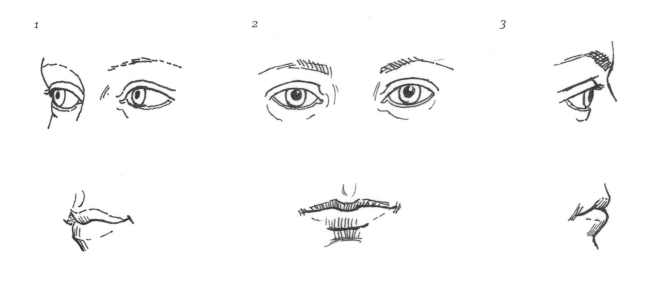

1 *2* *3*

Figs. 4 and 5 show how the eye is set between the lids, and remember that it is a ball shape.

4 *5*

HEADS, ARMS AND LEGS FROM UNUSUAL VIEWPOINTS

When the head is seen from below it appears quite different from our usual view of it; the same is true of seeing it from above. These two diagrams give you some idea as to the differences that you have to take into account when drawing them.

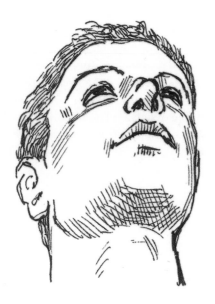

The first version is seen from below and the hair and top of the head have almost vanished from view. The nose is very prominent and the eyes emerge as just two semi-circles beyond it. The mouth forms quite a large semi-circle below the nose, and the chin displays a surface that is rarely seen. Looking at the underside of the chin, you are presented with a large area of the lower jaw. Note also how low on the head the ears appear.

Everything changes with the view from the top of the head, and what is visible is mostly the hair. The eyebrows are more prominent than the eyes and, once again, the nose juts out clearly from the face. The mouth is reduced to a mere semi-circle, following the curve of the upper and lower jaws. The ears seem less obvious from this view.

When viewed from certain angles, it is all too easy to get the proportions of an arm or leg incorrect. So it is worth taking a moment to examine these limbs to see what happens.

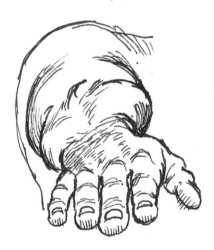

When an arm is extended as if someone is pointing at your face, the hand becomes the most prominent part of the picture. The fingertips seem larger than normal and the length of the fingers is foreshortened. The model's wrist, elbow and shoulder stand out clearly, but appear to be telescoped into one another, making the arm look very short.

The view from the shoulder end is similar in its foreshortening, but this time the bulge of the biceps and forearm make the most bulk. The hand looks tiny by contrast and it is difficult to see the fingers at all.

If you study the leg in the same way, the foot looks enormous seen from the foot end. The next prominent feature is the knee. The thigh, although quite wide, seems very short and difficult to make out clearly.

The leg seen from the thigh end seems to be all thigh, knee and foot. The calf all but disappears.

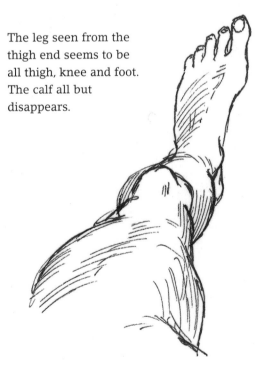

FACES AND EXPRESSIONS 1

The most interesting thing about a face is the way that it changes expression so easily and rapidly. We all watch these changes quite carefully in other people because they give the best clues to what our friends and relations are thinking about, and maybe about us. Here are a few of the most obvious facial expressions together with some suggestions for drawing them easily.

The smile

First, that most charming of all expressions, the smile: this is not quite so easy to draw as you might imagine, because it is quite a subtle image. If you make the mouth and eyes too exaggerated, the whole thing looks rather manic. So, it is important to show restraint in your drawing, marking the corners of the mouth very slightly curved, and the eyes only narrowed a little.

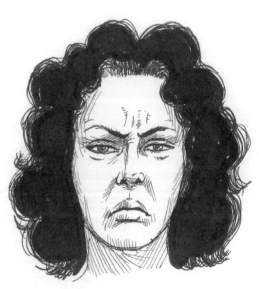

Surprise

The expression of surprise, however, is one where you can go over the top to good effect. Open the eyes so that the iris is not touching either the lower or the upper lids. Open the mouth into a fairly rounded shape and put some small lines above the eyebrows, which should be well arched. Some stress shadows around the jaw and nostrils will help portray the general air of astonishment too.

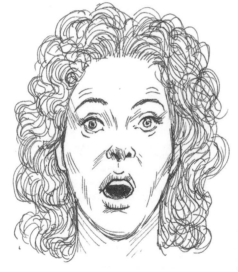

Anger

Anger is a good expression to depict because you can really let yourself go on the down-turning of the mouth and the knitting of the brows. The eyes may be narrowed, as in this picture, or opened wider to give a more ferocious aspect. Frown lines in the middle of the brow, and lines from the corner of the nostrils and under the mouth, all help to make the face look suitably lowering.

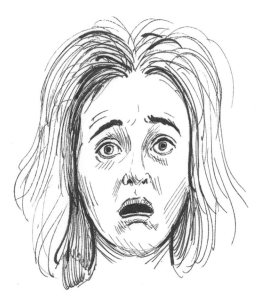

Fear

Fear is a difficult one because it is all too easy to make it look ludicrous. Make sure that the whites of the eyes show all around the irises. The eyes are wide open and the eyebrows are arched as high as they will go, with lines on the forehead above them. Shadows under the eyes also help. The mouth is open but turned down, with lines around it and the nostrils.

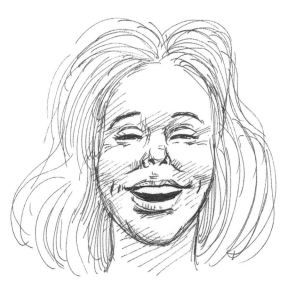

Laughter

Laughter can also look a bit mad, if you overdo it, but the key feature is the widely stretched mouth with an upturn at the corners. The eyes should be almost closed and there should be creases around the mouth and nostrils. Make sure that the cheeks are rounded and perhaps add dimples either side of the mouth.

Satisfaction

Satisfaction is a rather more subtle expression, and closed eyes that still look relaxed are a good sign. The mouth should be very gently smiling, nothing too exaggerated. The head held to one side completes the picture.

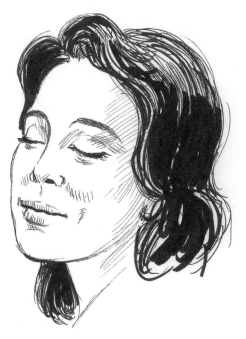

FACES AND EXPRESSIONS 2

Delight

Delight is a nice one and not too difficult. The mouth is perhaps open and curves upwards. The eyes are open too and looking at something that causes the feeling of delight. Probably the teeth should be on show and the eyes curved a little in laughter lines. But everything on the face should look relaxed and open.

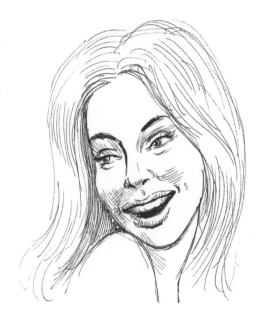

Desire

Desire is not so easy, but eyes gazing from beneath heavy lids and an open, relaxed mouth could be the best start. The head thrown back and to one side helps the illusion, and the whole pose must look relaxed. Make sure the mouth doesn't have a downward turn.

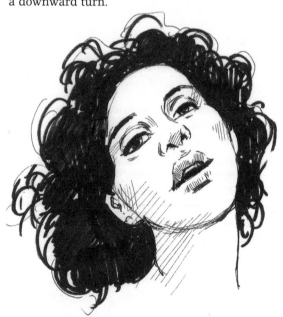

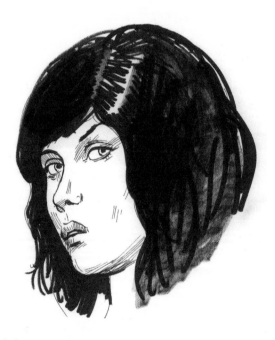

Suspicion

Suspicion is often shown with a sidelong glance and a defensive tilt to the head. The mouth might be open but there should be no hint of a smile or a grim look. The eyebrows could be arched a little to indicate doubt.

Dislike

Dislike is rather a milder form of anger, but with none of anger's force and not too many lines involved. The face should be a bit blank, but the brows should be knitted a little, and the mouth turned down. The eyes should be open but staring rather directly.

Haughtiness

A haughty expression means that the face looks as though it finds what it observes rather distasteful. Draw nothing too extreme, but arched eyebrows and narrowed eyes will help. The mouth can be open or shut but should appear downward-curving rather than upward-curving.

Come hither

The 'come hither' expression is not too difficult. The first thing is to tilt the chin down slightly. Then the eyes look more cat-like, especially with the lids lowered a little over the eyes. The mouth should have a mild smile that suggests that there is more to come and the gaze should be directed straight at you.

Indignation

Indignation is like anger but not so pronounced. The eyes can be narrowed and the mouth pushed forward a bit. No hint of humour should show on the face, and there should be few if any lines on the visage.

This is just a selection of expressions that you might like to try drawing but there are many more that you may observe for yourself.

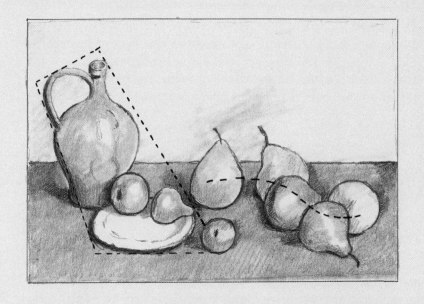

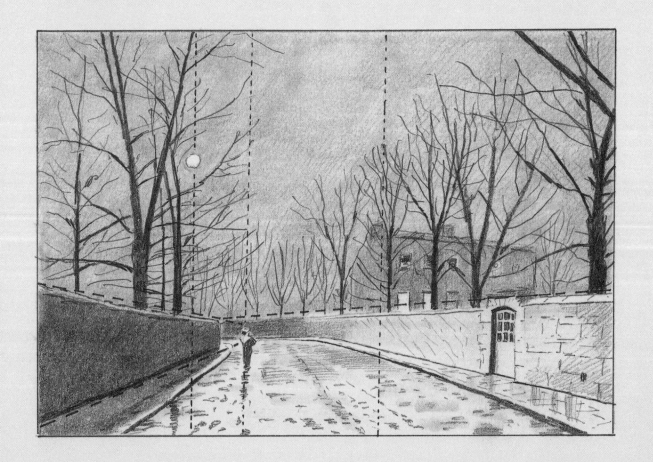

GEOMETRY IN COMPOSITION

When an artist composes a picture, the subject matter, or the objects within the frame of the picture, have to be marshalled in some way that will enable the artist to make the best arrangement. Alternatively, this could be left to chance and the picture then stands or falls by the instinctive understanding that the designer has for making a picture work. But generally, the artist decides how the various parts of the picture are going to relate with one another, and will do this by carefully arranging the main shapes of the composition in a way that he or she thinks is appropriate.

One of the most common ways of doing this without leaving anything to chance, is to use geometric relationships within the edge of the picture. So, simply dividing the area of the picture into halves, thirds or quarters might be a start. Then to relate one shape to another, you might line them up in a triangular formation or a curve, which serves to take the eye across and around different parts of the composition.

This use of geometry can solve your compositional problems and also will give a harmonious proportion and balance to the picture. It is a very old method that painters have used for centuries, to regulate their pictures and to make them more powerful. The eye naturally wants to find relationships between things and will impose some sort of pattern on to any random collection of shapes.

In the following section, I will be showing some of the ways that artists have done this in the past, and suggesting ways that you might apply this to your own work.

GEOMETRIC BEGINNINGS

*When you employ geometry to construct your picture,
it is best to start with very simple devices.*

Here are two basic geometrical figures that could be used for composing a picture.

The triangle has been used time and time again to produce extremely stable and powerful compositions, and when you go around a traditional art gallery it is interesting to note how many of the artists have used a triangular or pyramidal framework for their pictures.

For example, it provides a very satisfactory basis for a group of figures and makes a firm statement.

The circle is less used but is worth considering for creating a feeling of movement around the picture, without portraying the figures themselves in motion.

The two diagrams featuring rather
softly drawn figures give you some
idea how this might be achieved.

DIVIDING THE PICTURE

A trial approach to the composition of your picture is to divide the area with verticals and horizontals. The first obvious division is to cut it in half both ways so that you have a horizontal centre and a vertical centre. But this rarely provides a good enough balance, so the next thing is to try splitting the picture area into different proportions, such as thirds, fifths, or sevenths. These divisions, not being based on centre lines, are more satisfactory.

In the diagram, I have divided the area into squares, which are fifths horizontally and sevenths vertically.

So I have positioned the horizon line of distant hills at three-fifths from the base edge and two-fifths from the top.

The large tree feature (you have to assume that we are drawing a landscape here) divides the picture vertically at four-sevenths from the right-hand edge and three-sevenths from the left-hand one. This creates an interesting space either side of the main tree feature and places the horizon at a point where both the sky and the landscape have a strong role to play.

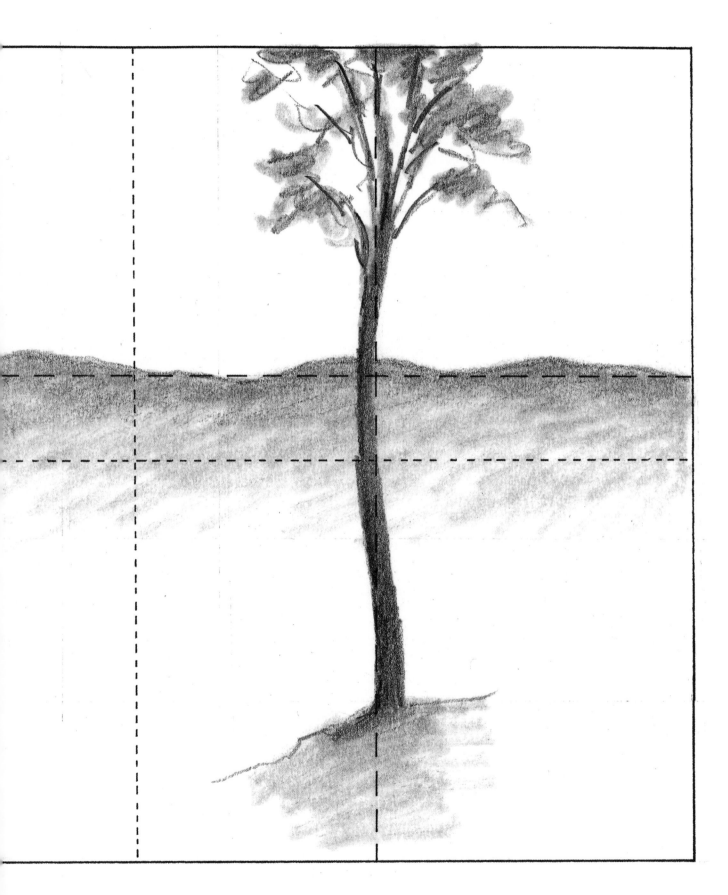

DIVIDING THE SURFACE AREA

Our first example is *London Bridge* (1905), after the French
Fauvist painter Andre Derain (1880–1954). As you can see, Derain
made a dramatic point of the way that the bridge crosses the
Thames by using a powerful diagonal, which becomes a shallow
curve along the top edge of the bridge. The horizon line is quite
high, conveying the claustrophobic effect of a large city.

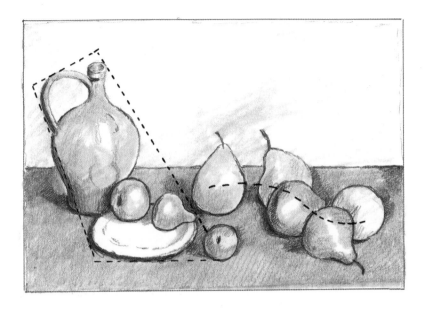

The next example is drawn from a still life by Paul Cezanne (1839–1906) where one can see quite clearly how the block of the jug and plate is set against the wavy line of the group of pears. The whole display is arranged on a table top that locates the horizon of the picture about halfway. This means that the space in the upper part of the picture becomes quite significant, and seems to be an attempt to balance out the rather solid still life.

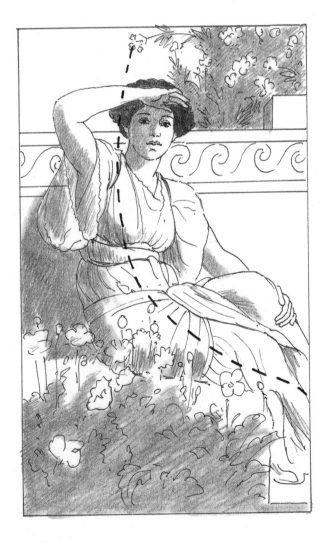

A Tryst (1912) is after the English Victorian painter John William Godward (1861–1922), who has posed a quasi-classical female figure against a wall, with flowers both behind and in front of her. The viewer's eye follows a smooth curve from the flowers in the top right corner, to the girl's head and raised arm, down through the line of her seated body, past the poppies growing below, and off to one side.

MANET'S METHOD

These two examples of the work of Edouard Manet (1832–83), *In the garden* (1870) and *On the beach: Suzanne and Eugene Manet* (1873), give us some idea of how he planned his canvases. Of course, this is an observation made after the event and shouldn't be taken as the way that he always worked out his paintings. Nevertheless, in these two instances, his mastery of composition was clearly both dramatic and successful.

In the first example, he has divided the picture area with a strong diagonal, on one side of which are seated the key figures of the man and woman, with the woman and her long skirt dominating the space. On the other side stands the baby carriage, with the baby's trailing white gown making a triangular shape that points towards the main diagonal. It may be significant that the heads of the adults are in the same (upper) half of the picture as that of the infant.

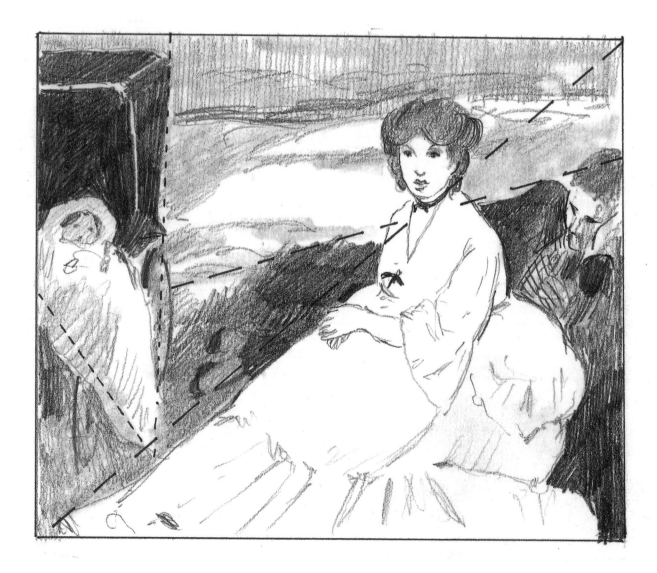

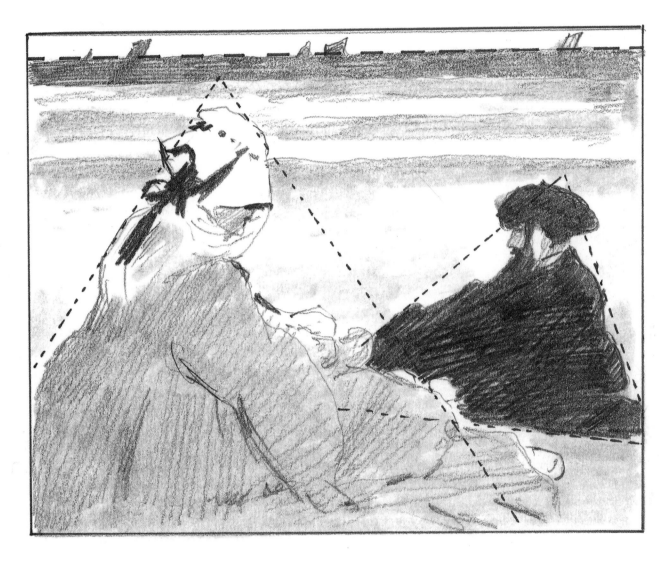

Whereas the first picture had no horizon to speak of, this second Manet, of a beach scene at Berck, features a high horizon line that places the area occupied by the sea in the top of the picture. The male and female figures are composed into larger and lesser triangles that 'answer' each other, although again the female figure is in the larger, more dominant triangle. They are both set below the level of the horizon, and the larger one sits firmly on the base of the picture.

GEOMETRY TO FLATTER

Next, we examine the works of two British painters who lived around the same time as Manet. Each of their pictures was painted specially to show off the splendour of the decoratively dressed female figures.

In my copy of *Bountiful Nature* (1897), by Talbot Hughes (1869–1942), the woman's figure forms a triangle rising from the base of the picture into the centre of the top half. All the surrounding 'props' serve to enhance the force of this dominant triangle. As you can see, I have indicated a smaller, inverted triangle intersecting the main one but this does not in any way detract from the power of the main shape.

Vanity, Frank Cadogan Cowper's (1877–1956) painting finished in 1919, is also constructed on a large triangle reaching up from the base of the picture, but with two shallow curves moving across the angle of the apex, on a level with the model's shoulders. These curves serve to soften what might otherwise have been rather too dominant a feature of the composition.

THREE'S A CROWD

The next compositions consist of three nude females, and both purport to deliver some sort of message.

The first, after Sir Edward Poynter (1836–1919), is called *Cave of the Storm Nymphs* (1903), who are presumably luring unsuspecting mariners on to the rocks. The figures are carefully composed to form a downward curve from the mouth of the sea cave to the interior. The outer edge of the cave itself echoes this curve and, with the help of dramatic shadows and highlights, the image holds together remarkably well.

This picture is after a painting by an Italian painter, Cagnaccio di San Pietro, who worked in Italy at the beginning of a period dominated by Benito Mussolini. It is called *After the Orgy* (1928) and is supposed to indicate the state of the polity after it has been seduced by Il Duce's promises of power and economic growth. The three female figures are grouped in a circle with a sort of three-pronged axis. The 'props' of bottles, glasses and hat do not interrupt the circular movement.

OUTDOOR COMPOSITION

The next three drawings give some idea as to the potential of figures and objects in a landscape and how they affect the composition.

The first example, after *Bright Summer* (1892) by the Royal Academician Marcus Stone (1840–1921), is of a garden with trees and a fairly low horizon. The picture is almost in two halves except for the strong lines that cut into the horizon. The diagonal from the tops of the trees uses the horizon as a base and divides the upper half of the picture. The small seated figure in the lower half links up with the other tree line on the right of the picture and draws the viewer's attention to the activity of the young woman seated there. This helps to create a space across the middle of the composition.

Another picture by Edouard Manet, this image is after his *View in Venice: The Grand Canal* (1874). Here the horizon is very low and the buildings rear up across the background; however, the four striped mooring posts help to divide the picture vertically in an interesting way. The line of the figure in the gondola and the buildings on the right-hand side create a diagonal across the dominant verticals. This is a static and peaceful picture even with the dramatic intervention of the gondola prow, jutting into the picture from the bottom left-hand corner.

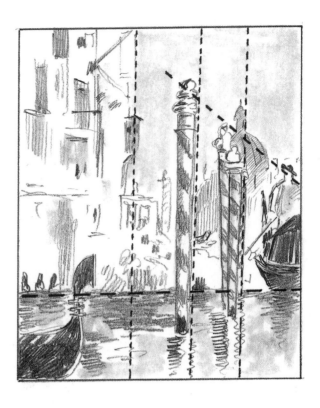

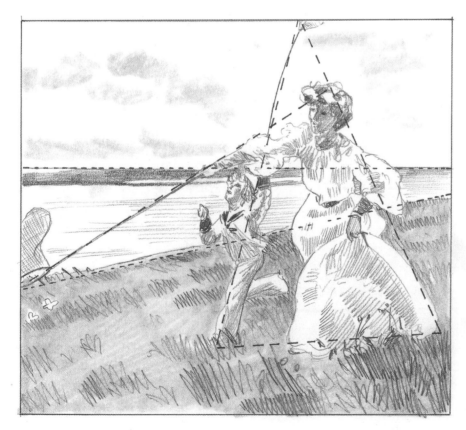

The third example, after *Butterflies* (1904) by another Academician, Charles Sims (1873–1928), is much more lively, despite using the stabilizing device of a triangle as its main figure position. With their careful positioning and angle, both the horizon and the slanting line of the cliff-edge produce a wide, open-air feel. The strong triangular combination of the young woman and the little boy doesn't detract from the activity of butterfly hunting. The outstretched arm of the woman cuts into the main triangle quite dramatically and effectively puts the dynamic into the scene.

CREATING DEPTH

Our next pair of pictures shows how a good artist can take up his position in the landscape to create an interesting spatial relationship between the viewer and the scene.

John George Naish (1824–1905) sets his scene behind the sea wall of a small harbour in the Channel Islands, *Le Creux Harbour, Sark* (1858). Cutting out any deep sense of landscape are the rocky cliffs and then to the left is a large wall, casting a shadow across the water. Near the foreground some boats are moored, and just about to disappear behind the harbour wall is another boat with two men in it. So although we are aware of how spacious the harbour is, it is carefully circumscribed by the wall and the farther rocks.

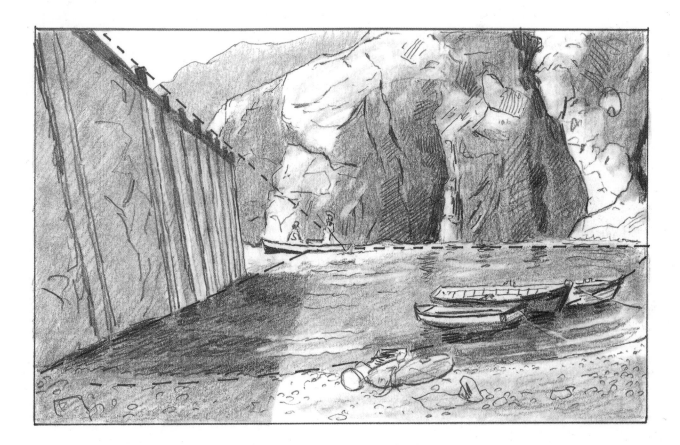

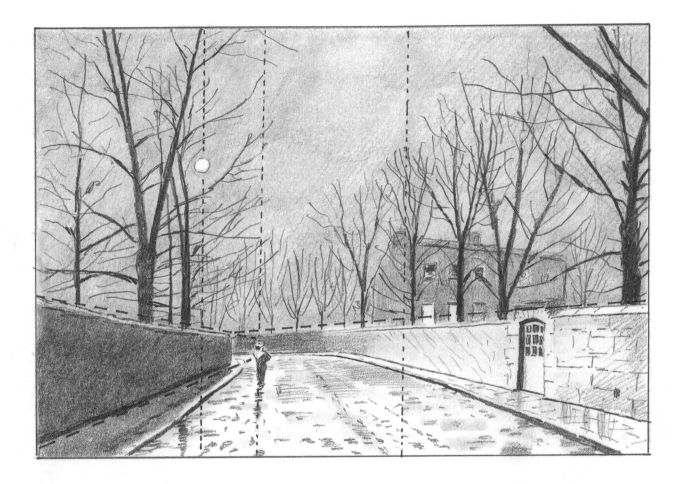

This picture, after John Atkinson Grimshaw's (1836–93), *Old English House, Moonlight after Rain* (1882), is one of his marvellous night scenes where the moonlight plays a significant role. The walls on either side enclose the road as it recedes from our viewpoint, and the bare trees emphasize this movement away from us. The light reflected off the wet road and pavements draws attention to the way the space in the picture takes the viewer in. The vertical divisions that I have marked demonstrate Grimshaw's achievement of depth: the distant moon, the retreating figure, and the house visible over the wall in the distance.

So, as you can see, the use of geometry is useful and can make the difference between an unremarkable picture and something that really catches our notice. It seems that our minds quite like to consider geometrical propositions, even if we are not totally aware of them.

SETTING UP A LANDSCAPE

When starting to paint and draw, one of the first subjects that we think of trying is frequently a landscape of some sort. This is because 'landscape' is always there and doesn't have to be persuaded to pose for us.

It is a good discipline, the weather changes – sometimes radically – and so the same scene can present itself in many variations of light and colour. One advantage to landscape drawing is that unless your friends and critics are actually seated alongside you, they will not be aware of any of the things that you may have altered to make your picture more interesting or easier to draw.

It will still look like a genuine landscape as long as your perspective is all right and the vegetation is reasonably drawn. So take heart in this, the most attractive of subjects for the aspiring artist.

However, there are a few rules that you should adhere to in order to produce the best results.

You do not have to travel far. Immediately outside your house is a landscape waiting to be discovered. It might be the view from your window; the garden behind your house; or the street in front of you. Somewhere nearby there is usually a park, or gardens open to the public. Maybe a short walk or drive from home will bring you to open countryside. You don't have to go to a specific area of natural beauty that artists have painted before. The artist learns to see beauty anywhere, even in the most unlikely circumstances.

So, make the effort to explore your own neighbourhood. There's no saying what you may accomplish. You might even make it famous, like John Constable with Suffolk, or Edouard Manet with Giverny, or Newell Convers Wyeth (1882–1945) with New England.

Going on holiday always provides a good opportunity to explore a landscape that you may not have seen before, so don't forget to take your sketchbook. A sketchbook is invaluable for an artist, because a record can be made of any thing or place that attracts the attention. Equip yourself with a handy pocket-sized sketchbook, as well as a larger one for more considered expeditions.

LANDSCAPE VARIETY

Here are a few examples of how you might approach various scenes.

In this view, the landscape takes up almost the whole area of the picture, leaving only a small strip of sky at the top. This is a typical high-horizon view, and eliminates very much interest in the heavens. It is the way that you tend to view a landscape when you are in an elevated position. Because you can see more, you will want to draw more. It may create a mild sense of claustrophobia, but can also lead to a detailed and interesting landscape.

This view is quite the opposite because the observer occupies a relatively low position and the horizon is therefore also very low. This brings the sky into the picture, and you might find it more interesting when there are some good cloudscapes to draw, rather than on a totally clear day. What this view gives is a great sensation of space.

The next one is an interesting mix of fairly high horizon level and lots of open space in the shape of the sea. The two headlands are the main feature of the landscape but it is the sea that really forms the picture. The noticeable depth in this view has everything to do with the perceived distance between the two headlands. This sort of landscape also gives you a chance to work on the representation of water.

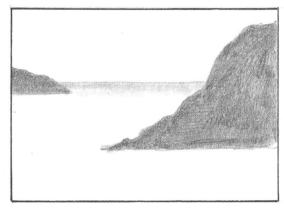

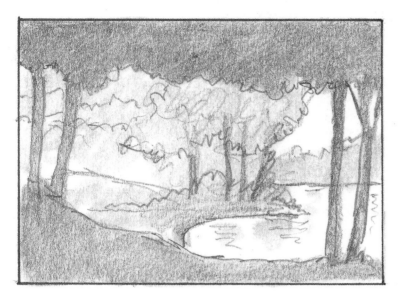

This landscape is enclosed by the grouping of trees around a stretch of water. The viewpoint is from beneath the trees on the bank. The other trees across the small inlet tend to obscure any horizon line; you can just see it to the left, where you get a glimpse of the opposite bank. This composition is almost a vignette because of the frame created by the closest trees.

This is a classic case of the path or roadway pulling the viewer deep into the picture. The fence emphasizes this movement, as does the row of trees alongside the road. They naturally draw attention to the little group of cottages at the end of the path. This is a very popular device used by the landscape artist to get his audience to engage with the scene.

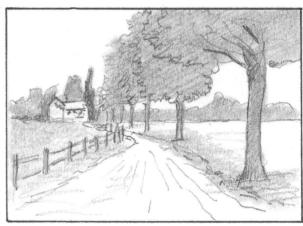

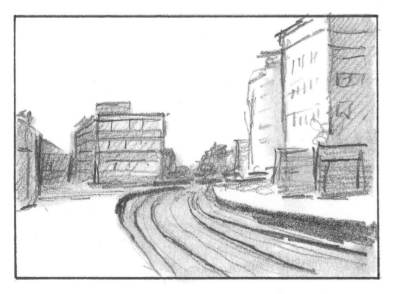

The final example is similar to the image directly above, but sited in a purely urban environment. Here, the exact position in which the artist sets up is critical, because the size and position of the buildings change quite radically with the vantage point. This is another situation in which a viewfinder, as shown previously (p 15), would be of great use. It's a good idea to have the large building on the right, cutting into the top of the picture, because it helps to give an impression of greater depth between the viewer and the building near the centre of the picture.

These examples are a taste of the possibilities available when drawing landscapes.

LOCATING THE SCENE

To show that you do not have to travel vast distances to gain plenty of good landscape experience, the next drawings were made within a few hundred yards of the same location, situated within a small area of the county of Surrey, England. Some of them were observed by the artist staying on the same spot and merely turning through about forty-five degrees. Some were done by walking a little way along a path to obtain a different view; the point is that if you happen to find yourself in a place of great natural beauty, there will be hundreds of different aspects within a very small area.

The first landscape view is full of trees and fields that recede towards the misty hills on the horizon. Notice how high the horizon line is, because of the elevated vantage point from which the drawing is being done.

The next picture is similar in concept but quite different in texture and depth. The fact that the view is directly down a fairly steep hill helps to give something else to the scene.

LOOKING AROUND THE SCENE

The next one is still in the same area but now the light has changed. The closer hills, topped with trees, are almost silhouettes against the skyline and you seem to be able to look around a corner of the high ground to other hillsides beyond. This is quite a gentle landscape, but can be interpreted dramatically depending on the time of day. The little groups of buildings, seen in the mid-ground, act as focal points.

The last drawing is of a place about one hundred yards from where the previous drawings were done. However, it looks very different due to the inclusion of part of a wire fence situated close to the onlooker, and also due to an alteration in format, from landscape (horizontal) to portrait (vertical). In this picture the sky becomes more important.

BLOCKING IN·THE SCENE

When drawing an urban landscape you don't have quite the freedom that you have in a rural setting, because the buildings will force you to take note of their rectilinear formality, and so a certain amount of discipline is necessary in dividing up the picture.

Here is a typical London street scene, where the architecture displays rather a muddle of styles and is structurally varied. The side of the central building is awaiting the addition of new ones, which will butt up against it when they are ready. There is a space that, although temporary, helps to show off the balance of the existing structures. In the left background is a fairly new building, stacked up a little like a ziggurat. To the right is the edge of another new building, which is suitably blank and gives a good clean edge to that side of the picture. In the foreground, there is enough street width to afford the viewer reasonable space between their viewpoint and the nearest building. To make the drawing easier, you should block in the simple outlines of the main buildings facing you. When you have done this you can go on to the next step.

Now you need to put the main areas of tone on to the faces of the buildings, being sure to differentiate between the surfaces facing the light and those turned away from it. This helps to give solidity to the buildings and you will find that they look more convincing. Then you can put in all the detail necessary to give the scene a sense of occupation – windows, doors, street lamps and anything that gives local colour to the street – otherwise the buildings will look too stark and unusable. The empty side of the central building is all that needs to be left bare.

LANDSCAPE CHOICE

The dimensions of a landscape can appear daunting for sketching and drawing purposes, but it is in fact up to you how much of it that you draw.

The example given here is a composite, based on the drawings of the leading French landscape painter, Claude Lorraine (Gellee) (1600–82). This panorama may contain more than you want to tackle. The solution to such an abundance of material is to select a portion that you think might work best for your picture.

I have divided the whole landscape up into three distinct scenes, each of which overlap one another.

A The first scene is to the left side of the panorama, and includes a part of the central group of trees. It provides quite a pleasant vignette effect, with the landscape framed between the two tree clusters.

B The next scene forms the central part of the panorama, in which the grove of trees becomes the focal point. The background stretches out behind them, giving the picture a sense of depth.

C The final scene is from the right-hand side of the panorama, once again framing the composition between two overhanging trees, which neatly encompass the distant seascape.

So, from a single panoramic view, one can easily pick out three, if not more, landscape themes. This goes to show that you should never be daunted by the amount of material available to you; some intelligent selection is all that is required.

LANDSCAPE PROJECT: STEP ONE

Choosing a landscape to draw is always a more difficult proposition than arranging a still life, because you have to go somewhere that you like the look of and this may take some preparation. Possibly the easiest way to decide is when you are going out for a day in the countryside with friends who will be willing for you to stay and draw while they go off for a walk. One day my wife and I and two friends of ours went to look at the old church in Chaldon, Surrey, which has a large medieval mural. While the others spent some time inside with the mural, I wandered around the immediate neighbourhood to survey the landscape.

View A

My first view (A) was of the path and road that swept away from the front entrance of the small church. It was really just a view of trees and the paths and a hedge down one side. In some ways it was almost too simple but I liked the way that the division in the paths created a natural focal point for the whole composition. So I drew it.

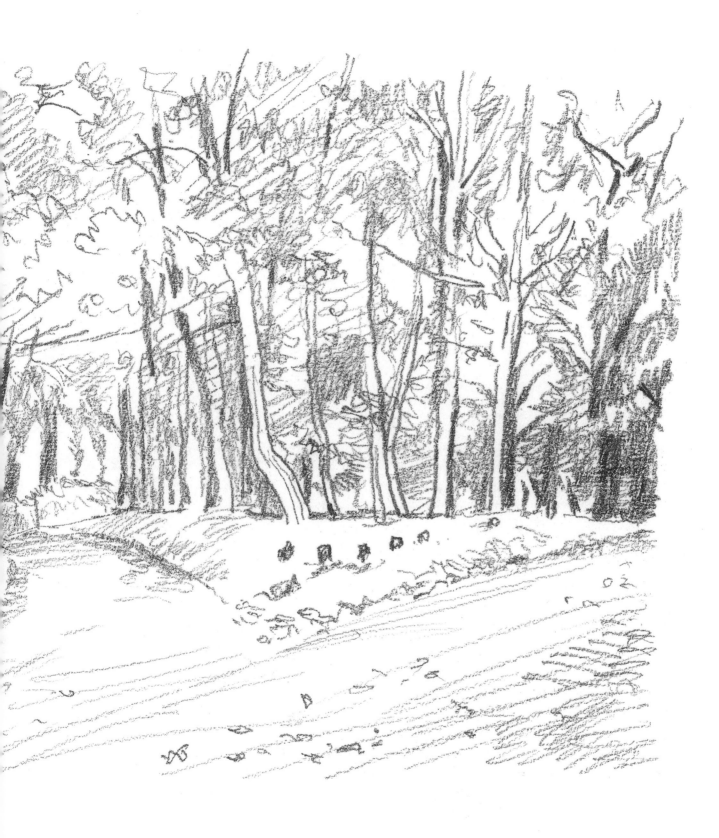

LANDSCAPE PROJECT: STEP TWO

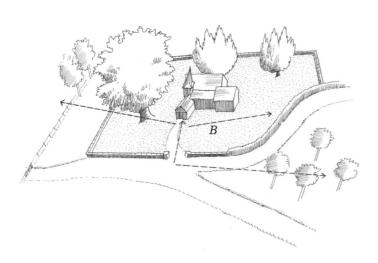

View B

The next view that struck me was (B), looking from
the front door of the church across several
gravestones towards some very dark cypresses or
yew trees. This view also took in some of the church
wall at the left-hand edge of my drawing. The worn
shapes of the gravestones gave a venerable look to
the scene, and the dark trees in the background set
them off well. There was also a more extended
aspect to one side of the picture, which gave focal
depth to the composition.

LANDSCAPE PROJECT: STEP THREE

View C

After (B), I just turned around and looked in exactly the opposite direction, which turned out to be view (C). That included a very large, mature tree with a view beyond the churchyard, towards the fields close by. There was a screen of younger trees that formed a backdrop to the mature one in the nearer part of the churchyard. A low wall separated this great tree from the others with a small open space, giving some balance to the picture. It was a fairly grey day, and the mature tree, set darkly against the paler grey of the others outside the wall, made a good contrast.

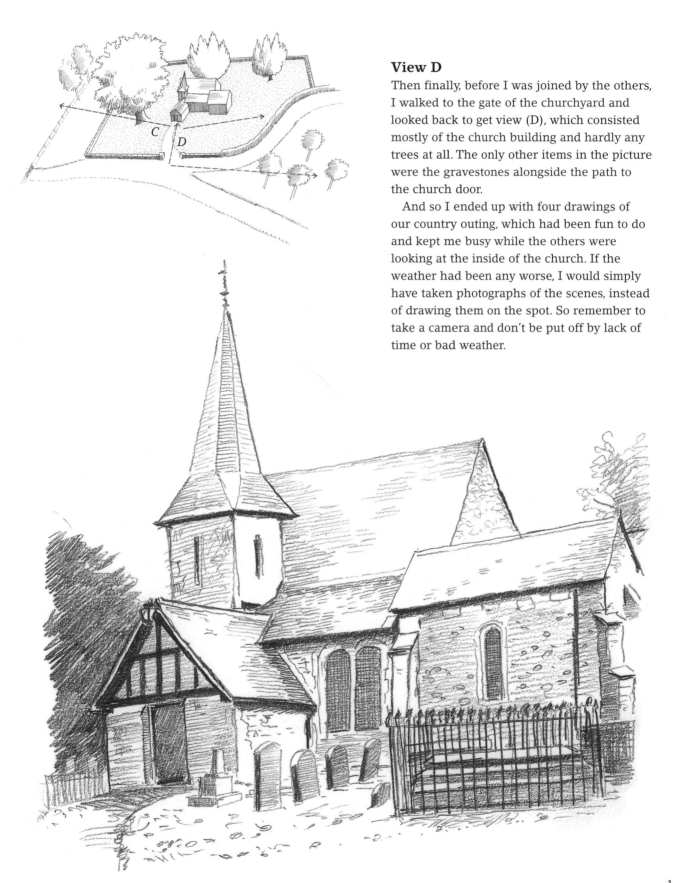

View D

Then finally, before I was joined by the others, I walked to the gate of the churchyard and looked back to get view (D), which consisted mostly of the church building and hardly any trees at all. The only other items in the picture were the gravestones alongside the path to the church door.

And so I ended up with four drawings of our country outing, which had been fun to do and kept me busy while the others were looking at the inside of the church. If the weather had been any worse, I would simply have taken photographs of the scenes, instead of drawing them on the spot. So remember to take a camera and don't be put off by lack of time or bad weather.

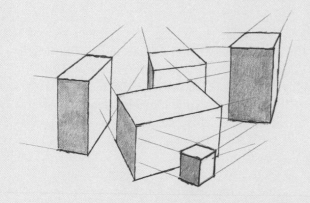

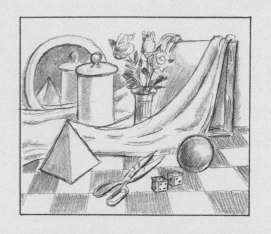

SETTING UP A STILL LIFE

When you come to draw still life, it is only natural that, after practising with anything to hand, you will want to start using objects that have rather more interest for you, even things that have significance in your own life. This is all to the good, because it leads you to consider how a still-life project should be set up, and why. Generally speaking, there are two quite distinct approaches to the subject, one being aesthetic and the other more symbolic.

The aesthetic approach consists of considering only how the objects that you have collected together will work as a whole, in terms of the composition of the picture. For example, you might want a very spare, empty-looking still life, and consequently select your objects with an eye to their shapes and how they would appear within the picture area. The shapes of the spaces between the objects ought to be as interesting as the objects themselves, and so the relative position of each object in the picture space would assume importance.

On the other hand, you might want a very crowded composition, with heaps of things all vying with one another for attention, lending a feeling of abundance to the picture. In this case, their relative positions would not be so significant except in the way that they fit against each other and how they could be differentiated in the mass. Neither of these compositions needs necessarily to have a particular theme, just to be an interesting arrangement of objects.

With the more symbolic approach, the objects would in fact become very important for getting your theme across. You would not have anything in the picture that didn't contribute in some way to the story or theme that you were trying to convey. So, in the aesthetic kind of picture the objects would be chosen to make an arrangement pleasing to the eye; and in the symbolic, they would all have to contribute to the underlying theme.

One of the great advantages of still life is that the objects you are drawing will not complain if you keep them in place for days on end, until you are satisfied with your efforts. Artists down the ages have practised object drawing, keeping their hand and eye in with a control over the finished article that is not found in other genres. It is the easiest type of drawing to organize and that is why it is so popular.

SOME STILL-LIFE APPROACHES

Here I show six ways of approaching still-life subjects, and although this is not by any means the end of the story, these will give you some idea of the variety of choice.

The first picture concentrates on a single shape and repeats it several times in a group at the centre of the composition. All the objects are cylindrical and close in size to one another. Nothing stands out on its own; it is the group that matters as a whole. There is no theme, except for the aesthetic satisfaction that it gives to the eye.

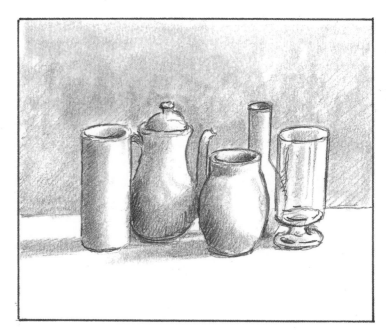

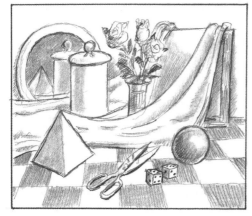

The next picture is not themed either, but is an attempt to create an interesting composition with objects unrelated to one another, except possibly in size. The idea is similar to the first picture, but with objects of different shapes spread out across the space more extensively. Here the particular quality of each object is important in producing an interesting group.

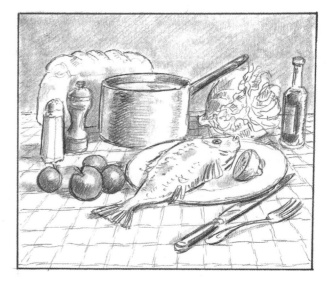

This example is a themed composition using objects associated with cooking a meal. There are various foods such as fish, bread, tomatoes and cabbage, and things like saucepans and cutlery and condiments. So there is a sort of story to the picture, which suggests that we are witnessing the initial stages in the preparation of a meal.

The next example is also themed but with a less enclosed look to it because we can see through a doorway to a drive beyond the room, where a car is standing. This suggests that someone is about to go off on a journey or has just returned from one. All the objects seem to be related to travel in some way.

The next picture is a type of themed composition but less 'arranged'. It has the look of a random collection of items left by someone who was recently present. It could be a group of objects that you might see lying around untidily at home, not yet cleared away. The treatment of space is crucial and the objects take on added importance.

The last picture is more symbolic than the previous examples because it seems to hint at art and literature being like a candle and shining light upon us. The arrangement covers the whole area and each object is part of the message, including the vase of flowers, which adds the right natural note to the still life.

SEEING THE STRUCTURE OF STILL-LIFE OBJECTS

Here are a few ways in which to simplify the arrangement of still-life groups when faced with a collection of objects.

First consider rectangular objects and note how the position of each block relates to the perspective view. This will help to place them in some relation to each other.

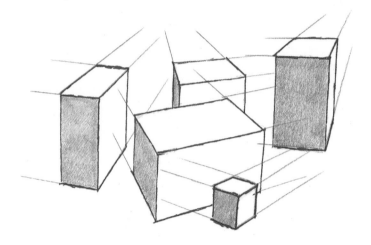

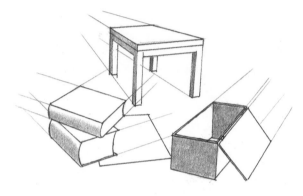

In this drawing, the blocks have been replaced by objects such as books, boxes and a table. The one thing that they will have in common is the eye-level.

The next group of objects is based on the shape of the cylinder, a common feature of many still-life objects chosen by painters. The main thing to observe here is to connect them by their perspective and also their roundness of form.

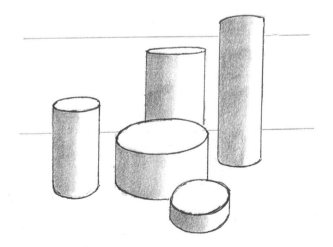

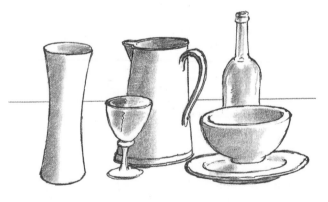

These objects are a vase, wine glass, jug, bottle and a bowl and plate. They all present elliptical shapes and that factor helps to hold them together.

The next group is based on
spheres, which of course means
that you will have to look carefully
at the way that the shading
indicates the form.

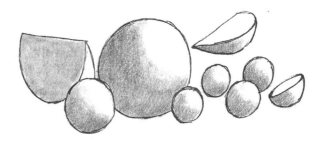

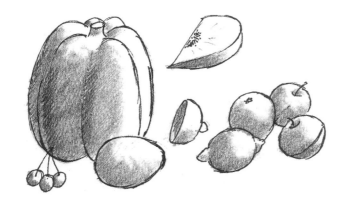

Probably the most frequently used
spherical objects in still life are
fruits. Here are a pumpkin, melon,
lemon, apples and oranges – and
an egg, for practice. Cross-sections
give added interest and reveal
fascinating patterns.

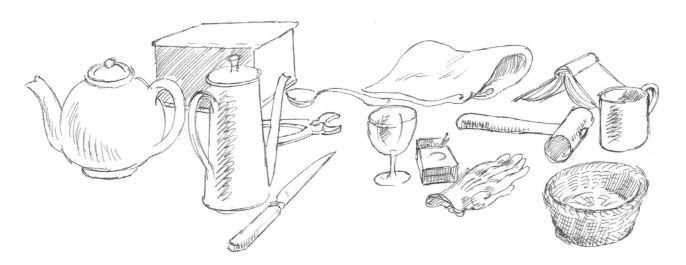

Looking at a whole selection of objects that might be used in a
still life, the variety of shapes makes for even more interesting
arrangements. Sometimes you might limit the shapes to a few
that appear sympathetic to one another, at other times you could
contrast them as radically as possible. But whatever you choose,
you have plenty of scope for very different effects.

HISTORICAL COMPOSITIONS: TABLETOPS

The history of still-life painting is the story of what was once considered the lowest register of artwork; the hierarchy being history painting at the top, then portraiture, followed by landscape painting, with still life coming fourth and last. Since discovering still-life painters like Chardin and the seventeenth-century Dutch school, the more perceptive collectors of art have raised our appreciation of the genre rather higher, with history painting taking a back seat.

So let us consider a few examples of still-life progress; my pen drawings give the shape and layout, but none of the depth and richness of the originals.

Still life with Cherries and Strawberries in China Bowls (1608) after Osias Beert (1570–1624) shows how the Flemish artists of the seventeenth century laid out their compositions in an abundant style filling the picture with a number of objects of repetitive shapes. The decorative glasses of wine and the porcelain bowls of fruit are set against a mainly dark background, with a few scattered additions like knives, bread rolls and cherry stalks. It is essentially a straightforward demonstration of the artist's painting ability, intended to attract more commissions. Many artists served their apprentice years as still-life painters in order to make a name in the business.

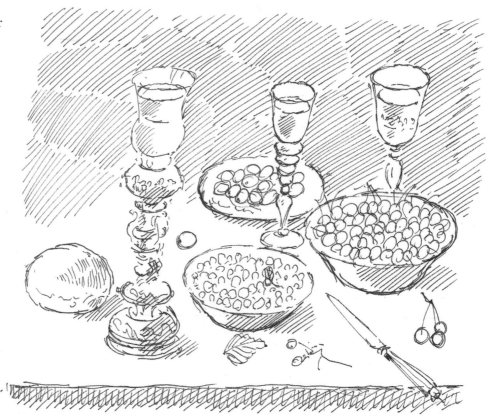

The work of the Spanish master Francisco de Zurburan (1568–1664), *Lemons, Oranges and a Rose* (1633) takes a slightly different approach to the genre. He has limited his objects to three pieces, laid out along a shelf or narrow table. The brilliant lighting of the objects throws them out in stark relief against the very dark background. This graphic approach to the design of the picture makes it almost modern in flavour. The colours of the citrus fruits in the original are strong and bright, and the whole composition makes a powerful statement.

Willem Claesz Heda (1594–1680), painter of *Still Life* (1651) was a very successful artist in his own day and this sort of picture was much in demand by appreciative patrons in Flanders and Holland. The background is not as dark as in the two previous examples, and the assemblage of food and utensils on the table top looks rich but slightly chaotic. As a painter, Claesz had great powers of observation, producing textures and surfaces so realistically that it still seems one could reach out and touch them. The subtlety of his work has rarely been surpassed.

HISTORICAL COMPOSITIONS: DECORATIVE STILL LIFE

Next, we step back in time to the work of German Renaissance artist Ludger tom Ring the Younger (1522–83). His *Vase of Flowers with White Lilies and Brown Iris Blooms* (1562) depicts a marble vase of formalistic flowers against a dark background, very decorative and one of several pictures that he produced in the same period. They were probably intended as panels for a decorative chest or wall covering and are not quite as realistic in method as the others that we have examined.

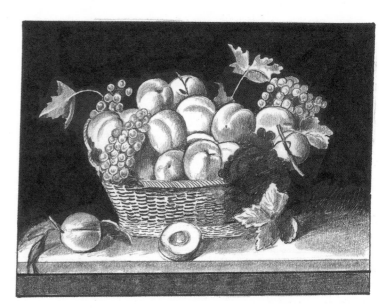

The piece by the French painter Louise Moillon (1610–96), *Basket with Peaches and Grapes* (1631) is another from the seventeenth century, and shows how the single decorative theme of a basket of fruit has moved on from the piece by Ring. The handling of the surfaces of the fruit and leaves is much more convincing than that of the century before and the understanding of the shadowy parts of the composition, giving more feeling of depth to the whole picture, is notable.

Another century later, and the work becomes even more realistic in this drawing after Pierre Nicholas Huillot's (1674–1751) painting, *Still Life of Musical Instruments* (1740). The theme of music and other professions was very popular at this time and had built up quite a history of development. Not only were such pictures a sign of your cultural background but they became increasingly natural-looking (or 'trompe l'oeil'), so much so that the effect was of having a few real musical objects strewn across a shelf in the house.

HISTORICAL COMPOSITIONS: ENDURINGLY EFFECTIVE

Now we come to Jean-Baptiste-Simeon Chardin (1699–1779), the great exponent
of still life that the discerning collectors of the eighteenth century would prefer
to the much vaunted history paintings. Even in his own lifetime, Chardin was
admitted to be an artist of the highest class. In this example, *Water Glass and Jug*
(1760), he shows a simple arrangement of a glass of water with a pottery jug
accompanied by a few cloves of garlic on a wooden top. The depth and elegance
of the composition is quite masterly.

Moving into the late nineteenth century, age of change and experiment, Paul Cezanne's *Nature Morte* (1895) shows how artists have progressed to a point where merely representing the substance and texture of objects is no longer the main concern. Here the traditional still-life arrangement has been revolutionized by the quality of the paint and colour values. No longer is tricking the eye (trompe l'oeil) enough to satisfy the post-Impressionists, and Cezanne is held as one of the founding figures of modern art.

STILL-LIFE PROJECT: STEP ONE

While considering this project I looked around my own house and garden, to choose objects that would be readily available in most households. I finally decided that I would set up a still life with a gardening theme. One reason for this being that the objects would be fairly large and most of them were just standing around waiting to be drawn.

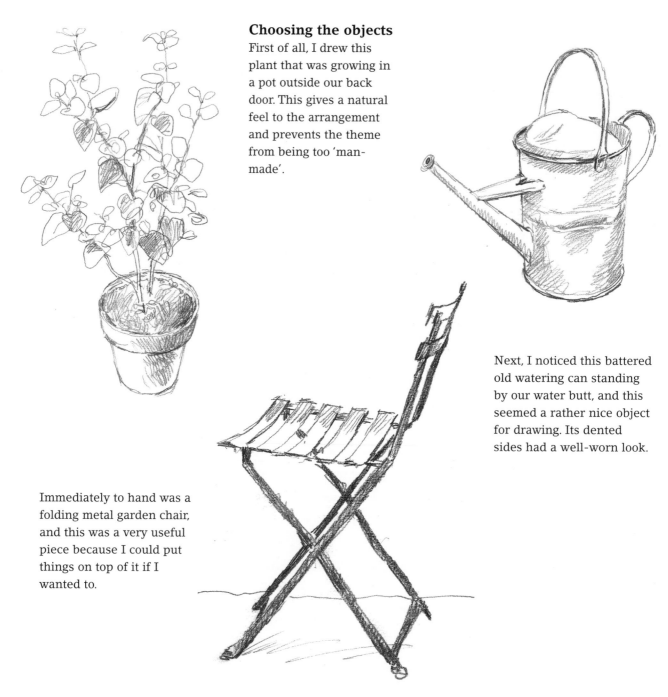

Choosing the objects

First of all, I drew this plant that was growing in a pot outside our back door. This gives a natural feel to the arrangement and prevents the theme from being too 'man-made'.

Next, I noticed this battered old watering can standing by our water butt, and this seemed a rather nice object for drawing. Its dented sides had a well-worn look.

Immediately to hand was a folding metal garden chair, and this was a very useful piece because I could put things on top of it if I wanted to.

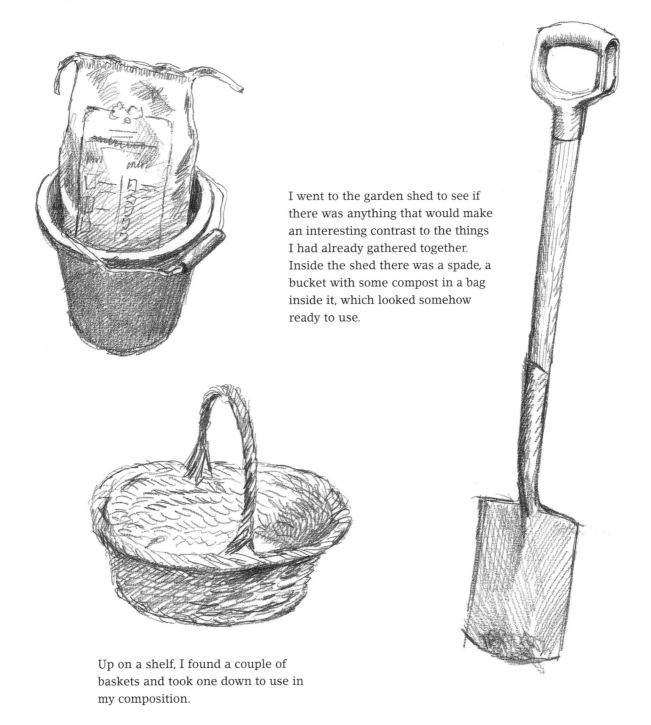

I went to the garden shed to see if there was anything that would make an interesting contrast to the things I had already gathered together. Inside the shed there was a spade, a bucket with some compost in a bag inside it, which looked somehow ready to use.

Up on a shelf, I found a couple of baskets and took one down to use in my composition.

STILL-LIFE PROJECT: STEP TWO

Then I went inside the house for a moment, thinking that perhaps some clothing associated with working in the garden might be a good idea, because it would add a human, just-been-here touch to the scene. So I selected a waterproof jacket and an old hat as part of this arrangement.

I had eight objects associated with gardening, and I now needed to look at them all together to see if I could arrange them in a way that looked natural, as if it might have occurred without design.

Checking out the composition

I first put my objects down in the doorway of the garden shed, with the metal chair in front of the open door and the waterproof jacket and hat slung over the back. Then, in front of these, I placed the spade lying on the ground, and the basket and watering can in front of that. At the side of the chair, I stood the potted plant. This looked OK but I wanted to try out some other arrangements as well.

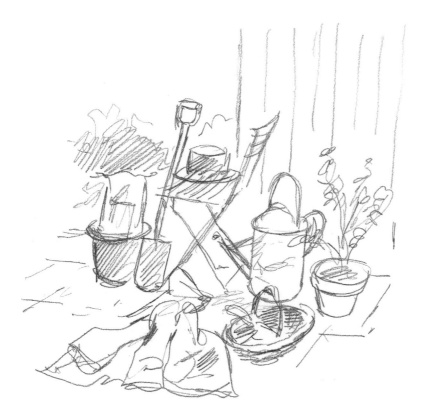

My second trial arrangement had the chair in the doorway of the shed again, this time looking through it, with only the hat on the seat. I leaned the spade upright against the chair and placed the bucket with the compost bag next to it. On the other side of the chair I stood the watering can and beside that, the potted plant. I placed the basket in front of the can, and lastly I threw the jacket on to the floor of the shed as though just discarded. This seemed a bit better than the first arrangement, because I had been making quick sketches of them as soon as I had put them in place. I could also have photographed the objects, in order to remember what the arrangements looked like.

The third attempt at a composition brought everything much closer together, with the chair draped in the coat and the hat hanging on its back, the spade leaning on the chair, the watering can in front of it, and the bucket with its sack of compost and the basket almost tucked behind the chair. The potted plant was half hidden behind the watering can. I did not feel very satisfied with this arrangement and returned to the second one, which I felt held more promise.

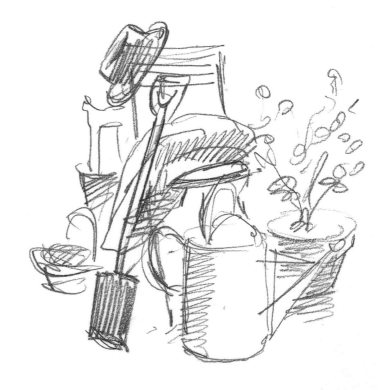

STILL-LIFE PROJECT: STEP THREE

The final set up

Once again, I put together the objects in the second arrangement and this time I noticed how the light coming in from the shed doorway produced an interesting effect. Carefully drawing the whole thing, I first made sure that the relative sizes and proportions of all the different objects had been observed properly, and that they overlapped one another in a pleasing way. How you decide to do this is up to you, but be sure that when things overlap in an arrangement, the amount that remains showing is important. So, don't hide too much of anything, and do check to see if the way they overlap looks agreeable and not awkward.

Now it is your turn to choose your objects and have a go at this exercise. It is quite good fun because you decide how the final composition is going to look, and that is part of the creativity of drawing.

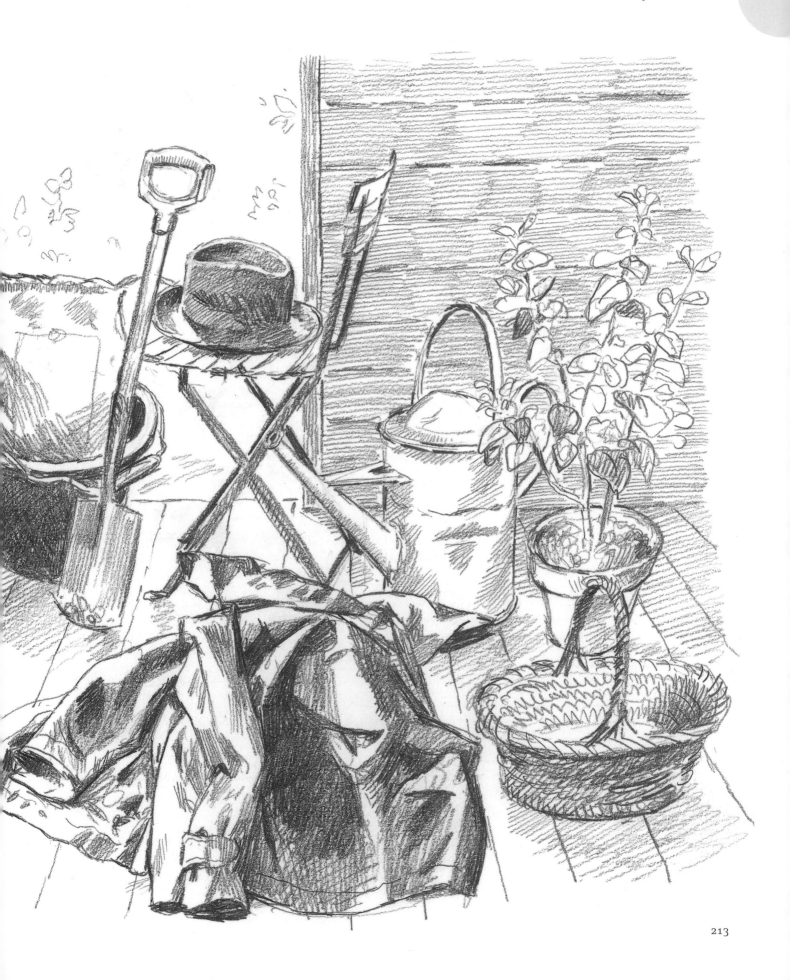

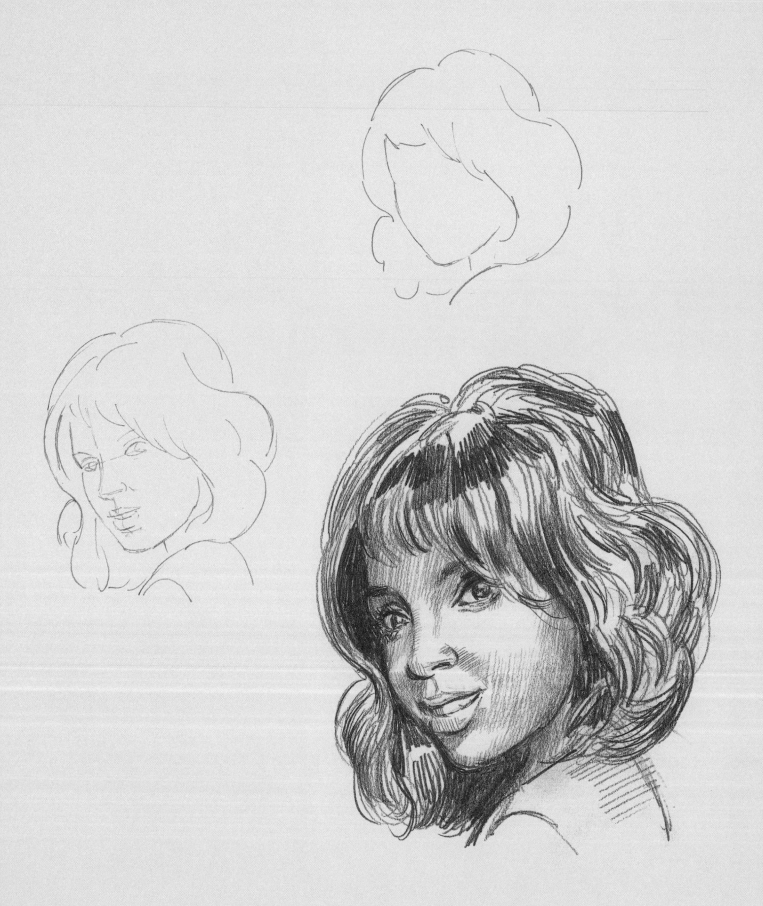

SETTING UP A PORTRAIT

Portraits have always been the test of an artist's worth. If a drawing of someone's face is convincing enough, the general public is fairly well-disposed towards the claims of the artist to know what he is doing. This isn't necessarily the view of those with a wider knowledge of art, but does have some point to it.

Quite often it is the human face, above all, that the beginning artist would like to be able to draw well. It is an excellent way to interest your friends and relatives in the process of drawing, and one where they will always have an opinion. It is immediately apparent to us all as to whether the drawing of the face resembles the person it is supposed to represent; it is equally obvious when it has gone wrong in some way. So at one and the same time, it is one of the most popular areas for the artist to work in, and also one of the hardest to impress your acquaintances with. This means a lot of hard work is necessary in order for you to achieve an acceptable result but that is one of the reasons it is so fascinating.

There have been many brilliant portrait painters and therefore no dearth of examples to look at. Friends and relatives will be quite keen to sit for their portraits because it is a kind of compliment – to think that their face is worth drawing by the artist. However, you will be taken to task if they think you have missed their likeness. Don't worry though, as any good artist knows, the likeness of an individual is by no means the whole story, or why are we so impressed by the old masters' paintings of people that we have never seen.

One thing you must appreciate when attempting a portrait is that the whole head is the key to getting a good result, a fact that many beginners fail to realize. Don't forget to refer to the proportions given earlier in this book (pp 114–117), otherwise the final result might look like a face lacking the foundation of a properly constructed skull.

PUTTING THE SUBJECT IN THE FRAME

When about to draw a portrait, your first consideration is the format of the picture. This is usually the normal portrait shape, taller than its width. But of course this might not always be the case, and you should follow your own ideas. In the examples I have chosen, I've stuck to the upright format in order to simplify the explanation. The idea of these pictures is to give some thought to the way that you use the format to determine the composition. You might choose to draw the head alone or include the entire figure.

The first example shows the most conventional treatment of the sitter, occupying a central position in the picture, showing the top half of the figure with a simple background suggesting the room in which she is sitting. There are probably more portraits showing this proportion of the sitter than any other.

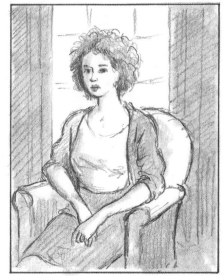

In the second picture, I have gone in close to the face of the sitter and the background is just a dark tone, against which the head is seen. The features are as big as I could get them without losing the whole head, and all the attention is on the face.

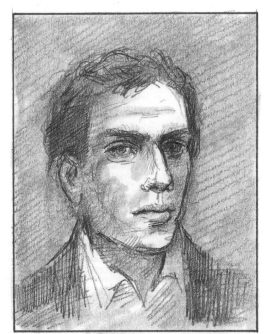

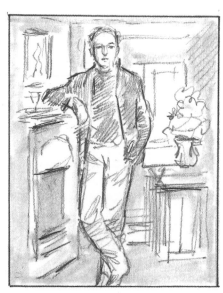

The next picture shows the other extreme, the full-figure portrait. In this, the figure is standing, with the surrounding room shown in some detail, although this does not always have to be the case; it could be an empty space or perhaps an outdoor scene. The full-length portrait is often a tour de force for the artist involved.

Here we see a figure, not quite complete, but taking on a more horizontal position. This could be done just as well in a landscape (horizontal) format, but can be most effective in the vertical. In this example, the space above the sitter becomes significant and often features some detail to balance the composition, like the picture shown.

A double portrait – such as a parent and child – creates its own dynamic. All you have to decide is how much of each figure you choose to show, and which person to put in the centre of the composition.

The final example is a portrait of the sitter and his dog. Putting pets into the portrait is always tricky, but the answer is to draw the animal first and then the owner. Once again, is the animal a mere adjunct or the centre piece?

There are many ways to approach the drawing of a portrait and this stage of consideration is crucial to the final result.

MAPPING OUT THE PORTRAIT

Starting on a portrait is always a bit tricky, but there are time-honoured methods of approach that should help you.

First, treat the head like any other object and make a rough sketch of the overall shape. This is not as easy as it sounds because the hair often hides the outline and so you may have to do a little bit of guesswork to get as close to the basic shape as you can.

When you have done that, block in the hair area quite simply – not trying to make it look like hair – and note how much of the overall shape it occupies.

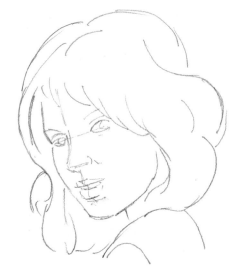

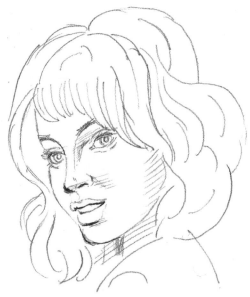

Now comes the most critical part of the drawing, the features. These must be placed at the correct levels on the face, in a very simple form. Check by measuring if you are in any doubt, but remember that normally the eyes are halfway between the top of the head and the point of the chin, and make sure the eyes are far enough apart. Also, check the size of the nose and its relationship with the mouth. In this example, the face is seen three-quarters on, and this means that the space occupied by the far side of the face measures much less than the near side.

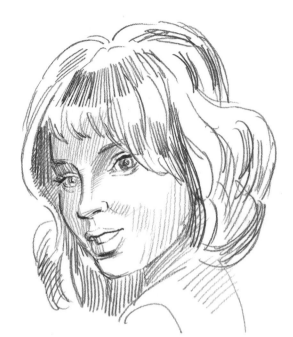

Having sketched the features in the right place – and basically the right shape – now draw them in greater detail.

Mark the main areas of shadow; keep shading light to start with and add more intensity when you are satisfied that all is correct. Finish off by refining both the shapes and the tonal areas.

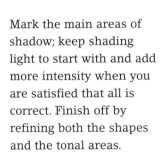

AN ALTERNATIVE METHOD

Using this method, you start with a line down the centre of the face, drawn from the top of the head to the chin and neck. Mark this line at eye level (halfway down the whole length), then a line for the mouth, the tip of the nose, and the hairline. Check these thoroughly before moving on.

Now carefully draw in the eyes, the nose, the mouth, the chin, and the front of the hair.

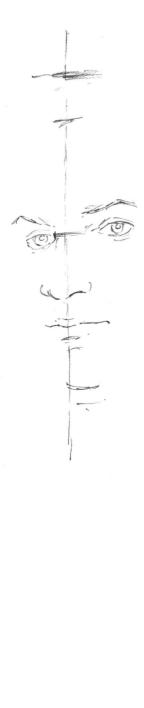

Ascertain the position of the nearer ear in relation to the eyes and nose. Next, draw these in clearly so that you can see if the face looks right. If not, alter anything that doesn't appear like your sitter's face.

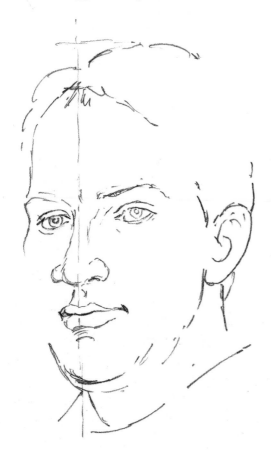

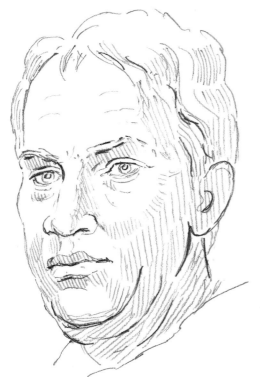

Now you can put in all the rest of the head outline and then the main areas of shading. At this stage, shade lightly, in case it needs to be changed.

After rubbing out the initial guideline, work in the more subtle tones and details of the face. You may need to increase the intensity of the tonal areas in some places.

These are two methods of achieving a good result.

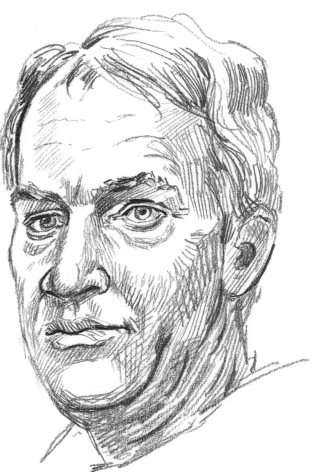

DETAILS OF THE FEATURES 1

One practice that you will have to make regular is to look at all the features of the face in some detail. Before you start drawing, you need to check how the features of the face work together.

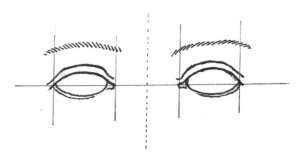

1 Corners aligned

Eyes

Looking at the eyes of your model, viewed from the front, the corners may be aligned exactly horizontally; or the inner corners may be lower than the outer ones, which will make them look tilted up; or the outer corners may be lower than the inner ones, which will make them look tilted down.

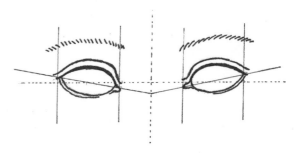

2 Outer corners higher than inner ones

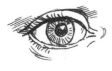

3 Outer corners lower than inner ones

Eyes can have either thin or heavy eyelids, again as shown.

Eyebrows can be arched or straight, as shown. They can also be thick or thin.

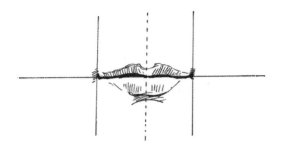

1 Straight mouth

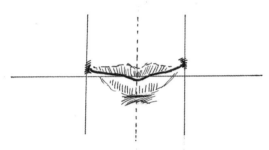

2 Curved up at the corners

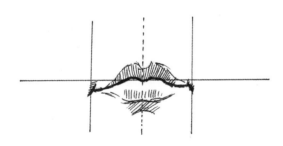

3 Curved down at the corners

Mouths

Mouths may be straight along the central horizontal; or curved upwards at the outer corners; or curved downwards at the outer corners.

Mouths can also be thin- or full-lipped, as shown.

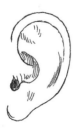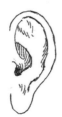

Ears

Ears are unique to the individual but the basic shape is very similar to the first diagram here. The other drawings show some possible variations.

DETAILS OF THE FEATURES 2

Noses

Noses vary in shape but all project a certain distance from the surface of the face. Here are seven types of nose for a start, and no doubt you will be able to find more.

The first four are masculine, and this one is a relatively straight nose.

The next is a more aquiline shape, with the bony structure giving the bridge a distinct curve.

The next is the classic boxer's broken nose, with the bridge crushed back into the face leaving the tip protruding.

The next is not so common on men – although it does occur more noticeably on younger men –and it is the snub or retrousse nose. The curve is the reverse of the aquiline type.

Now let's look at more feminine shaped noses, which can have the same characteristics as the male ones, although rather finer in form. The first is the straight nose, and this can be really straight.

The aquiline version in the female form is not usually quite as dramatic as the masculine version, but the accompanying face is also usually softer and finer.

The retrousse or snub nose is also very similar to the male example above, but again the form is often quite delicate.

Hairlines

The hairline can either lie evenly
across the top of the forehead, or
appear less regular due to something
like a 'widow's peak'.

PORTRAIT PROJECT: STEP ONE

SETTING THE POSE

The first concern when you set out to draw a portrait is how to pose your subject. As shown in the introduction, there are many possibilities and you must decide how much you wish to draw of the subject, apart from the face. You might choose the whole figure, or go for half or three-quarters; your subject may well have ideas on how he or she wants to be drawn too.

In this session, I decided to draw my daughter and so I sketched out various positions that she might sit in.

In a chair...

...or on the ground?

...on the arm of a sofa...

Which was it to be? As I couldn't get my daughter to pose every time I tried a new angle, I drew her sister or her mother instead, giving the figure a neutral look so that it could be adapted to the real subject as and when we were ready.

PORTRAIT PROJECT: STEP TWO

To make sure that you are familiar enough with the facial features of your subject, you need to produce several sketches of the face from slightly different angles, so things are easier when you come to do the finished drawing.

Of course, I had been familiar with my own daughter's face over the years, and was able to call on several drawings that I had done before, which I studied carefully for the salient features.

There was this profile, which is quite easy to draw as long as you get the proportions right. The hair tends to dominate a side view.

This three-quarter view is the kind of angle that people like in a portrait, because the face is more recognizable.

This drawing, glimpsed from a distance when she was smiling, is useful but it doesn't give much detail to the face. This is often the sort of result that you get from a quick snapshot.

This is a view of her drawn while she was busy reading and was almost unaware of me. This could work quite well, but has slightly obscured the face.

And finally, here is a straightforward drawing of an almost full-face view.

Repeated attempts help to produce a better piece of work when finally you come to it. So don't rush to finalize until you've done a reasonable amount of groundwork.

PORTRAIT PROJECT: STEP THREE

When I decided to do the final portrait, my daughter just sat down in a chair and told me I had only a short time to draw her as she had other things that she needed to do.

I let her arrange herself until she felt comfortable although, as you can see, she is perched on the edge of the chair, ready to go at a moment's notice. This is a mark of character that will probably help to give the drawing more verisimilitude.

The background was just the texture of a Venetian blind, so it was not too difficult to draw. I first sketched in the whole head and then the rest of the figure, to make sure that I had got all the proportions right. The facial proportions took three attempts before I was satisfied with the result.

I kept the shading simple and only allowed two grades of tone, a mid-tone and a dark one. I used the 2B pencil in a light, feathery way to put on large areas of tone evenly, and I emphasised certain areas where I thought the darkest shadows should be. This seemed to work all right and I finished off the portrait with a few areas of tone on the background, to help set the figure in the space.

Follow these steps when you come to try portraiture for yourself, and you should end up with a good drawing.

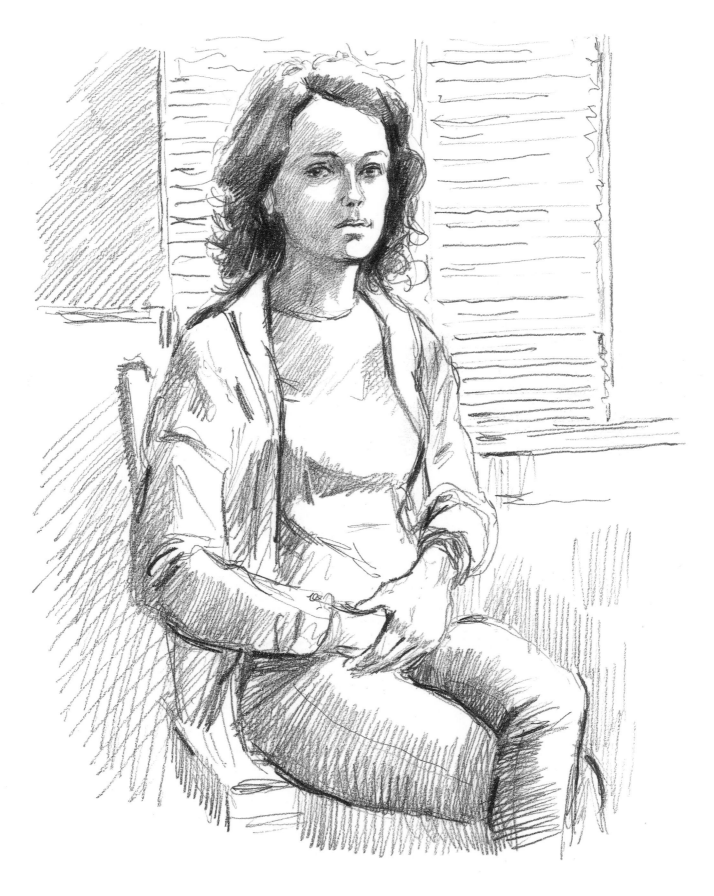

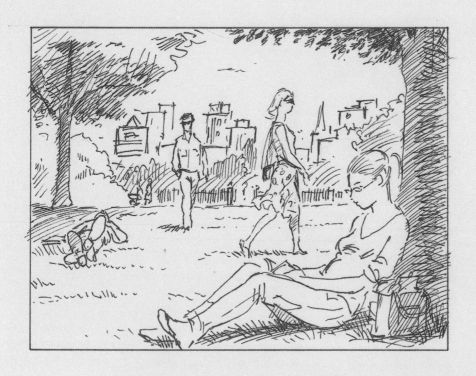

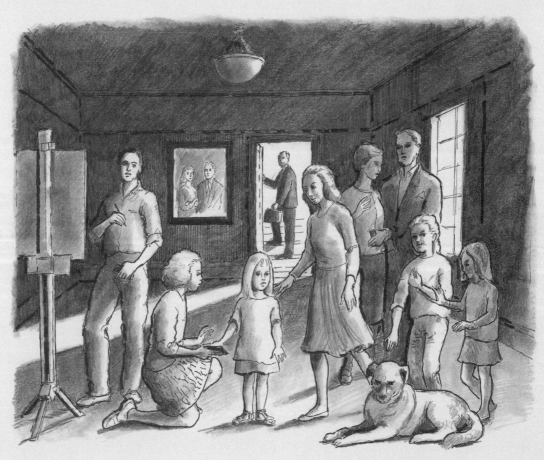

SETTING UP A FIGURE DRAWING

When it comes to setting up a composition for figure drawing, you need to think in terms of things that you would naturally be doing, activities that are not out of the ordinary for you. So taking an everyday situation and making it the subject of your drawing is generally the best approach, especially at the start of your drawing career. For example, if you are connected in some way with selling or repairing cars, draw the scene at a salesroom or repair workshop. If you are a farmer or someone who works outdoors, groups of people engaged in some countryside pursuit would be the obvious choice. A sportsman or woman would draw the scene at an athletic meeting or training session, and a banker might show the interior of a bank, where people are being seen by bank personnel.

My own life as an artist is spent in the realm of normal artistic activities, such as drawing from landscapes, still-life subjects and portraits. These don't involve many figures, as you can imagine, so I naturally went for the life class where a number of people are drawing from a life model, which is the basis of all drawing.

My experience in the life class is fairly extensive, as not only do I tutor one on a regular basis but I also attend a weekly session myself at a local art school, to keep my hand in. In order to improve one's skills, one can never draw too often from the human figure.

So my advice for your figure composition is to draw a scene that would naturally occur in your everyday life.

APPROACHES TO COMPOSITION

In these six compositions, I address the problem of organizing a group of figures in various ways that you might find useful if attempting a picture where figures are the main ingredient. In no way do my suggestions exhaust the possibilities of the genre and, after a few attempts, you will probably be trying ideas of your own.

The first example is set in a typical Italian cafe with wide open windows and doors that put everybody practically outside in the street. The two main figures sit under the cafe roof but also quite close to the people walking by. Outside can be seen a town with a campanile and other buildings, all in the sun. The two figures either side of the table take up most of the space, with a waiter to the right and a couple of passers-by visible between them. This is an informal composition that concentrates on the pair at the table.

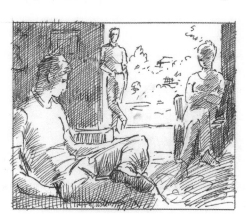

The second example is an interior in which the background is half dark and half light. The nearest figure is on the left, cropped by the lower edge. He is well lit and the curve of his body seems to hold the edge of the picture like a second frame. To the right, a woman is facing him in a rather defensive posture that contrasts with the lounging man in the foreground, suggesting some kind of tension between them. The man in the centre background acts as a focal point to indicate the depth of the room and his position, above the knee of the foreground figure, seems to isolate the woman on the right. Note how important the picture depth is in making the composition work.

Next, I have drawn a beach scene with a suggestion of outdoor space and distance that the three figures help to define. Across the background lies a horizon line of sea and low cliffs. The nearest person has her back to us and appears ready to catch the ball, which has been thrown by the furthest one. However, halfway between these two is another player who has actually caught the ball. See how the differences in size of the three figures provide clues as to the space available on the otherwise empty beach. This is definitely an open-air composition.

This scene is of a park or public gardens and in the right foreground there is a figure, sitting leaning against a tree, reading. The vertical line of the tree-trunk, and the legs of the figure act like an additional frame to this picture. In the near left background, another tree acts like another part of the frame, underlined by the reclining figure on the grass, seen in perspective or foreshortened. Two walking figures cross the middle ground of the picture. Once again, different elements of the composition contribute to the spatial quality of an open area.

This picture is definitely an interior, but also gives the sense of a larger than normal room. This is partly indicated by the spotlights criss-crossing the dark space above the dancers, and partly by the distance between the nearest couple and those further away on the dance-floor. The nearest dancers establish a stable focal point, while the jiving couple nearer the centre give the impression of movement within the space.

The last scene is another exterior composition, set this time in a garden with three figures performing typical outdoor activities. The space is enclosed, unlike the park and beach scenes, and typical garden vegetation seems to enfold the figures. The little boy in the foreground kicks a ball and the two adults get on with their gardening. They are all facing away from us, the viewers, which makes us appear to be observing them without their knowledge. Either that, or they are just too busy to give us their attention.

BLOCKING IN THE MAIN FORM

When you come to draw a human figure from life, it's a good idea to simplify it at first. To start with, try blocking in the main shapes without any detail and then work on from that point.

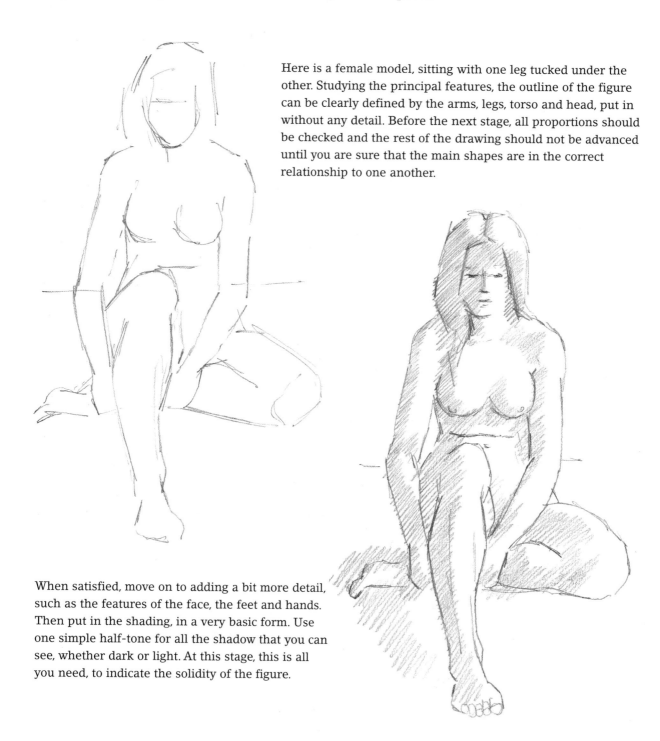

Here is a female model, sitting with one leg tucked under the other. Studying the principal features, the outline of the figure can be clearly defined by the arms, legs, torso and head, put in without any detail. Before the next stage, all proportions should be checked and the rest of the drawing should not be advanced until you are sure that the main shapes are in the correct relationship to one another.

When satisfied, move on to adding a bit more detail, such as the features of the face, the feet and hands. Then put in the shading, in a very basic form. Use one simple half-tone for all the shadow that you can see, whether dark or light. At this stage, this is all you need, to indicate the solidity of the figure.

Then, once you are sure
where all the shading should
go, you can put in darker
tones to round out the form
more realistically. This is the
time for any refinements to
be added, where appropriate.

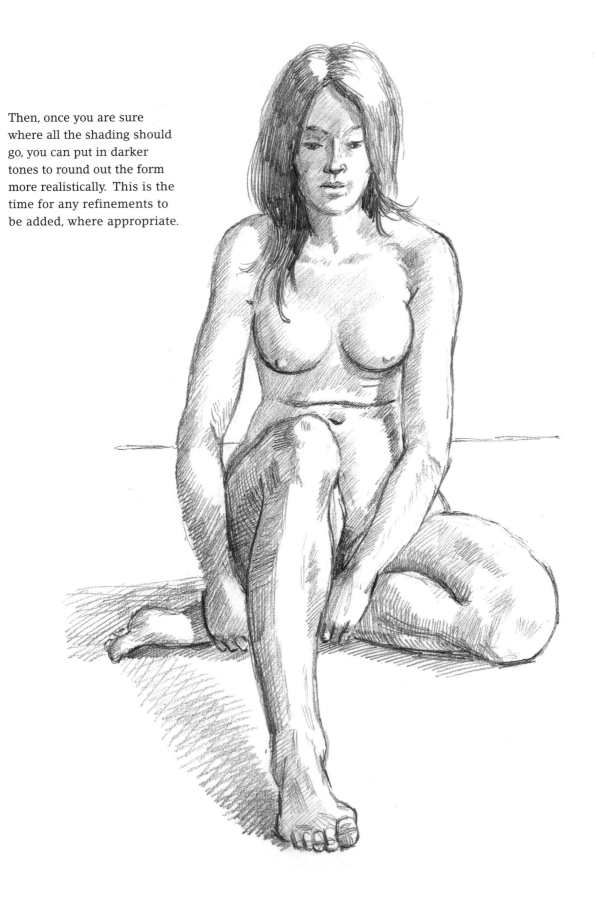

DRAWING MOVEMENT

Drawing a figure in motion is not easy but at some time you should take the plunge and have a go at it. Instructing your model to keep repeating the same movement is one approach that works very well. While this performance is going on, you should try to capture each phase of the sequence and sketch it as well as you can. If the movement is repeated often enough, it is possible to keep returning to a certain position and take another look at how to draw it.

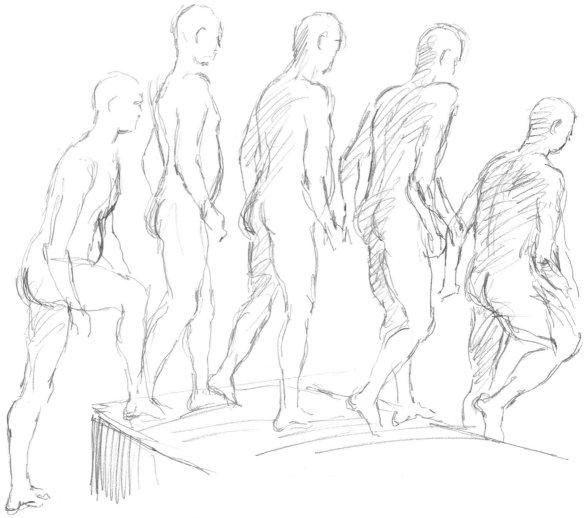

In this example, which is from a life-class session, the model walked across a dais over and over again, trying to keep the action the same each time. You could enlist the help of friends for this, if you were to choose some simple movement to begin with. Even if early attempts don't look too good, persevere with practising whenever you can and you will find that your 'fast drawing' will improve.

Catching the fleeting gesture

Once you have begun experimenting with action drawing, set yourself up
in a place where you can view plenty of people walking about and see how
many quick sketches you can get down. If that is not so easy for you, try
getting a friend to move around slowly and draw as many of their changes
of position as you can.

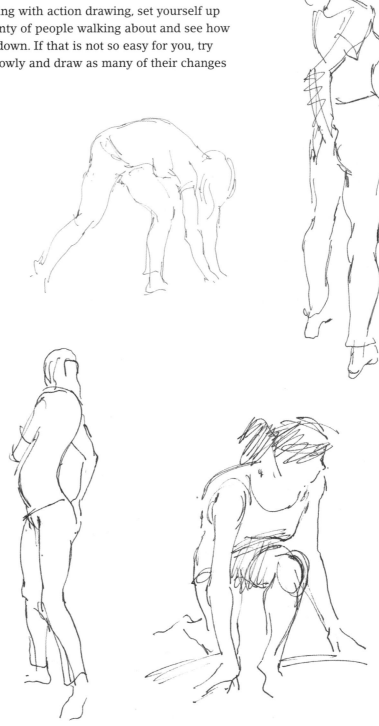

These drawings were
all done extremely
quickly, with the same
model moving around
and performing very
simple, ordinary
movements. Don't
struggle to be too
accurate, but remember
that the more you do
this the easier it gets.

239

SHORT CUTS TO BODY LANGUAGE

Here are some stickmen (a graphic shorthand for the human figure) in the sort of positions that the human body might adopt when trying to express certain attitudes.

1 The first suggests humility, similar to Dickens' Uriah Heap from *David Copperfield*. The hands are wrung together, the shoulders droop, the face expresses worry. Also, the feet are turned a bit towards each other to give the idea that the figure will not move far.

2 The second figure is quite the opposite, in that it seems to be taking charge of things and laying down the law: hand on hip, the other wagging a finger in disapproval, firm stance on both feet, and a frown on the face.

3 This figure could be a bit ambiguous: caught in some form of embarrassment, an uncomfortable gesture of hands poking knees, legs a bit constricted, face apologetic but grinning to get approval. He is probably at a crowded function and feeling out of place.

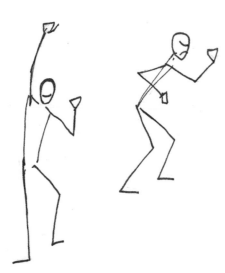

6 Anger shown with a shaken fist, an aggressive stance and down-turned brows and mouth.

4 The classic pose of disbelief, with the shoulders shrugging and the arms and hands held out in surprise. I've put an uplifted brow on the face, but I'm not sure that it reads properly.

7 Guilt is shown with the hand clapped over the eyes and an apologetic stoop to the whole body.

5 Triumph, demonstrated in the familiar gesture of punching the air, accompanied by a big grin.

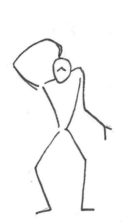

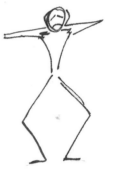

10 Determination shows a fast-moving figure with fists clenched, head pushed forward, chest stuck out. A real 'don't get in my way' attitude.

8 Adoration is difficult to show subtly, so I have gone for a cartoon-style exaggeration of hands-to-face, big smile, squirming body and close-together feet.

9 Doubt is not so obvious either without going for the cartoon element. Here I have drawn one hand scratching the head, rather too-obviously frowning brows, and the other hand outstretched.

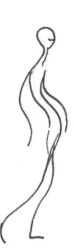

11 The unwilling figure is rather like Shakespeare's reluctant schoolboy, dragging his feet, with arms and head drooping, and a downturned mouth.

13 This figure has adopted the classical 'contrapposto' pose where the hips and shoulders are counterbalanced. The arms are gesturing to cover the body and are reminiscent of the central figure in Botticelli's *Birth of Venus*. Like the goddess of love and beauty the figure seems to be responding to adoration.

14 Lastly, the figure of distraction with the 'I'm going mad' look: hands holding the head, face showing anguish, and knees bent to brace against shock.

12 This sinuous figure, gliding along with everything smoothly undulating, is someone confident of attracting attention. The smile on the face also gives a clue.

These are just a few of the shapes that our bodies assume to express emotional states, and no doubt you will have fun trying out other expressions of body language in your own figure drawings.

ACTUAL BODY LANGUAGE 1

The next series of figures are more considered examples of how to express something characterful through attitudes and dispositions. I show first four male and then four female forms that give impressions of certain attitudes.

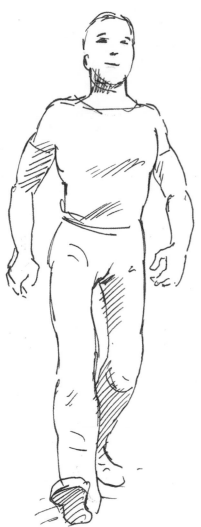

Swagger

Here is the classic cocky swagger usually shown by younger men when they think they have everyone's approval. Upright posture, arms swinging and legs striding.

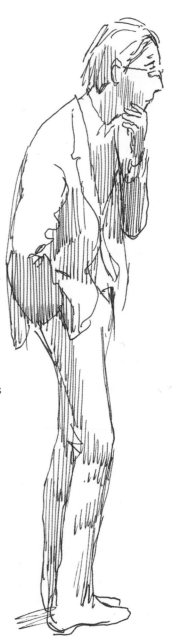

Doubt

Now for the opposite, where the figure looks as if it is in great doubt about something. A rather scholarly stroking of the chin complements the stoop of the shoulders. This chap can't make up his mind at all.

Confidence

The relaxed gesture of someone who thinks that they know all about the topic in question. Possibly a little conceited with it, as well.

Despair

This poor fellow has obviously been crossed in love or lost his job. Total droop suggests despair rather than just fatigue, the tucked-in feet showing tension.

ACTUAL BODY LANGUAGE 2

Assuredness

This young lady looks like a ballet dancer with her out-turned toes, her upright stance, poise and confident appearance.

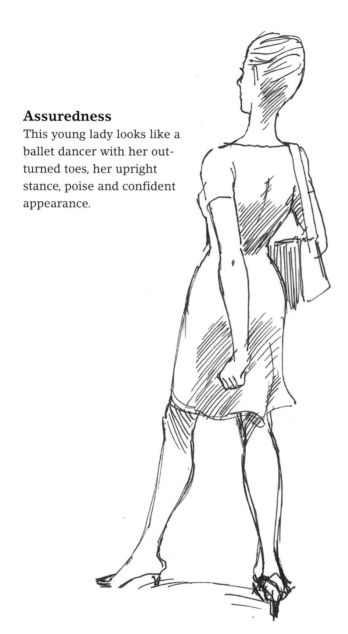

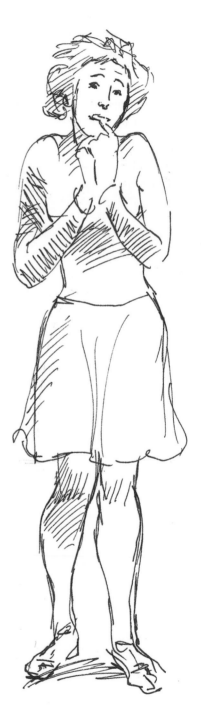

Embarrassment

This figure is reduced to a squirming held-together shape, with hands up to her mouth and anxious eyebrows. Not a happy situation to be in.

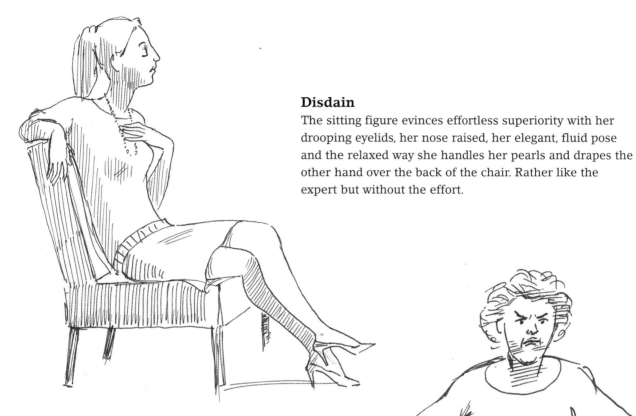

Disdain

The sitting figure evinces effortless superiority with her drooping eyelids, her nose raised, her elegant, fluid pose and the relaxed way she handles her pearls and drapes the other hand over the back of the chair. Rather like the expert but without the effort.

Anger or defiance

This feet-astride position, arms akimbo and head jutting forwards, bodes ill for anyone not complying with the owner's principles.

Any or all of these attitudes can be used in your figure compositions to create activity or tension in the picture or to get a dynamic story across to the viewer.

A GREAT ARTIST'S INSPIRATION

Gaining inspiration from great master artists of history is a time-honoured way of working for all artists: it is often the attempt to realize the way a master painter designed his painting that increases the power of our own work. So have a go at recreating a major work that you feel some affinity with.

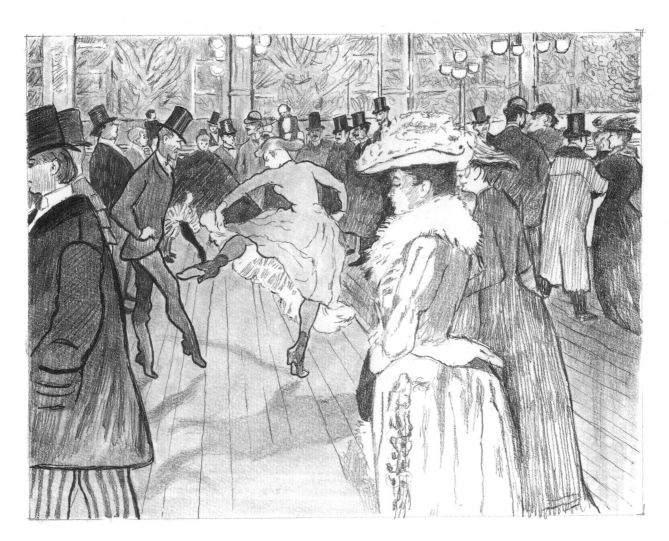

This drawing shows the disposition of the various figures in Henri de Toulouse-Lautrec's *Dressage des Nouvelles par Valentin le Desosse* (c. 1889). The grouping of the two dancers, and 'La Goulou', a famous entertainer, among the strolling and drinking boulevardiers is a dynamic composition that is well-known among artists and art-lovers. The space around the the figures is well realized, with all the characters placed in an interesting way in groups, meeting and greeting.

In my version of this painting of lively, late-night activity, I have grouped
the figures in exactly the same way, but with references to a different era.
The central couple is now two young people dancing to a jazz band. The
other figures around are also similar in grouping but in modern dress, and
the space above their heads is now filled with strobe lighting, as in a modern
night-club. Once again, the composition makes for a very interesting picture,
even though the occasion is very changed in time; so, basing your picture on
a famous old master's work is not a bad way to learn how to compose a
pleasing image.

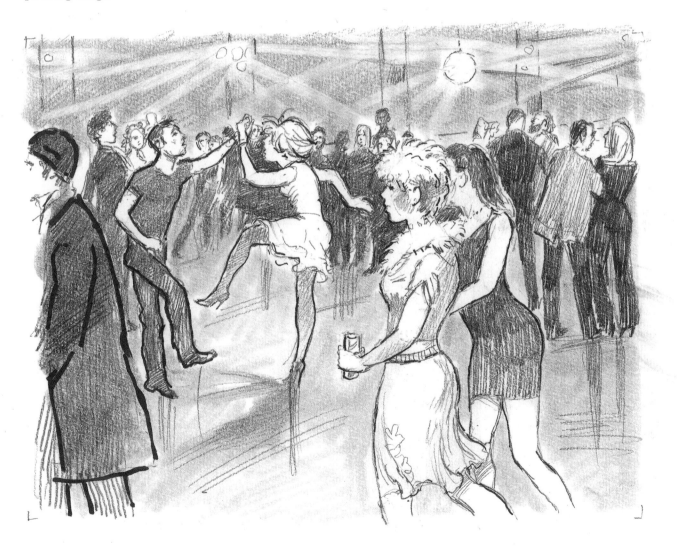

FIGURE COMPOSITION PROJECT: STEP ONE

When I first decided to do this project, I thought that the most obvious and easiest subject matter for a figure composition was the weekly life-drawing group that I attend. I could draw people in situ and they might make a good arrangement. So, the subject matter here almost chose itself. You can be more adventurous, of course, but I suggest that to make your first attempts in surroundings that you are familiar with would be simpler and more effective.

Setting the scene

My chosen venue was the studio in which my class normally takes place and which I can get into any time I need to. I carefully drew up a view of the studio from the position that I thought would be most appropriate for my picture. I placed the easels around the dais, so that when the students came in they would probably fit in to the pattern I had set up.

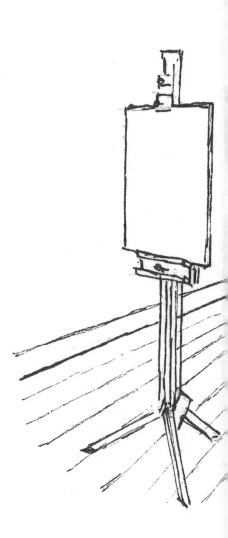

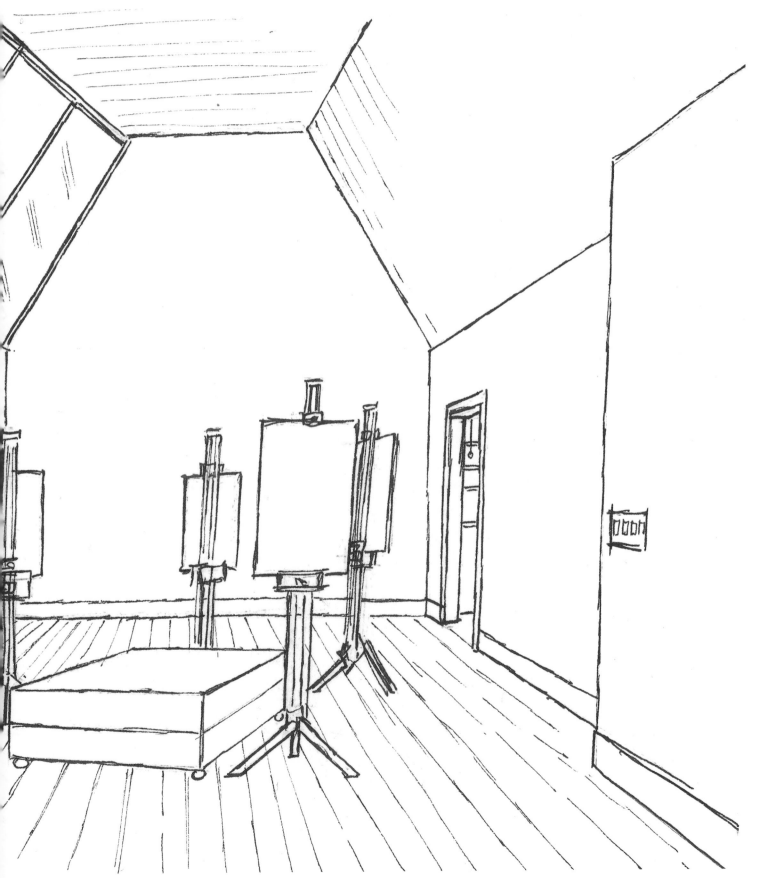

FIGURE COMPOSITION PROJECT: STEP TWO

The next thing was to wait until the art students were all busy drawing and quickly sketch them in as they worked.

First figure
The first figure was a man who worked away vigorously and took not the slightest notice of anyone who might be drawing him.

Second figure
Then I got the back view of a girl who was working quite quickly. I put in two different positions of her drawing arm, in case I preferred one to the other.

Third figure
Next, I drew another woman on the far side of the studio, who was working slowly and deliberately, with her hand on her hip and her head tilted to one side.

Fourth and fifth figure

Then I chose two more students on the far side of the room – one man, one woman – trying to capture the steady stare towards the model as they drew. I had to decide whether to draw them when their gaze was on the model or on their drawing.

The model, centre of the scene

Finally, I had to put in the reason that these people were all there, which is the model who poses for them. This was easier, because the model held still, whereas the students moved about quite a bit.

FIGURE COMPOSITION PROJECT: STEP THREE

Having made decent sketches of all the players in the scene, I had to put them together to make a complete figure composition. The only real problem was to get the figures in the right proportions to one another, so they looked as if they were all inhabiting the same space. I also needed to make sense of the light falling both on the figures and within the room setting, but this wasn't such a problem because I had drawn everyone from the same vantage point and the light was therefore the same for each one. If you draw people initially in different lights and you want to make a group composition, you will have to balance them out in the final picture.

I used pen and ink to do the final drawing, partly because I had drawn the original figures in ink and partly because it forced me to be more economical with my shadows. The hundreds of small strokes you have to make with a pen, do mean that you don't put in any more shading than is absolutely necessary.

Now have a go at this yourself and have fun with it, not getting too despondent if your first attempt doesn't come off. It is one of the most demanding types of composition that you can attempt.

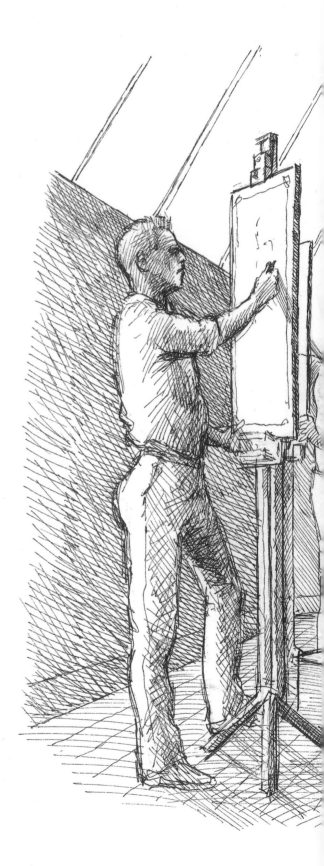

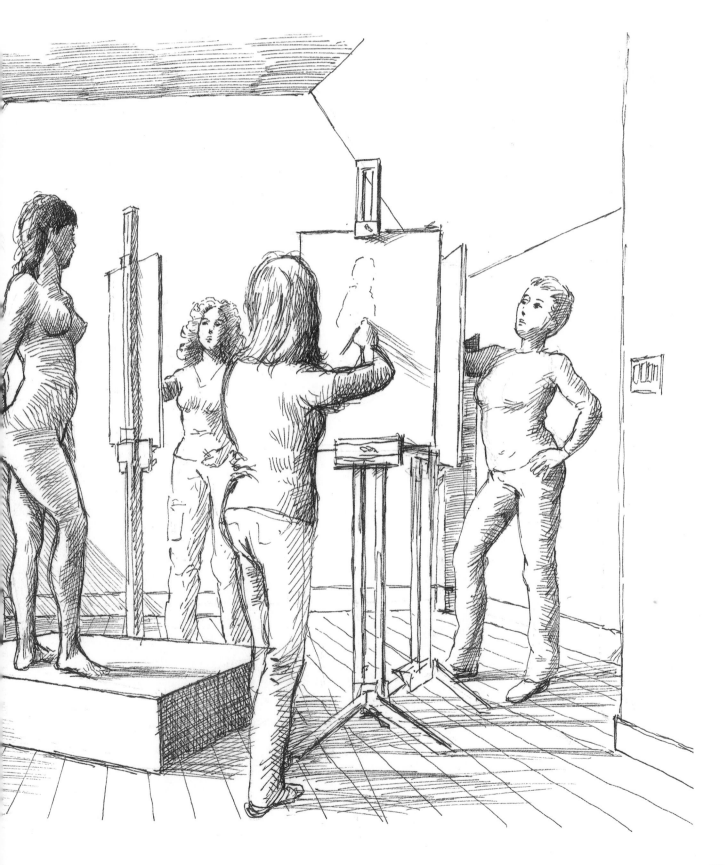

LEARNING FROM THE PAST

For a student of drawing, it is especially useful to observe how other artists make their pictures. Luckily, the majority of countries now care for their artistic heritage well and there are many galleries and museums that display great works of art for you to study. To help you to make the most of the treasures on show, national galleries are generally very pleased to allow serious art students to copy the works in their collections. In some places you can even set up an easel and paint, within certain restrictions.

But even if you don't actually do any drawing, a visit to a gallery is always worthwhile. Places like the Uffizi Gallery in Florence, the Accademia in Venice, and the National Galleries of London, Berlin, and Washington D.C. – to name but a few – are full of the most accomplished pictures from all periods, and are worth seeing in order to increase your own desire to excel. Of course, visiting your local, smaller galleries and museums is just as useful an exercise. It is by getting out and discovering how other people see and communicate with the world that you learn to expand your own skills, away from the merely representative, to something much more interesting and alluring. Studying the works of other artists is never time wasted if you are serious about learning to draw.

One helpful hint for visiting a major gallery is not to just wander around hoping to be able to see everything; this way lies 'gallery fatigue', which means that not only do you stop taking in the beauty of the pictures, but you also begin to forget the ones that you have examined more carefully.

Be decisive and go with a plan in mind to study landscapes, say, or just to look at paintings from the eighteenth century. By-pass those that fail to attract you at first glance, and when you begin to feel jaded, stop immediately and either take a rest before you look at any more or call the visit to an end.

Regular gallery visits train your eye and help you to take in the works more easily, and if you are keen on art then this will not prove a difficulty.

ANTIQUE ART

*Here are a few examples of the very oldest works available to us.
Done in the earliest of times, they are still a marvel of close study;
with evidence of an appreciation of perspective and close
anatomical observation.*

The first is a bird from an Ancient Egyptian wall-painting (1450 BC)
and reveals how precise the Egyptian artists were in their
observation. This picture, in its simplicity, not only shows the type of
bird quite clearly but also its flight action, which is remarkable for a
time when there was no photography. Its simplicity is refreshing.

The next is an image from an
Apulian krater (a bowl with a wide
mouth, two handles and a foot or
stand) painted in the fourth
century BC. This drawing
demonstrates the exceptional
draughtsmanship of the Greek-
inspired artists living in the 'heel'
of Italy around that time, and
although the perspective of the
seat is a little suspect, the overall
effect is quite modern. This was
originally executed in paint on
ceramic, so the artist probably had
only one shot at it. The contrast of
the line drawing with the dark
surround is extremely elegant.

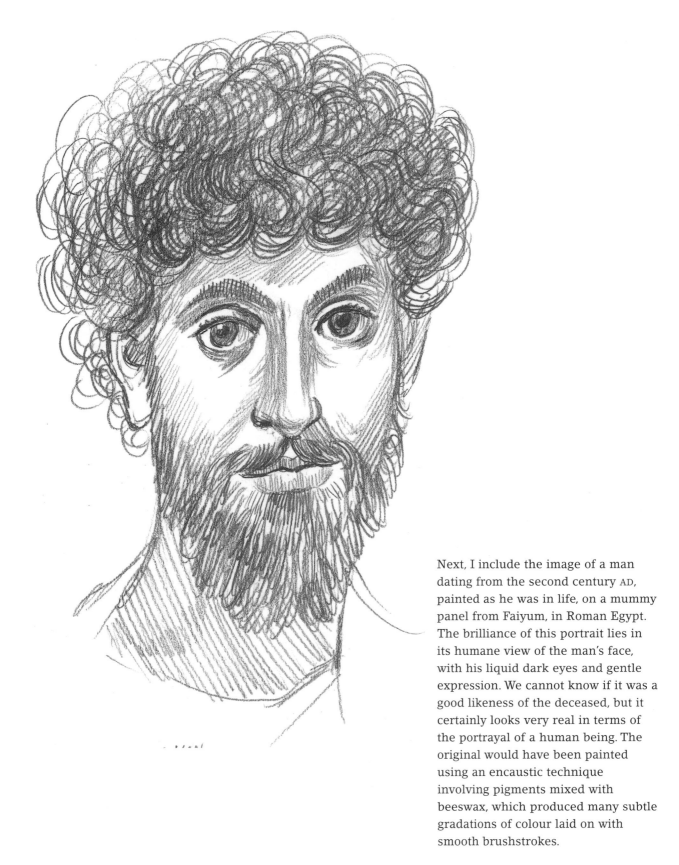

Next, I include the image of a man dating from the second century AD, painted as he was in life, on a mummy panel from Faiyum, in Roman Egypt. The brilliance of this portrait lies in its humane view of the man's face, with his liquid dark eyes and gentle expression. We cannot know if it was a good likeness of the deceased, but it certainly looks very real in terms of the portrayal of a human being. The original would have been painted using an encaustic technique involving pigments mixed with beeswax, which produced many subtle gradations of colour laid on with smooth brushstrokes.

MEDIEVAL ART

*Produced at a time when art and religion were closely connected,
these images suggest that it was to depict the glory of God that
art and artists were pushed to new limits of experimentation
and inventiveness.*

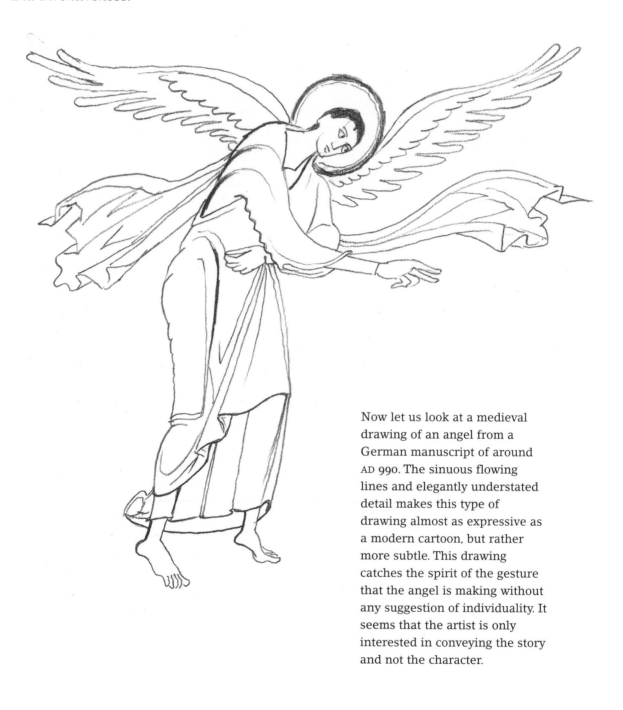

Now let us look at a medieval
drawing of an angel from a
German manuscript of around
AD 990. The sinuous flowing
lines and elegantly understated
detail makes this type of
drawing almost as expressive as
a modern cartoon, but rather
more subtle. This drawing
catches the spirit of the gesture
that the angel is making without
any suggestion of individuality. It
seems that the artist is only
interested in conveying the story
and not the character.

The next example is a Byzantine *Virgin and Child* from the period AD 1200. It typifies the style of work produced before Giotto (1267–1337) came upon the scene. The design is rigidly formal and follows the traditional methods of all the artists who had gone before. The positions of the hands, the tilt of the Virgin's head and the gesture of the Child were set stereotypes. Note also the stylized patterns on the robes of both figures. This in no way detracts from the value of the piece, but it is interesting to know that artists have often been expected to produce work to a specific structure. Highly formalized pictures like this one were no deterrent to the quality of a great artist, and the system also helped to support the lesser talents.

EARLY RENAISSANCE VIEWS OF HUMANITY

The painters in Renaissance Italy and the rest of Europe (about 1400–1600), produced works that we now regard as introducing humanism and realism to art. Here I have chosen two portraits, after both Piero della Francesca (1410/20–1492) and Fra Filippo Lippi (c.1406–1469). Both these Renaissance masters took the trouble to look very hard at their subjects and put down recognizable images of their faces.

The first portrait is of the famous Duke of Urbino, Federico da Montefeltro (1465), featuring his distinctive profile. This learned statesman, patron of the arts, and 'condottiere' – leader of mercenary soldiers – would only allow the left side of his face to be portrayed because of a disfiguring wound on the other side. But from other contemporary paintings and medallions, we recognize that this was indeed a true likeness of the Duke.

The face of the Virgin in Lippi's *Madonna and Child* (c.1464) is generally believed to be a portrait of Lucretia Buti, the young nun with whom he fell in love whilst chaplain to her convent, and who eventually became mother of his two children. It is interesting to reflect that the majority of Madonnas must have been modelled by flesh-and-blood women, many of them the artists' own wives and lovers, which supposedly led to the affectionate portrayal of the Virgin's gentleness and devotion. There are several versions of this young woman painted by Lippi, and her type of face became the ideal for the next generation of artists.

THE CREAM OF THE RENAISSANCE

The next generation ushered in Sandro Botticelli (1445–1510), who was at one time a pupil of Filippo Lippi. His great picture, *The Birth of Venus* (1486) portrays a very similar kind of face to the one Lippi made famous. However, the model for Venus was the legendary Florentine beauty, Simonetta Vespucci, one of the favourites of the Medici family. Botticelli's drawing of the goddess arising from the sea is admired everywhere and reminds us that our ideals of beauty are still hugely influenced by the images that the Renaissance masters set before us. Venus' lissom body with elegant hands and feet, is posed in an undulating fashion that we also recognize as the 'contrapposto' copied from Ancient Greek sculpture. One of the guiding principles of Renaissance culture was to reconnect with classical antiquity.

Andrea Mantegna (1430–1506) was another notable Renaissance figure, who worked mainly in the north of Italy. He knew many scholars involved in the study of Roman antiquities around Padua and used what he learned from them in his art. His extraordinary, austere view of Christ laid out after his death, *Lamentation over the Dead Christ* (c.1490), shows how far artists had progressed in the treatment of perspective, within about three generations. This could hardly be bettered by a photograph for accuracy of foreshortening. The original can be seen in the Pinacoteca di Brera, Milan.

Of course, we cannot ignore the contribution of Leonardo da Vinci (1452–1519), whose desire to know all aspects of the universe led him to draw almost everything at one time or another. Here is his astonishing *Embryo in the Womb* (1510), which although not correct in every detail, is still the icon of this subject. Leonardo's work was a combination of endless observation and analysis; he made around fifty anatomical dissections over a period of twenty-eight years and then was banned from any further investigations by the Pope in 1515. This piece is in the Royal Collection at Windsor Castle.

LATE RENAISSANCE DEVELOPMENT

This picture, after one from the Accademia in Venice, is by the Venetian artist Giorgione (1477–1510). *Old Woman* (c.1505) is one of the best portraits of old age ever made. Possibly an allegorical work – the woman holds a piece of paper on which is written 'col tempo' ('in time') meanwhile pointing to herself – it reminds the viewer that old age comes to everyone, beautiful or not. The quality of the skin and features has to be seen to be believed; Giorgione is a prime example of the Venetian genius for painted textures.

Michelangelo Buonarroti (1475–1564) is another High Renaissance artist, renowned in all three fields of architecture, sculpture and painting. This unusual picture, done in 1506, of *The Holy Family with Infant St John the Baptist* (also called the *Doni Tondo*, in the Uffizi, Florence) would probably not have been allowed in a church before Michelangelo's time. His prestige, however, overcame the innate conservative attitudes of the Church, since he had been the friend of Popes as well as other rulers. The Virgin Mary twists round to lift the Infant Jesus from Joseph's knee, providing us with a fine example of Michelangelo's eye for the play of light on bodies and draperies. Why there should be a procession of classical-style nude youths in the background has never been satisfactorily explained.

THE EARLY NINETEENTH CENTURY

With the advent of the nineteenth century, the whole of Europe was producing artists of very high quality, and Joseph Mallord William Turner (1775–1850) was England's leading land- and seascape painter.

This celebrated image of the great warship *The Fighting Temeraire* (1839) being towed to her final berth by a tug, also points to a significant change in the industrial world. The humble steam tug has more power than the greatest sail-driven warship; sail was already a dying method of travel. Turner gives us the splendour of the setting sun, at the same time suggesting that this is the end of an era. His amazing ability to catch the gradations of light in the sky and its reflection on the water, not to mention his painstaking handling of the tall ship's rigging, shows how expert artists were becoming in representing the visible world.

NINETEENTH-CENTURY FRANCE

The French artist, Jean-Francois Millet (1814–75) was another who could work with nature through all its seasons, although he used it chiefly as a backdrop to depicting peasant life. A farmer's son himself, he drew upon his own experience and was greatly concerned with showing the dignity of labour. With Millet, realism had arrived; *The Gleaners* (1857) honoured the lowliest of rural dwellers – those who could only pick up the harvest leftovers. This master influenced Vincent Van Gogh (1853–90) thirty years later, while the Dutchman drew and painted the peasants of northern Holland. Millet's three women have a monumental quality, the shapes they create as they bend to their task are echoed by the ample haystacks on the horizon.

Edgar Degas (1834–1917) was influenced by the imported Japanese prints being sold in Paris and London during the latter half of the nineteenth century. He also had a keen interest in the then new art of photography. The oddly off-centre composition of *Viscount Lepic and his Daughters* (1873) was typical of Degas' attempts to re-see the way the world looked. His use of one figure to establish the left-hand edge of the picture and the casual poses of the three members of the Lepic family appears to capture a fleeting moment and looks like a sample of photo-reportage from a much later time.

GERMAN COLLECTIONS OF THE NINETEENTH CENTURY

The following are some nineteenth-century works from the Old National Gallery in Berlin.

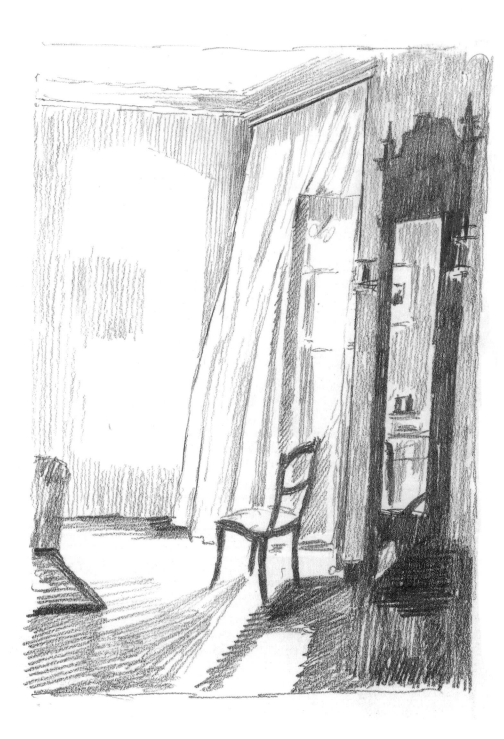

The first is, appropriately enough, after a picture by the German painter, Adolph Menzel (1815–1905). *The Balcony Room* (1845) is one of his best-known paintings. It is a masterly depiction of an interior with the breeze blowing a light curtain through a French window, and next to it a dark-framed mirror and two chairs. The way that the artist has defined the light and space is remarkable. My sketch of it is a rather oversimplified version and cannot really give you the full power of the original.

The next is from the gallery's French Impressionist collection. It is after *In the Winter Garden* (1879) by Edouard Manet, and pictures a couple talking in a garden. The elegance of the drawing and the balance of the design is very satisfying. It provides a good pattern for the composition of a double portrait.

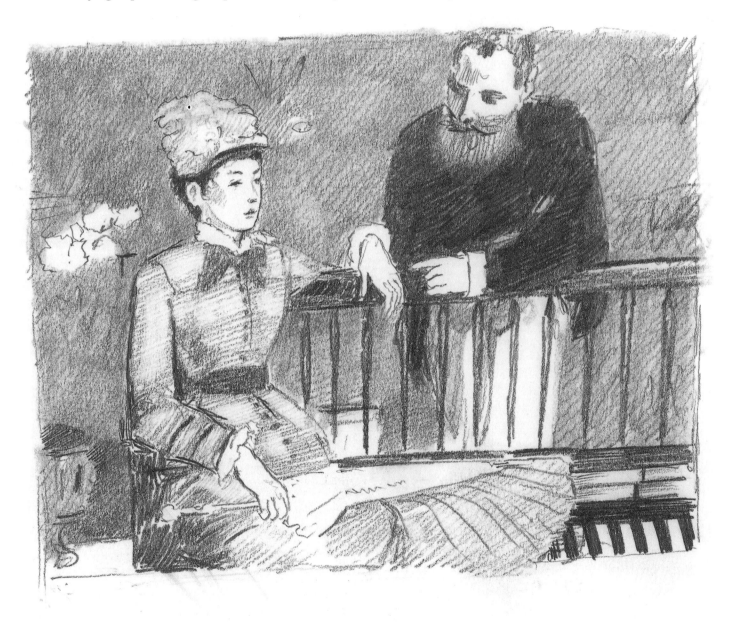

MODERN EXPERIMENTS

Here I show a drawing
based on *Expectation* by the
Viennese Secessionist
Gustav Klimt (1862–1918).
It comes from the Stoclet
frieze (1905–9), a mural of
mosaic decorations that
Klimt designed for the
Palais Stoclet in Brussels.
Patterns abound both
across and behind the
female figure and set up a
fascinating exchange
between figure and ground.

Next is a graphic representation of the singer *Aristide Bruant,* drawn by Toulouse-Lautrec for a lithographed poster in 1893. The elegance of the line contrasts with the solid mass of dark tones to produce a high-impact image. The flat expanses of colour were originally designed to be overprinted with poster lettering, depending on the venue at which Bruant was giving his performance.

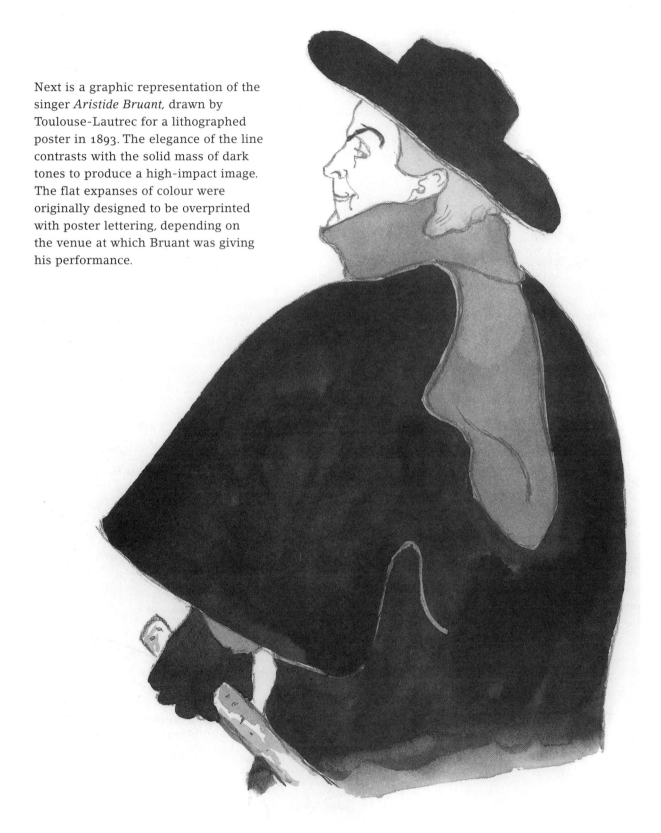

WINSLOW HOMER AND THE NEW WORLD 1

The National Gallery in Washington D.C. is the next place we visit, and this time I begin with the work of an American painter and illustrator, Winslow Homer (1836–1910).

Famous for his marvellous sea pictures, my copy of *Breezing Up* (1876) gives you some idea of his ability to portray a sense of sportsmanship and adventure, and to capture the fleeting moment among wind and waves.

WINSLOW HOMER AND THE NEW WORLD 2

In Right and Left (1909), Homer has caught a moment of a different kind, just as the hunter in a boat far below has discharged both barrels of his gun and the two birds cease their flight to become abstract shapes, twisting and tumbling above the waves.

The Dinner Horn (1870) – also after Winslow Homer – shows a farm girl blowing a horn to call the farmhands in to dinner. Notice how the action of the wind is caught in the movement of the girl's dress, and the branches of the trees.

THE NEW WORLD IN THE TWENTIETH CENTURY

This is from a painting after the American Impressionist, Edmund Charles
Tarbell (1862–1938). His beautifully observed, spacious interiors – of which
Mother and Mary (1922) is one – often featured the tall French windows of his
New Hampshire house. The play between interior and exterior light might act as
a model for your own efforts to draw an interior in your house.

Here are two pictures after the New York artist Edward Hopper (1882–1967). He specialized in stark pictures of city life, especially the type that was being lived in New York in the middle years of the last century. His figures frequently seem to inhabit a rather melancholic world where each person seems isolated among others. Sometimes he shows them alone in the impersonal settings of modern life, as with the woman in *Compartment C* (1938), which is empty except for her. She sits reading by harsh electric light, completely cut off from the world glimpsed through the window.

The second shows an office scene, *Study for Office at Night* (1940), with two people that seem just as isolated as the girl in the train. It is a glimpse of people at work, but not of the dignity of labour.

ABSTRACTION 1

Abstract art began with a watercolour painted by the Russian artist Wassily Kandinsky in 1910. The idea was that painting should become a synthesis of form and colour, as abstract as music and no longer dependent on the subject matter.

The first abstract artist that I show here was one of the most uncompromising. Kasimir Malevich (1878–1935) called his work Suprematism. *Suprematist Composition: White on White* (1918) put a white square on a white background, and the colours were just differenced by a faint tone near the edge. We can imagine the shock that it evinced in the art world: no subject, no representation, just the one square imposed slightly off-balance within the other, and not even a colour to produce any emotional impact.

Soon, other artists followed suit, and the Dutch painter Piet Mondrian (1872–1944) again tried to reach a final abstract language with his Neo-Plasticism. This movement showed very pared-down aesthetic values, with no emotional connections to what might be called real life. His carefully measured-out canvases used only the three primary colours and black and white, *Composition in Blue, Yellow and Black* (1936) took the hard-edged school of abstraction along this road of no imagery.

ABSTRACTION 2

Later in the twentieth century, the Americans followed suit and minimalist Ellsworth Kelly (born 1923) and abstract expressionist Franz Kline (1910–1962) produced work where the colour usage might be increased, and the shapes make different patterns. These are two drawings of *Painting No 7* (1952) by Kline (above) and *Red, Blue, Green* (1963) by Kelly (right). The originals were not alone in doing this but their artists are among the most uncompromising practitioners of abstraction.

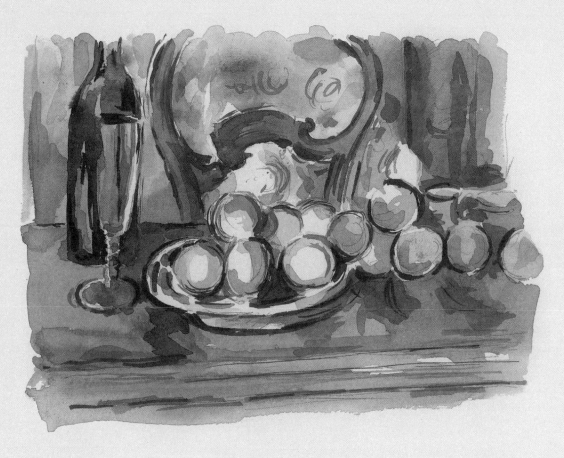

STYLES AND INFLUENCES

In this section, where I show you the various styles and techniques of some established artists, I decided it would be very interesting to do a careful copy of an individual piece and then have a go at my own composition, executed in a similar way to the chosen artist. This has several virtues as a process. It means that first of all you become conversant with the difficulties of copying a really good artist's work, which in itself is a useful exercise, and then you have to adapt that technique and the artist's style to an example of your own. The 'style' of an artist is the characteristic way that he or she draws; and the technique is the chosen method, such as pen and ink, or watercolour brushwork. This is not quite as easy as it may seem because you are working in an unaccustomed manner and, in order to get the most out of the drawing, you will have to try and emulate the actual strokes used by the artist in the original drawing.

I picked a range of artists that were not too similar to one another, so that you might see how one person can experiment with varying styles and techniques without being overwhelmed in the process. I recommend that you too should practise copying and then drawing up your own version in similar style and technique.

It is also a good idea to choose subject matter similar to that of the original artist. In the following examples, I have drawn a scene each time that is very much like that of the original, but I have interpreted it in a contemporary version.

OLD MASTER PORTRAITS

Rembrandt van Rijn, one of the most enduring old masters in the history of art, was renowned for his portraits. His often simple compositions and superb technical ability with chiaroscuro (extreme light and shade) has made many of his portraits iconic in their power.

This one, painted in 1660, is called, *Portrait of a Lady with an Ostrich-Feather Fan* and the sitter was probably the wife or daughter of some rich merchant.

Notice how strongly Rembrandt has lit the face and hands and reduced the rest of the composition to dark shapes in a shadowy space. The lighting gives strong modelling to the woman's features, and so the sense of a real person sitting before you is very compelling. The portrait is like a high contrast black and white photograph in its intensity.

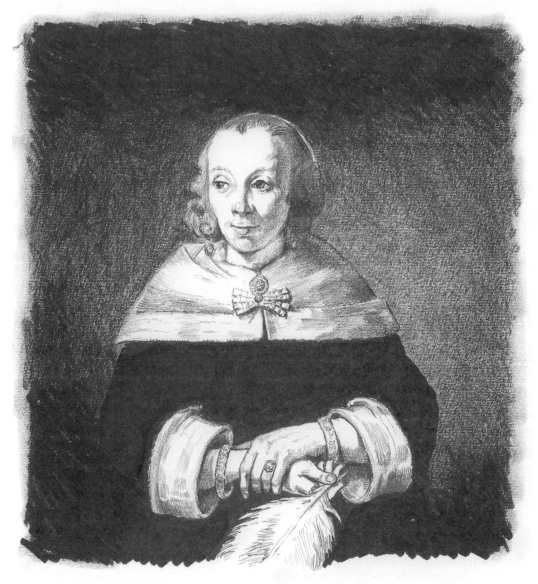

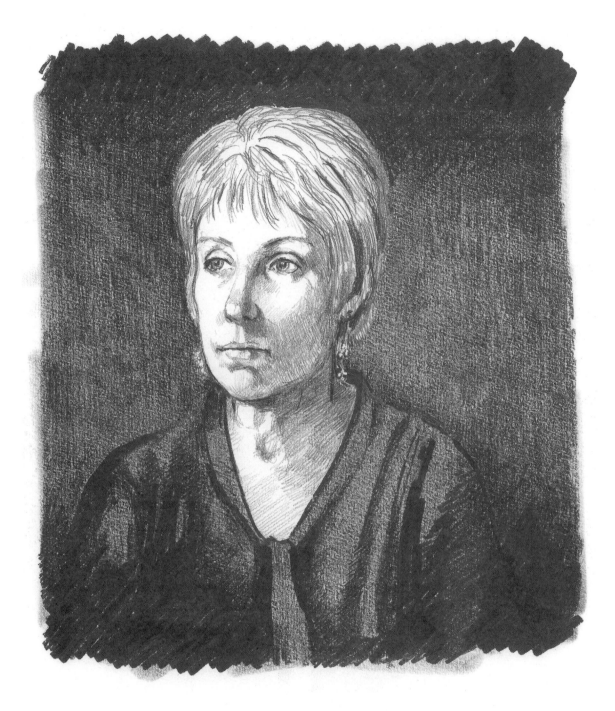

My attempt to recreate a similar look also makes use of a dark background and a dark dress. The dress is no way as decorative as the one worn by Rembrandt's sitter, but it is formal enough, and the earrings echo the adornment that is more evident in the older picture. The lighting is similar but not quite so intense, and I couldn't arrange for the shadows to fall in quite the same way. But as you can see, the end result does have a feel of the original.

The technique that I used for the imitation Rembrandt involved pencils of varying hardness and a stump to smudge and blend the darker tones. This allowed me to produce a smooth tonal area, which I then worked over with a darker, softer pencil, helping to build up some rich, deep shadows.

NEW MASTER PORTRAITS

David Hockney (born 1937) is a contemporary practitioner of the art of portraiture, and a very good one at that. This drawing of a friend of his, *Ren Weschler* (2002) is done in ink. Hockney has used a sepia ink to draw the face and hands and black for the clothes, background and notebook. His gentle, wobbly line technique works very well to indicate the texture of flesh and cloth. He keeps his marks fine and builds them up gradually.

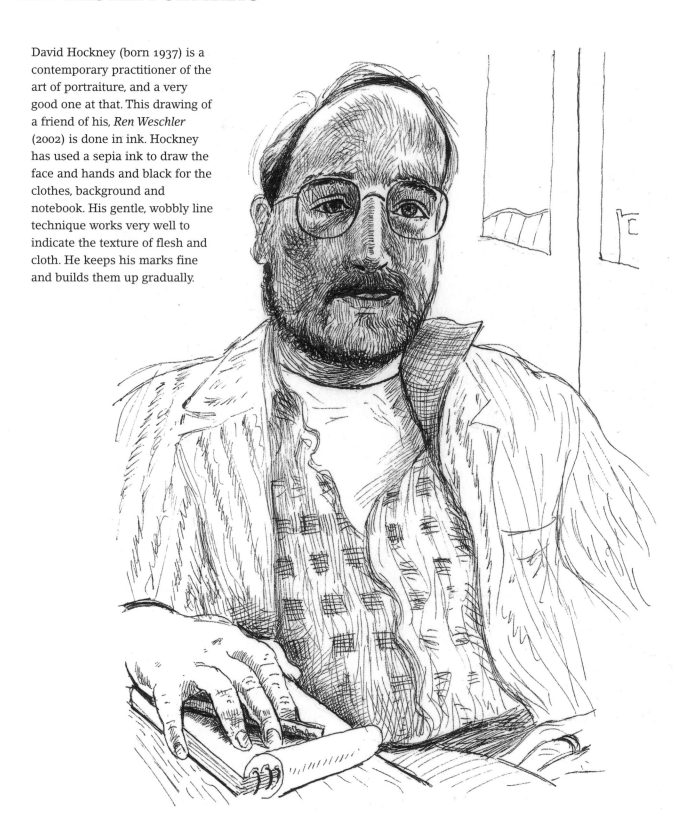

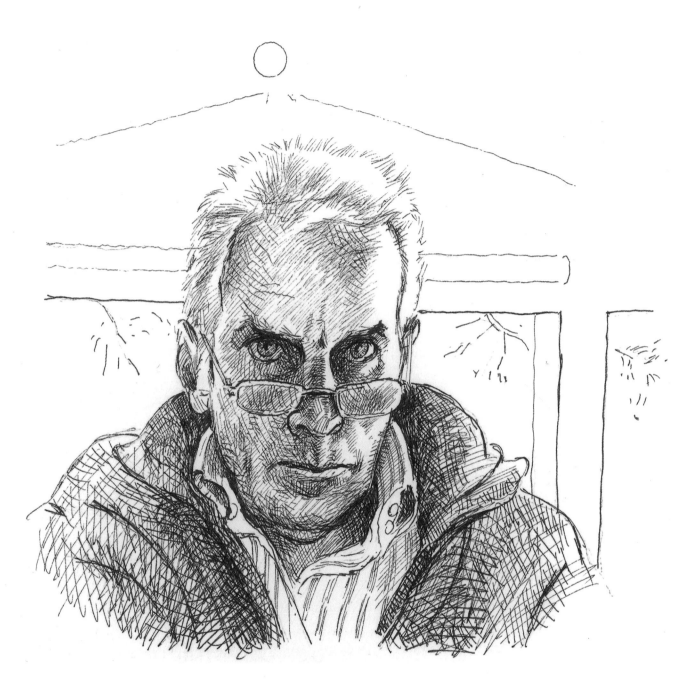

For my version of the portrait, I have used my own face, which is why the glare looks a bit intense. This is what happens when you are concentrating on drawing yourself. I did not use two colours of ink, because this book is printed in one colour only and so the subtlety of tone would be lost anyway. I tried to keep my marks fine and gentle, but I probably have a slightly stronger mark-making tendency than Hockney. However, I have built up the tones in the same way and you can judge that the result is similar.

STILL LIFE IN BRUSH

Paul Cezanne's still-life work was revolutionary in his own time and painters still use the methods that he initiated in trying to produce a new realism in their work.

Here I show one of his still-life compositions, *Apples, Bottle and Chair* (1905). There's a bottle, a glass and bowl of apples on a table top, with the back of a chair in the background. Note the way that Cezanne has not completely defined all the outlines of the apples but still managed to suggest roundness and depth. His tonal range has been kept quite narrow so that nothing jumps out of the picture at you. The whole effect is one of a subtle depth and of 'almost seeing' everything. Just as in real life, you don't see everything sharply defined but your gaze roams over the surrounding area and in a general way, takes it all in.

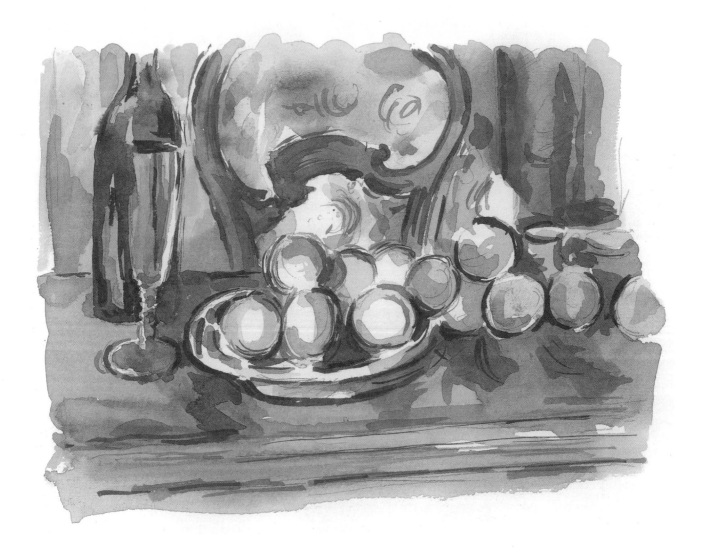

My version of a still life, employing similar methods to Cezanne, involves still-life objects of the same sort and arranges them against the light. I have used watercolour this time, to capture the Cezanne mode, and have also used a variety of tints from grey to black, to achieve the range necessary. The main thing is not to try and put everything in, but to allow your eyes to supply or infer the detail. Keep the shape loosely accurate and allow the tones to melt into one another. You may not end up with a Cezanne-type masterpiece, but you will have produced an interesting, atmospheric still life.

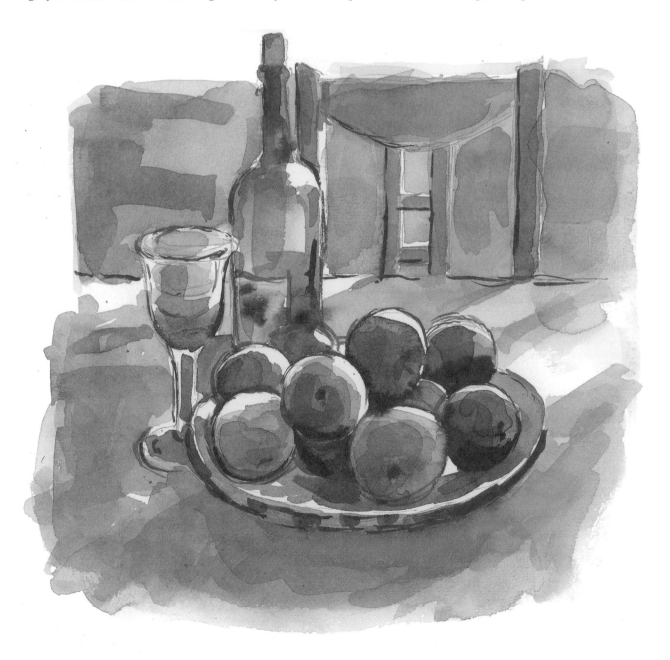

STILL LIFE IN PENCIL

William Brooker (1918–1983) was a very accomplished painter who practised during the period after World War II, and whom I was lucky enough to know for a while in the late 1960s. His still-life paintings, which have been widely exhibited, are marvellous examples of a very measured approach to his subject. He was extremely careful to evoke the essence of simple arrangements of pots and bottles on a table top, and had great ability to show depth and space. There are shades of the famous Italian painter Giorgio Morandi (1890–1964) in Brooker's cool, restrained pictures. This particular painting, *White Bottles with Black Tin* (1966), was typical of the way he would regiment his objects and show them as a tight group in a well-defined space. The objects cluster near the centre of the composition, and the table helps to define the space around them. Note the marks that I have replicated where he has set out the drawing to be sure of the relationships between objects.

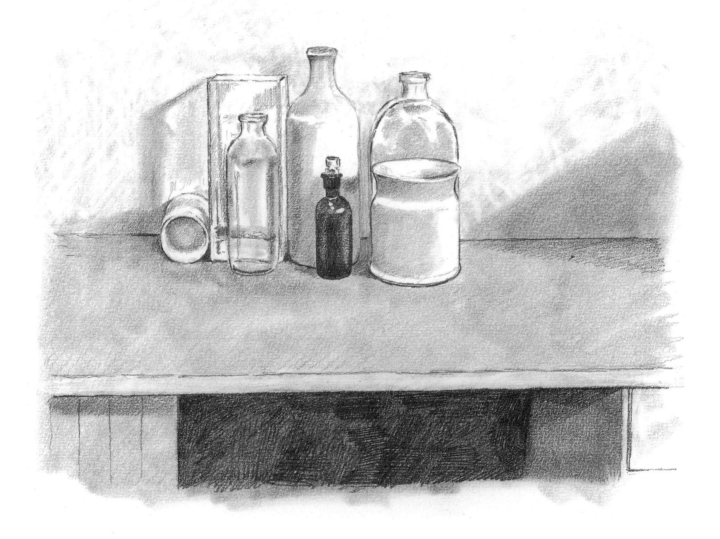

My version of this kind of still life was produced in pencil with a stump used to soften some of the marks. I gathered together glass bottles and white vases, with one bottle made of dark glass and it all sat on a table top against the back wall of my studio, which is basically a white tone. I don't think I have achieved quite the ordered intensity of the Brooker picture, and I have sacrificed some of the space in order to draw the objects more clearly. The very dark marks are important, in that they help to define the depth under the table, and the intensity of the dark bottle against the paler shapes. I could probably have set the whole picture back a bit in space to imitate William Brooker's work, but you don't need to be too slavish when using another artist's work for your inspiration.

LANDSCAPE

I have picked two Matisse pieces from the period before World War I to give examples that are in a style that is fun to imitate.

Both are views from a window. One looks out on to a landscape in the South of France, *View from a Window in Collioure* (1905); the other is a seascape in Morocco, *View from the Window, Tangier* (1912). Both use the window-frame to produce a vignette effect, and the surround adds to the interest of the picture. The drawings are in ink and, typically, Matisse uses a very loose, spare, line technique that he seems to have acquired effortlessly.

In the version produced by me, I have used a similar technique, trying not to be too accurate as to the detail of the picture, but endeavouring to convey the spirit of the view seen from my studio window, allowing the scribbly looking lines to approximate to the scene. Drawing like this is a make-it or break-it effort, and you don't have much chance to alter anything. So be prepared for more than one go at the subject, but you can at least take your time between strokes and determine just how each line will look.

SIMPLE FORM AND TONE

Taking the American influence on art into account, I have used Edward Hopper to make a point here.

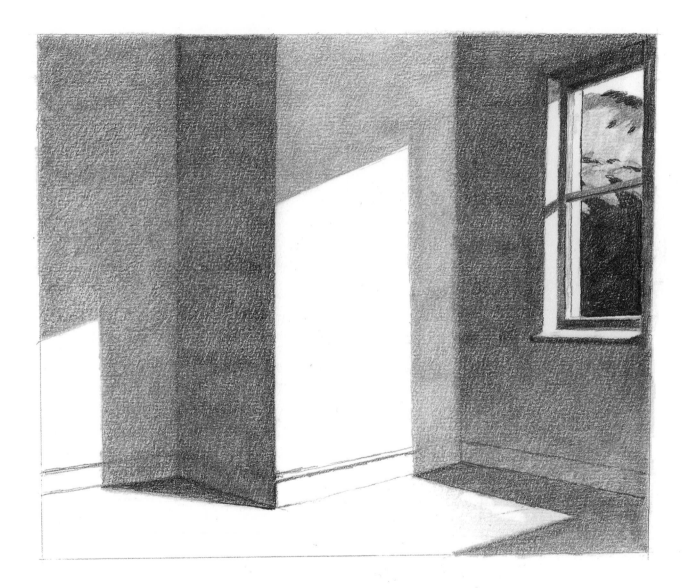

This picture is after the American painter Edward Hopper (1882–1967). *Sun in an Empty Room* (1963) with the sunlight casting areas of bright light against shadowy corners, could almost be an abstract piece of art. The clear-cut, well-defined edges of the shapes makes for an ordered geometrical pattern across the picture. The consistency of each tonal area helps to give this calm formal look.

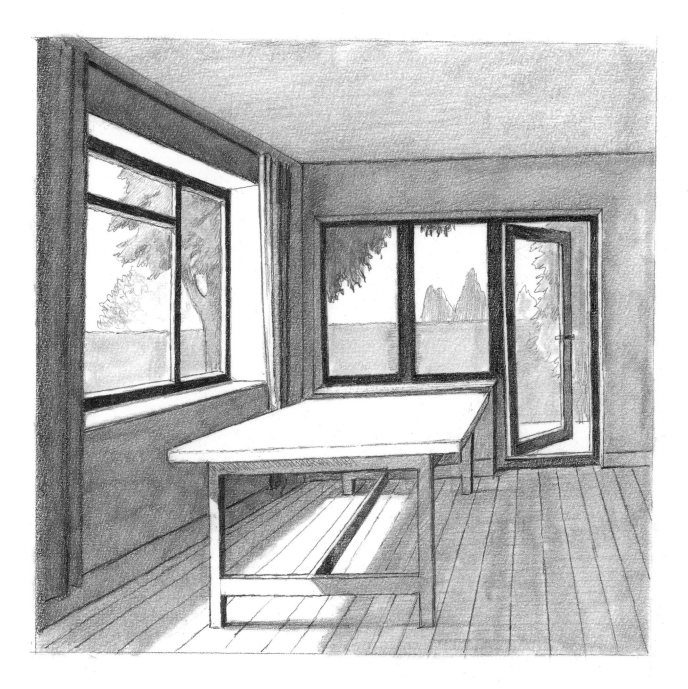

In my version of a room with no people or ornaments in it, I have tried to produce a similar effect. Of course, the room was not actually quite as bare as this, so I had to leave out any extraneous furniture or objects. I included the table, because it was such a big shape, but left out the chairs, for example. I kept the tones even, as Hopper did, and merely suggested the outlines of trees and so on, to indicate the outdoor space. It may not have quite the abstract quality of the American master, but I think it gets across a similar idea. Any room will work for this sort of drawing, but the simpler the better. Use a soft pencil with care, and a stump for smoothing out the tones.

MOVEMENT IN LOOSE LINES

Toulouse-Lautrec was a master draughtsman. Anyone who has seen and tried to copy his distinctive work knows how hard it is to emulate, and how satisfying it is when you get just a touch of it in your drawing.

Henri de Toulouse-Lautrec (1864–1901) drew this *Horse and Carriage* in 1884. It is typical of his brilliant, lively drawings, and is not an easy act to follow. However with a bit of practice you will soon develop your own version of this fluid drawing style and will then find it a challenge to try it out. The handling of tone is masterly, because he only puts in enough to make the picture work but not a touch too much. His line changes as he draws around the outline of the animal, so that the edge varies in intensity, as we observe in real life.

My own version of this was done in a field, where the horse just moved around slowly all the time and so I had to draw quite quickly. Again, you can see how the drawing varies in the sort of line used, some being heavier and some lighter. I had to keep the lines very fluid in this case, or I would not have been able to draw enough of the animal to show his whole shape. My advice is to use a very soft pencil and not to go over your marks. Let the almost accidental feel of the lines work for you. Drawing from a live model like this is always an interesting exercise for an artist, because it pushes you beyond normal expectations. And it either works or doesn't; but you can always try again.

SEEING BEYOND THE MUNDANE

When artists look at buildings, they don't necessarily class them as 'good' or 'bad' or 'pretty' or 'ugly' architecture, but see them as opportunities to produce skilled pictures.

The eighteenth-century artist Thomas Jones (1742–1803) was unusual for his day because when in Italy he often drew and painted quite ordinary buildings, whereas most other artists concentrated on the famous Roman ruins. Now Jones has become a real collector's item because of his habit of looking at superficially unremarkable buildings. As you can see from this copy of one of his pieces, *Buildings in Naples* (1782), he managed to make the most mundane walls and roofs look marvellously rich and textural.

Here, I have taken as my subject the sides of several buildings backing on to a parking lot. They are all parts of the buildings that usually go unnoticed and which very few people would normally want to draw. But to my mind, they seem to take on almost monumental size and power when seen properly. Using a watercolour technique, with one large and one smaller brush, I laid in large areas of flat tone and gradually built up the texture on top of them. You cannot rush this, because you have to wait until one area has dried before you work more detail into it. It helps if, first of all, you outline the main buildings very lightly with pencil. This is a great exercise in keeping control of your medium. Laying down the tonal washes needs considerable concentration to avoid them becoming smudged.

This book should help you to enjoy the many different ways that artists have devised for representing the visual world. But don't stop here. Experiment with any techniques, mediums or ideas that occur to you and see if they work. It is great fun, even if sometimes it makes a big mess. Good luck in your endeavours.

Index